Art and Identity
in the Roman World

Art and Identity in the Roman World

Eve D'Ambra

The Everyman Art Library

Acknowledgements

I owe much to my teachers, Professors Diana E.E. Kleiner and Susan B. Downey, who showed me the richness of Roman art. Many of the ideas in this book depend upon the work of Natalie B. Kampen with its dovetailing of social analysis with art history. I also thank Judith Barringer, Bettina Bergmann, John Bodel, Elaine Fantham, William Mierse, Brian Rose, R.R.R. Smith, Susan Walker, and Katherine Welch for fielding questions on matters of interpretation, bibliography, or photo resources. Two Vassar students, Therese Wadden and Anna Vallye, tracked down books and xeroxed for me. The curators of collections of Roman art, particularly in Rome and Naples, have been gracious in permitting me to view works not usually on display. My husband, Franc Palaia, devoted his time taking photographs under trying conditions and demonstrated patience during all stages of the work. I would like to dedicate this book to my daughter Lily who was born in the midst of this project.

First published in Great Britain in 1998 by
Weidenfeld and Nicolson Ltd
The Orion Publishing Group, Orion House
5 Upper St Martin's Lane
London WC2H 9EA

A catalogue-in-publication record for this book is available from the British Library

ISBN 0 297 82406 6

Series Consultant Tim Barringer (Yale University)
Senior Editor Kara Hattersley-Smith
Designer Karen Stafford
Picture Editor Susan Bolsom-Morris
Printed in Hong Kong/China

Frontispiece Portrait statue of a woman as Venus, page 108 (detail)

Contents

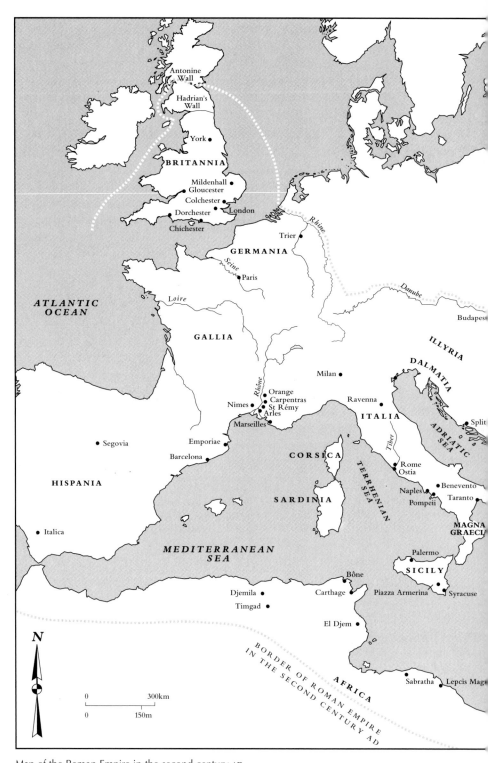

Map of the Roman Empire in the second century AD.

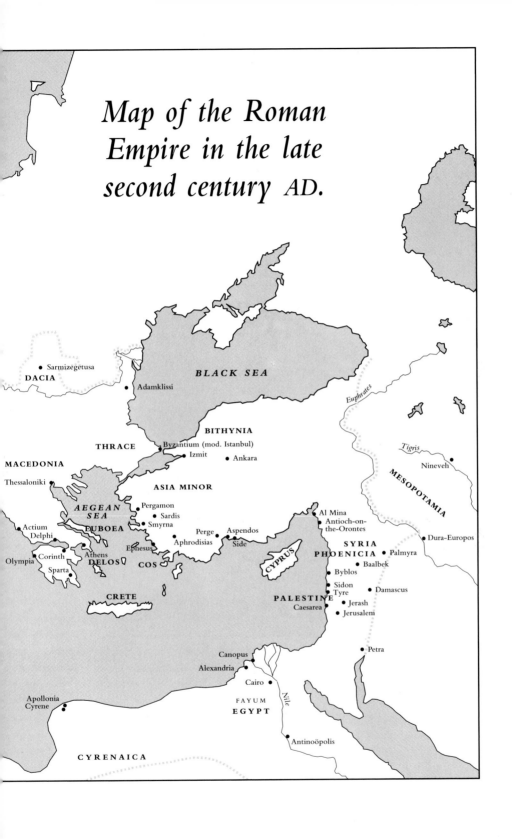

Map of the Roman Empire in the late second century AD.

DACIA

- Sarmizegetusa

BLACK SEA

- Adamklissi

Euphrates

BITHYNIA

THRACE
Byzantium (mod. Istanbul)
- Izmit
- Ankara

Tigris

Nineveh

MESOPOTAMIA

MACEDONIA

Thessaloniki

ASIA MINOR

Pergamon
- Sardis
- Smyrna

Al Mina
Antioch-on-
the-Orontes

Actium
Delphi

AEGEAN
SEA

EUBOEA

Perge Aspendos
Aphrodisias Side

Dura-Europos

SYRIA
PHOENICIA Palmyra

Olympia Corinth
Sparta

Athens
DELOS COS

Ephesus

CYPRUS

Byblos

Baalbek

Sidon
Tyre Damascus

CRETE

PALESTINE
Caesarea Jerash
Jerusalem

Canopus
Alexandria

Cairo

Petra

Apollonia
Cyrene

FAYUM
EGYPT

Nile

CYRENAICA

Antinoöpolis

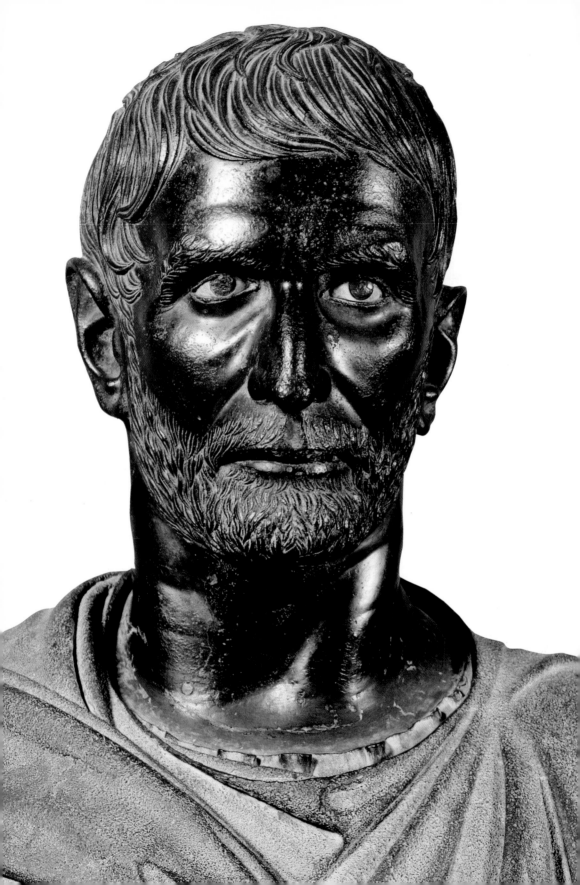

Empire and its Myths

1. Portrait of "Brutus," fourth–third century BC. Bronze, h. 27⅛" (69 cm). Capitoline Museums, Palazzo dei Conservatori, Rome.

The head, perhaps portraying the legendary founder of the Republic in 509 BC, who led a popular insurrection against the last Etruscan king of Rome, has been seen to express distinct predispositions to form and structure of the indigenous Italian peoples, particularly in the reductive geometry and the cubic form that give this work its authoritative presence.

T he study of Roman art has been complicated at the very start by the varied meanings of "Roman." It refers to place as the city that was the center of the imperial government and the hub of cultivated and sophisticated living – so much so that Rome came to be known simply as *urbs* ("the city" in Latin), the city among cities. Yet "Roman" may also indicate the vast expanse of territory: to the west it was bounded by the Iberian peninsula and the hinterlands of Scotland; to the east by the Tigris river (in the third century AD); to the north by the Danube; and to the south by the oases of the Sahara (see pages 6–7). And then it also refers to time as in the historical periods of the Republic and Empire (from the sixth century BC through the fourth century AD), marked by political systems that managed the transformation of Rome into the master of the civilized world through raw conquest and efficient administration. Although the extent of Romanization is disputed, the spread of Latin, the wearing of the ceremonial toga, and the construction of urban institutions such as amphitheaters and baths throughout Europe, sections of the Middle East, and north Africa show the effects of Roman cultural domination.

The adjective "Roman" seems to sit more comfortably with political geography and historical development than with easily classified and recognizable works of art. The Romans themselves were responsible for propagating the cliché of the business-minded bureaucrat or hardheaded military man dismissive of or confounded by the fine arts, which were denigrated as a pastime for idle and pampered foreigners. In the epic narrating the founding of Rome, the hero Aeneas is given a civic lesson by his dead father in the underworld: "Others will cast their breath-

ing figures more tenderly in bronze, and bring more lifelike portraits out of marble... Roman, remember by your strength to rule earth's peoples – for your arts are to be these: to pacify, to impose the rule of law, to spare the conquered, battle down the proud" (Virgil, *Aeneid*, 6.1145–47, 1151–54). As we shall see, the imperial mission of the Romans did not disqualify them from cultivating the arts or, at least, acquiring and collecting works of art. There were generals and politicians who understood the value of stately marble buildings and public portrait galleries for a young city, recently enriched by foreign conquests, striving to be the capital of the world. Its citizens saw how tombs conspicuously sited on the roads leading to the city or grand houses brought them prestige in the eyes of their peers.

The problem of characterizing Roman art arises from its relationship to its esteemed predecessor in the Hellenic world. According to the old theories, Greek art provided the model, Roman art followed suit. Traditionally, historians of Roman art have had to defend their field against charges of inferiority to and derivation from the achievements of the Greeks, particularly the idealized figure style of the fifth and fourth centuries BC that defines Classicism. Yet to do so ignores the innovations of Roman architecture, for one example, and also presumes that invention was valued for itself in traditional cultures that looked to the past before facing the future. Roman art was dependent on Greek precedents because it developed in the cultural climate of Hellenism in a Mediterranean landscape saturated with the products of Greek civilization. These came directly through the Greek colonies established in southern Italy and Sicily in the eighth and seventh centuries BC and from the war booty from the conquest of the Greek east in the third through first centuries BC, and indirectly through the Etruscans: their adaptation of Greek styles adorned their city-states in the central Italian peninsula and, ultimately, the city of Rome itself when it came under Etruscan rule in the sixth century BC (FIG. 2). In its beginnings, Roman art should not be seen either as a slavish imitation of Greek art or in rigid opposition to Classical styles of the fifth and fourth centuries BC but, rather, as an offshoot of Hellenism that developed an unusual and complicated relationship with the source of some of its styles and themes.

Yet there are works of art that give us a sense of Rome's awareness of its historic role from the beginning: a bronze sculpture from the early fifth century BC depicts a she-wolf that bristles with menace and pent-up energy; the animal is also represented suckling two little boys identified as the twins Romulus and Remus

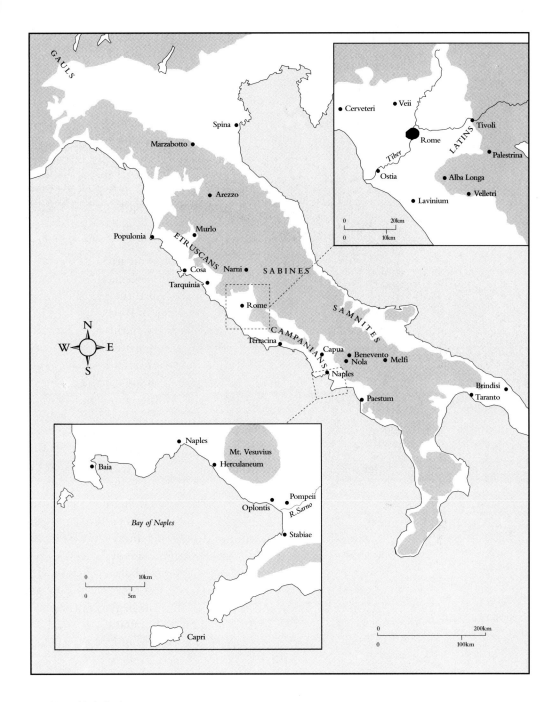

GAULS

Spina

Marzabotto

Cerveteri • Veii
• Rome
LATINS
Tivoli
Tiber • Ostia
Palestrina
• Alba Longa
• Lavinium • Velletri

0 20km
0 10km

Arezzo

Populonia

Murlo

ETRUSCANS

Cosa Narni SABINES

Tarquinia

Rome

SAMNITES

CAMPANIANS

Terracina
Capua
Benevento
Nola Melfi
Naples

Paestum

Brindisi
Taranto

N
W E
S

Naples

Baia

Mt. Vesuvius

Herculaneum

Pompeii
Oplontis
R. Sarno
Stabiae

Bay of Naples

0 10km
0 5m

Capri

0 200km
0 100km

2. Map of Italy in the
third–second centuries BC,
including earlier Etruscan cities
and Greek colonies.

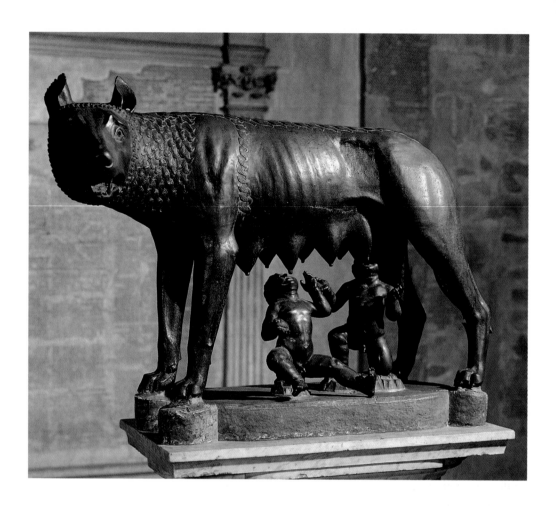

3. She-Wolf, early fifth century BC. Bronze, 29½" x 44⅞" (75 x 114 cm). Capitoline Museums, Palazzo dei Conservatori, Rome.

It may be that this work originally had nothing to do with the legend but instead evoked the menace of the predator for a pastoral population.

(FIG. 3, here the twins are Renaissance additions). Romulus, the first king of Rome, born from a priestess and the war god Mars, was abandoned in the wild and succored by this untamed guardian. Later Republican coins depicting the she-wolf with twins certainly depend on the story of savage but heroic beginnings, although the image of the she-wolf may have served as a totemic animal for the early Romans. The wolf demonstrates an early interest in bronze casting and in highly stylized forms – the barred fangs, hooded eyes, pricked ears, and taut flanks sharply rendered on the metallic surface. The mane in particular, with its interwoven locks, has no place on a wolf but, perhaps, it served to ennoble the creature who came to be synonymous with the values of early Rome: its vigilance, aggression, and ferocity.

The question of identity is central to the study of Roman art because it brings those who commissioned works of art and those who viewed them to the forefront. It allows us to con-

sider the persistence of standard motifs and styles across the Mediterranean for several hundred years: did they appeal to the officials of provincial cities who merely wanted to curry favor with Rome or was there a deeper satisfaction found in exhibiting the heraldry of the Empire that indicated membership in a privileged society? Can we speak of a sense of civic or national identity in the period when Rome expanded its influence beyond its city walls and the Italian peninsula to rule peoples of diverse ethnic backgrounds and cultures? The quest for identity figured prominently in Rome's rise to power as an undistinguished and uncultured city with global ambitions: one of its first steps was to establish itself as the guardian of Hellenic culture through its adoption and adaptation of Classical style and forms, yet, as we shall see, it also defined itself against the model of Greece.

Works of art commissioned by patrons of varying social ranks or in farflung regions of the Empire reflect the extraordinary receptivity to diverse influences that characterizes Roman art and culture as a whole. This quality is also evident in the political character of the Empire, which grew through conquest and assimilated its former enemies as residents or citizens of the Empire. Not only were geographical boundaries fluid, but the rigid social order had loopholes: it permitted owners to free their slaves and confer Roman citizenship on them; these ex-slaves or freedmen and women enjoyed a degree of social mobility unprecedented in the ancient world and commissioned art with styles and motifs familiar from the monuments of the elite. In a society driven by demonstrations of power and wealth, mainly concentrated in the hands of a very few, it is striking that there were styles and standards appropriate across the social spectrum. What defined the Roman character and allowed a person to pass as a Roman was never simply given. It had to be tested, challenged, and sorted out through the system that granted rank and status to citizens according to factors such as birth, wealth, and accomplishments, which occasionally clashed with one another. The social order is the subject of Chapter One.

Identity here means the construction of a social identity by external forces that dominate individual choices and freedoms (not the psychological interior of subjects). A Roman could place any stranger simply by looking at him or her, because social rank, marital status (for women) or sexual proclivities, background, and even political clout or cultural aspirations were apparent in grooming, dress, and bearing. Custom or tradition (rather than the appeal of fashion to which we are accustomed) governed a person's appearance: the white wool toga, for example, distinguished a Roman

4. Esquiline Tomb painting, late fourth–early third century BC. Fresco fragment, 34½" x 17¾" (87.6 x 45 cm). Capitoline Museums, Palazzo dei Conservatori, Rome.

The protagonists are distinguished by their uniforms: the black spear and white toga of the Roman Q. Fabius, upper right; the golden greaves (shin-guards) and waistband of the Samnite Fannius, left, confirm the historian Livy's report that the Samnites tried to impress the Romans with their deluxe armor.

citizen who, even though he may have worn it only on special occasions, was granted the respect and dignity of a participant in public life; a toga worn by a woman, on the other hand, signalled that she was a prostitute, because the costume that marked the public role or political agency of men could indicate only dishonor or notoriety for those denied these rights. Such a highly inflected visual code also existed in Roman art.

Foundations

In order to rationalize its course of conquest and to glorify an unimpressive lineage, Romans accounted for the origins of their city and its early history with myths and legends. Foundation myths were ubiquitous in the monumental arts of the Empire, particularly in periods when emperors asserted their legitimacy by proclaiming themselves descendants of the founders. The project of defining Roman identity was confounded by Rome's origins as one city among many in the central Italian peninsula (see FIG. 2) that was more proficient at conquering her neighbors and managing larger and larger territories. The task of glorifying and justifying the Roman mission to rule fell mainly to the historians and poets of the Augustan period (31 BC–AD 14), such as Livy and Virgil, who instilled an aura of mission and destiny in their stories of warriors, politicians, and gods. In these accounts, history and myth are interwoven to give shape to the past and forge the identity of the Roman people as those destined to dominate most of the known world because of their inherent superiority of character and moral authority. The humble and crude beginnings of the city are often emphasized, as if to heighten the odds against the people who brought the Mediterranean and its vast hinterlands under their sway. We should recall the inventiveness of Roman intellectuals when considering works of art long acclaimed for their "realism" and their fidelity to historical "fact."

While the sculpture of the bronze she-wolf may evoke the spirit of early Rome through allusion to legend or as a totemic animal (see FIG. 3), painting provides an example of the documentary nature of Roman art in its formative stages. The fragment known as the Esquiline Tomb painting from the late

fourth or early third century BC in Rome depicts warfare and its aftermath (FIG. 4). The painting is composed in a series of horizontal strips one above the other, not unlike cartoon strips. The juxtaposition of image and text (the inscriptions above the figures' heads) implies that a specific event with known personages is depicted on the tomb walls. The story may unfold sequentially, the crowded action scenes alternating with those representing the stately and static confrontation of the protagonists, whose figures fill the height of the strip. The subject matter of battles with backgrounds of crenellated fortifications and telling details of military or ceremonial uniforms corresponds to the reality of Rome's conflicts with its neighbors in the first wave of conquests on Italian soil. The tomb may be that of Q. Fabius Maximus Rullianus, whose victory over the Samnites, an indigenous Italic people, in the late fourth century (the Samnite wars lasted from 343 to 290 BC) is commemorated by these paintings in his tomb. This motif of commemorating a man by his military achievements undergoes extensive development in Roman art. Yet, the fragment – only a small section, poorly preserved, of the entire painting cycle has survived – seems to rely on the repeated motifs of the meetings of the Roman and Samnite generals in the center strips marked by gestures and stances that convey the stature of each: the partially preserved figure of the togate (that is, wearing the toga) Q. Fabius to the right plants his spear firmly in the ground as an indication of his *imperium*, the power to command and, perhaps in this context, the legal right to set the terms for peace or a settlement; opposite him the Samnite leader Fannius, in his military uniform of hemispherical helmet, greaves, and blue cloak (not visible in the second register), extends his hand in a gesture that may be interpreted as one of negotiation, trust, or acceptance of Roman terms.

The remote history of Greece played a prominent role in the other founding myth, the story of Aeneas, which complemented the story of Romulus and Remus and was represented in a variety of media from monumental relief sculpture (FIG. 5) to satirical paintings and graffiti. The Trojan hero is displaced by the Greek conquest of his city and set adrift on his historic mission to found a new homeland for his people, eventually landing in Italy. The myth is best known from Virgil's rendition in his *Aeneid*, the epic poem composed in the 20s BC under the influence of the emperor Augustus. Later, the two strands of the founding myths, Romulus and Aeneas, are fitted together: Aeneas's son Ascanius founds the city of Alba Longa, ruled by a series of kings until Romulus establishes Rome, allegedly in 753 BC.

The adoption of the Aeneas episode from the story of the Trojan war as a myth that shapes the cultural identity of Rome indicates the complexity of Rome's relationship with the Hellenic world. Through Aeneas Rome has origins on a par with the deep past of the Greeks but he also sets the Romans off from the Greeks, not merely as descendants of the vanquished Trojans but as those who retrieve glory and ascendancy from defeat and exile. Many variants of the Trojan myth circulated but the Aeneas story took hold in the early stages of Rome's expansion in the late fourth century BC (see FIG. 2) when the city overpowered her neighbors in central Italy and ventured to the south. In fairly rapid succession Rome took the rest of the Italian peninsula, including the north and central Etruscan city-states and Sicily, and then fought off Hannibal in the three long Carthaginian wars (264–146 BC). Continued military success provided Romans with a sense of legitimacy and the physical momentum for their wars of conquest, as well as a growing self-awareness of the responsibilities that accompany empire.

At the same time as Roman influence was expanding throughout the Mediterranean basin, Rome's governing body, the senate, remained a tight-knit and narrow clique, a senior council

5. The Ara Pacis (Altar of Peace), Rome, west facade, 13–9 BC. Marble, 36' x 32'9½" (11 x 10 m).

The senate erected the monument in honor of Augustus's return from wars in Gaul and Spain. In the upper relief panel, to the right of the door, the Trojan hero Aeneas performs his first sacrifice upon landing on Italian soil.

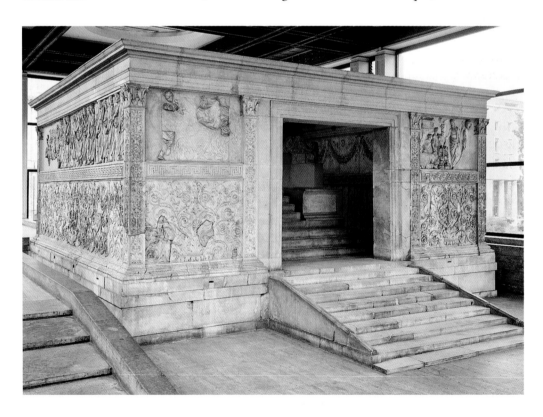

of men from a small group (approximately thirty) of elite families. Republican society was dominated by these patrician families, who ruled on the basis of the wealth and prestige of their bloodlines. They provided candidates for the two annual consulships, the highest magistrates of Rome, as well as the lesser offices, those of the *praetor*, *quaestor*, and *aediles*, from which younger men advanced in their political careers, after military training (the *equites*, or equestrians, a group that provided recruits for the senate, could also move into the lower administrative ranks). The senatorial elite also monopolized the priesthoods of the state religion, which served to supplicate the gods on behalf of Roman national interests.

An image of the Republican ideal, the statesman and military commander, is seen in the bronze head known as "Brutus" (see FIG. 1). Both the identification with the founder of the Republic and the date of the head (ranging from the fourth through the first century BC) are open to debate, yet the interest in expressing a physical type connoting moral strength and unwavering convictions suggests that the head may portray a heroized ancestor or leader of early Rome. The intense gaze of the inset eyes confronts the viewer, and the sense of focus and concentration is augmented by the squarish proportions that lock them in place. The severity of the features, along with their rigid regularity, points to the underlying geometry that is apparent in the horizontals and verticals formed by the prominent brows, the high-bridged nose, the creases on the forehead, and the tense, thin-lipped mouth.

The grid-like arrangement of features is only interrupted by the fine strands of the hair, arranged to the side of the forehead, and the deeply engraved lines flaring from the corner of the nostrils to the mouth. A similar juxtaposition of expressive features and linear patterns is found in the bronze she-wolf, another icon of Roman ancestry. In both works the powerful presence of the subjects is not muted by the rendering of carefully worked geometric patterns (as in the interwoven flame-like locks of Brutus's beard and a similar treatment in the mane of the she-wolf). Also like the she-wolf, the over life-size head of Brutus may have formed part of a statue displayed in a public setting, perhaps an equestrian statue because of the head's slightly downward tilt.

Reactions to Dominant Cultures

Wars of conquest enriched generals and their troops in the form of booty, the plundering of the defeated enemies' movable goods, which also introduced the Roman public to the arts of the Hel-

lenic world, first from the Greek cities of southern Italy and Sicily, and then from cities of the Greek mainland and the coast of Turkey. Booty was displayed in triumphal processions: military parades with the triumphant general riding in a chariot, with panel paintings displaying battle scenes, carts with bound prisoners of war, and gleaming bronze statuary or silver *objets d'art*. The processions followed routes through the center of Rome thronged with crowds who gaped at the moving spectacle of foreign places, peoples, and splendid objects. The commonly held view that Roman generals acted only out of greed and acquired the material wealth of their enemies merely for the sake of accumulating treasures – the image of the uncultured Roman hungry for status objects and exotica or, conversely, suspicious of their appeal – has some support in the ancient sources. For example, the historian Plutarch (first–second century AD) tells us of the triumphal display of M. Claudius Marcellus in 211 BC after his conquest of Syracuse in Sicily:

> When the Romans recalled Marcellus to the war with which they were faced at home, he returned bringing with him many of the most beautiful public monuments in Syracuse, realizing that they would both make a visual impression of his triumph and also be an ornament for the city. Prior to this Rome neither had nor even knew of these exquisite and refined things, nor was there in the city any love of what was charming and elegant; rather it was full of barbaric weapons and bloody spoils... The elders blamed Marcellus first of all because he made the city an object of envy, not only by men but also by the gods whom he had led into the city like slaves in his triumphal procession, and second because he filled the Roman people (who had hitherto been accustomed to fighting or farming and had no experience with a life of softness and ease, but were rather, as Euripides says of Herakles [Hercules], "vulgar, uncultured but good in things which are important") with a taste for leisure and idle talk, affecting urbane opinions about the arts and about artists, even to the point of wasting the better part of a day on such things.
>
> (Plutarch, *Life of Marcellus*, 21)

Plutarch's account is important because he claims that Rome was taken off guard by the arrival of so many wondrous and seductive art works. There is a litany of accounts in this vein, considered by modern scholars to represent the conservative reaction to an intellectual elite in the thrall of an alien, and therefore

suspect, Hellenic culture. Perhaps analogies can be drawn to contemporary culture wars in which the old guard fears losing ground to a liberal elite that is less reverential of traditional values. Before we accept this as the impartial truth, we must ask what was at stake in the looting and display of art works in the context of the triumph.

Clearly the political and economic motivations played a prominent role: foreign art was proudly displayed as a token of Rome's supremacy, and the gold and silver added to the coffers of the treasury or built private fortunes. Yet Rome had its own tradition of public art in the form of honorary statues of citizens. From the fourth century BC, eminent Romans were granted statues erected on columns or equestrian statues in the Forum, the civic center of the city. Those granted public statues were usually political officials and military heroes, the majority of men, but there were some women so honored, such as in the seated statue of Cornelia, daughter of the illustrious Scipio Africanus and mother of the Gracchi who promoted social reforms in the late second century BC.

Plutarch's account of Marcellus's triumphal display is misleading in several aspects: art, both imported and locally produced, was visible in Rome earlier than he implies; and the issue of the corruption of the masses by the display of booty clearly reflects elitist attitudes. We need to imagine varied and nuanced reactions to the sight of gleaming bronzes and lustrous marble figures in Rome in the third and second centuries BC: from the uncomprehending to the uninterested, from fawning admiration to the awareness of the value of these works for the promotion of Roman culture and ascendancy in the Mediterranean. The last view dominated. Rather than a resistance to Hellenic culture in general and Greek art in particular on the part of a conservative elite, we should see an embrace of it. The miscomprehensions come from the moralizing tendencies of later sources and from contemporary concerns that public art is serving private interests.

What types of art did Roman generals bring back from the defeated Greek cities of southern Italy and Sicily in the first wave of Hellenic influence? What kinds of monuments did the Roman elite install in public view to assert that Rome would now be the guardian of Hellenic civilization? Some generals exhibited the discrimination of connoisseurs in selecting works: Q. Fabius Maximus confiscated from Taranto (ancient Tarentum, a Greek city in southern Italy) a colossal statue of Hercules by the celebrated Greek sculptor Lysippus in 209 BC; and M. Fulvius Nobilior took a hoard of 785 bronze statues and 230 marble statues in 189 BC.

6. Female head with gold diadem, fourth century BC. Terracotta, h. 14⅛" (36 cm). Museo Archeologico Nazionale, Taranto.

Classical styles were transmitted to Roman patrons by artists such as Pasiteles (106–48 BC), a Greek living in southern Italy with a workshop in Rome that was responsible for eclectic works and training younger artists. Pasiteles wrote a book on famous works of art, evidence of Roman collectors' interest in Greek art.

A terracotta head from Taranto (FIG. 6) may give us an idea of the works that were admired for this purpose. Once part of a life-size statue, the head bears the stylistic signature of contemporary Greek art – the oval of the head, the widely spaced almond-shaped eyes, the unbroken profile contour from the slope of the forehead to the end of the nose, and the broad chin. Both the hairstyle, with waving locks swept back from a center part, and the gold jewelry, a diadem ornamented with an acanthus scroll, suggest that the figure represents a goddess. Idealization, synonymous with Greek Classical or Late Classical styles (fifth and fourth centuries BC) and apparent in the facial features without expression, age, or any forms that deviate from the accepted canon of a remote and generic beauty, also permitted a work to be fitted easily into a variety of new contexts – temples, basilicas, porticoes, gardens. There is grace, too, in the head's angle, reflecting the once lilting pose of the body.

Other glimpses of the art of the Greek colonists in southern Italy are found in painted vases and tomb paintings. Tomb paintings offer evidence for aristocratic imagery commemorating the heroic dead from the area known as Lucania south of Naples, around the city of Paestum (see FIG. 2). Originally settled by the Greeks, the colony was open to the local people, the Samnites, by the end of the fifth century BC and in the early third century was taken over as a Roman outpost, Paestum. The painting of a mounted warrior from the Andriuolo Necropolis (FIG. 7) has been interpreted as the warrior's return from battle, a motif providing heroic grandeur through the possession of a horse that exhibits high status and the ability to defend one's city that was crucial for the aristocratic ethos of the Greeks. The identification of the body in the tomb as a woman in no way contradicts the imagery; rather, it asserts the significance of military themes in the culture or, more particularly, the prominence of the woman's male relatives, father, brother, or husband, in the political life of the colony, and she may be defined in relation to their noble deeds, as we shall see in Chapter One. The solitary warrior, distinguished from the supporting figures of cavalry or infantry that enabled his success, enhances the ideal of individual valor as an essential component of victory, pursued in life and honored after death. This model of the warrior emerges from the Hellenic culture of southern Italy.

The Etruscans, originally inhabiting central Italy including Rome in the late seventh and sixth centuries and moving southward to the area of Naples and Salerno (see FIG. 2), also introduced the Classical art of the Greeks to ancient Italy. Loosely orga-

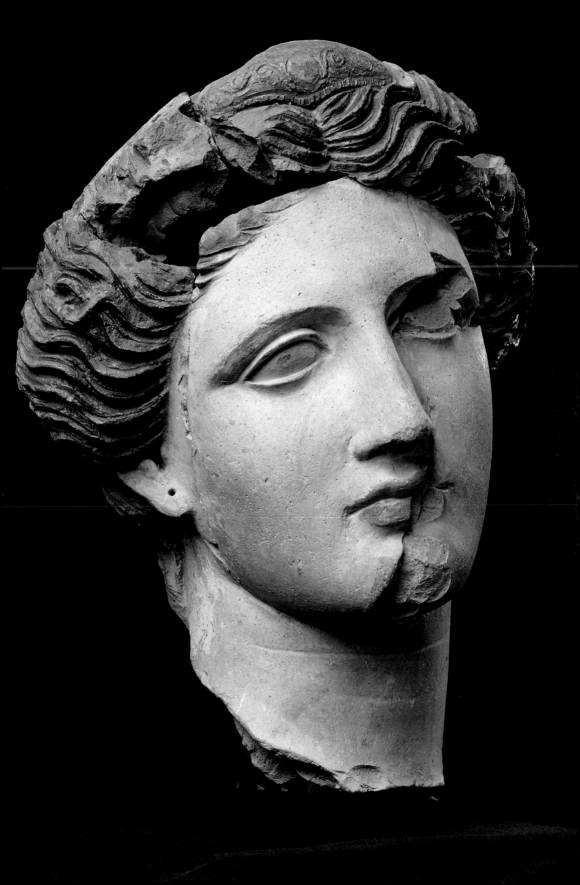

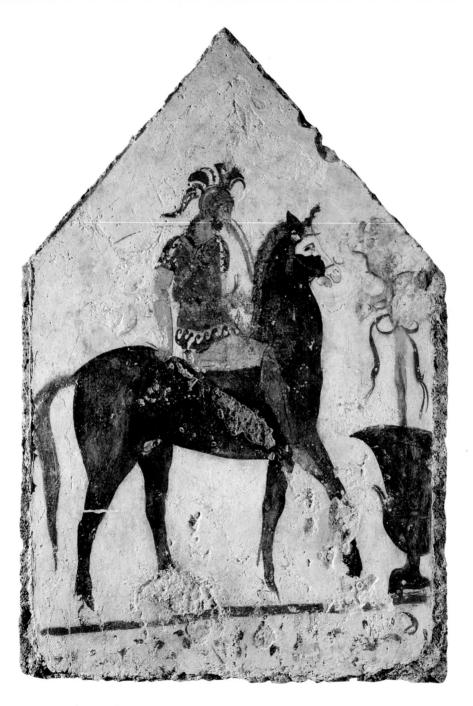

7. Painting from Tomb n. 58 from the Andriuolo Necropolis, Paestum, mid-fourth century BC.
Fresco, 57½ x 38½" (146 x 98 cm). Museo Archeologico Nazionale, Paestum.

The horseman's elaborate dress, the helmet with feathered crest, the red tunic, baldric (sword belt),
and greaves (shin guards), suggest parade attire for a procession or other ceremony. The simplicity of
the scene, its focus on figure and attributes rather than on setting, recalls Greek vase paintings, widely
distributed and also manufactured in the Greek cities of southern Italy.

nized in a system of city-states, the Etruscans maintained inland strongholds of hilltop cities with ports on the coast. They traded their technically advanced bronze and copper objects and utensils for the artworks of the Greeks and Phoenicians. After Etruscan prominence in the city of Rome, according to the legends of the Tarquins, Etruscan kings in Rome in the late seventh and sixth centuries, Etruscan power diminished with their defeat in the naval battle off the coast of Cumae in 474 BC (the Etruscans lost control of the Tyrrhenian sea to the Greeks of Sicily). The Roman conquest of Etruscan cities, the assimilation of the Etruscan nobility, and, eventually, the granting of citizenship mark the following period in which the Etruscan heritage of Roman art becomes difficult to delineate: although the Etruscan tradition of bronze casting has been detected in the statues of the she-wolf and "Brutus," their subjects seem to be Roman or so closely tied to what we have come to think of as specifically Roman genres (such as realistic portraiture or scenes of ceremony) that it is often difficult to realize that both the Etruscans and early Romans were responding to distinct aspects of Classical and Hellenistic art (produced from the late fourth through the first centuries BC in the east).

The Etruscans provided an awareness of Greek styles, along with their own contribution of dynamic forms that frequently disobeys the Greek formulas for representing figures. That most of the extant Etruscan art comes from tombs affirms our impression of the importance of the cult of the dead to the Etruscans, yet its cities have not been as thoroughly excavated until recently. Etruscan funerary art represents aspects of the privileged life and rituals for the dead, but there are also examples of violent scenes of combat or of demonic figures of Etruscan deities. The theme of providing the dead with the amenities of life is depicted in cinerary urns (containers for the ashes of the deceased) in tombs. Urns from the city of Chiusi from the late fifth century demonstrate a preference for anthropomorphic forms, the use of limestone, and for the theme of a banqueter reclining on a couch (FIG. 8).

The Etruscan features lie in the uneven treatment of the body –

8. Etruscan cinerary urn depicting a banqueter and demon, late fifth century BC. Limestone. Museo Archeologico, Florence.

The deceased man is shown feasting, enjoying the pleasures of the table in death as in life. Instead of his wife at the end of the couch, a winged figure identified as an Etruscan demon sits with one hand at her hip and her head turned to the deceased in a grim expression. She holds an opened scroll, perhaps with the names of those summoned to death, to which the deceased reaches. His impassive expression reveals no trepidation of this uninvited guest at the banquet; his heavy-lidded eyes, straight nose, and full chin typify the Classical style and indicate no attempt to render a portrait of an individual.

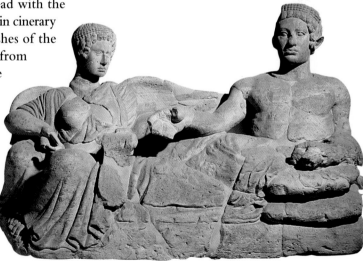

the modeling of a soft and heavy physique of the upper torso with an expanded diaphragm, while the lower extremities are summarily rendered with little modeling. This expressive exaggeration of selected features and the willful neglect of others is characteristic of utilitarian Etruscan treatments of the human figure; why laboriously carve the reclining figure's legs when they served only as props hidden under drapery, with no function in the sculpture? More important was the gesture of the right hand of the reclining figure, reaching out in response to the provocation of the demon's recoiled hand at hip and the proffered document: the demon blends the otherworldly with a menacing attitude.

Etruscan painting survives in tombs, many of which were hollowed out of living rock. The tomb chambers were often arranged in imitation of domestic architecture with large central courts surrounded by smaller rooms. Architectural features such as roof beams were occasionally carved in relief as an illusion. The walls frequently bore vivid paintings of various subjects, dancers, athletes, or priests, in nondescript or natural settings. The Tomb of the Reliefs in the Banditaccia Necropolis at Cerveteri (FIG. 9) is exceptional in omitting the human figure, instead displaying a still-life of domestic goods and utensils, military equipment, and items

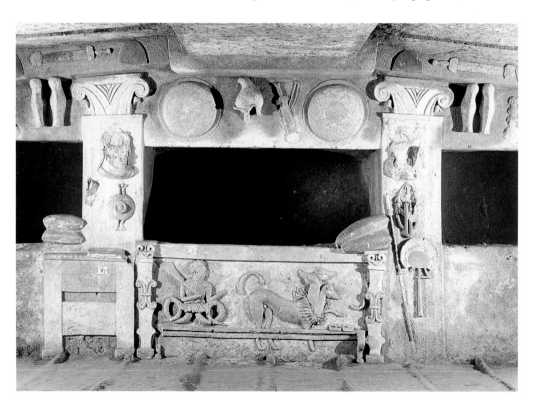

of personal adornment. Like the figures of sated banqueters with their unsteady wine cups, the fittings of the Tomb of the Reliefs offer a panoply of worldly goods required to sustain an opulent standard of living in the domain of the dead. As a large chamber outfitted with *faux* furnishings, the equipment of every-day life rendered realistically, the tomb seems eerily emptied of any human presence or domestic charm. The imagery moves us to consider what constitutes realism in Etruscan and early Roman art: the literal rendering of the objects on the tomb walls suggests cryptic meanings beyond the display of gentility, and the unde-niably forceful countenance of the head of "Brutus" (see FIG. 1), for example, may be that of a generic type portraying lead-ing citizens, heroes of the founding of the Republic, rather than that of a specific personality.

The Etruscans accommodated Greek styles, infused them with their own vigorous and non-canonical approach to the human figure, and so provided Roman artists and artisans with models for the adaptation of Hellenic forms. Clearly, the Etruscans and the other inhabitants of the Italian peninsula were saturated with Greek art that they revised as their own; one particular kind of Hellenistic art that appealed to them was the realistic art of the eastern Mediterranean and Aegean. In the late second and early first century BC the development of a singular type of portrait emerges in Rome and in places inhabited by Romans. It demonstrates a new self-awareness of the prominence of the Roman elite in international politics and a sense of the author-ity of their mission. The shaping of Roman identity is bound up with the new portrait style that appears in the political and social upheavals of the first century BC.

9. The rear wall of the Tomb of the Reliefs, late fourth–early third century BC. Stucco on rock, 24'11" x 21'4" (7.5 x 6.5 m). Cerveteri.

The interior of this Etruscan tomb in the Banditaccia Necropolis consists of one undivided space with a large couch in an alcove in the rear wall and benches along the side walls. The name of the family who maintained the tomb, Matuna, was painted on a stone. The stucco relief decorations stand out in the interior like a peculiar form of heraldry – a man's walking stick, a woman's fan, and musical instruments, testifying to the wealth and elite status of the deceased man and wife. They display both cultivated furnishings for domestic comfort and allegorical flourishes with images of monsters of the underworld.

From Republic to Empire

The Republic (sixth–first century BC) witnessed the conquest and expansion of Rome's power, but the end of this period was plagued by problems of administration and governance (corruption abroad, social conflicts at home, and the expense of the military machine). By the first century BC partisan politics had divided the politi-cal class (those who had distinguished themselves by their achieve-ments or service to the state rather than by their aristocratic lineage) over the distribution of power, the necessity of politi-cal and social reforms, and the spoils of empire. The senate became increasingly reactionary and resistant to the consuls, provincial governors, and generals who demanded greater recognition for their services and changes in the system to manage the unwieldy

empire more efficiently. The change in military recruitment (in the late second century BC) that allowed men without property to enlist and encouraged the troops' loyalty to their generals (for the share of booty) rather than to Rome offered ambitious generals the means to overthrow the government. The Republic ended in a series of civil wars in the 40s and 30s BC – the deal struck by Julius Caesar, Pompey, and Crassus in the first Triumvirate of 60 BC that led to the civil war of 49; the fighting between Octavian (later called Augustus) and Mark Antony that divided the west and east in the 30s. That some men, spurned by the system, resorted to violence against the state is not surprising: competition for positions of power became fierce because with more lower offices, there were bound to be politically ambitious younger men who would not proceed to higher posts because of the Republic's pyramidal political structure with little room at the top.

The image of the ruling elite appears in realistic portraits in sculpted heads, busts, coins, or portrait statues of the first century BC onward (FIGS 10, 11, and 12). At first glance, the portraits seem to depict individuals with faces marked by the experiences of middle age or advanced years – receding hairlines, creased skin, or pocked complexions, sagging cheeks or uneven jowls, and stern or grave demeanors. With such clinically observed, toughened faces, the style of the portraits surpasses realism to become a form of hyper-realism, for which the term verism is used. Despite the apparently close description of individual traits, the portrait heads share many features, whose repetition undermines the notion

10. Funerary relief of a man holding a portrait bust, mid-first century AD. Marble, 9⅞ x 13¾" (25 x 35 cm). Villa Albani, Rome.

The inscription names Quintus Lollius Alcamenes and his positions as *decurio* and *duumvir* (member of a town council and of a governing board of two) of perhaps Pompeii or a nearby town. The figure seated on the elaborate chair reserved for officials may be mourning the boy represented by the bust he holds, while the veiled woman offers incense. The scene thus shows us the role of portraits in funerary rites.

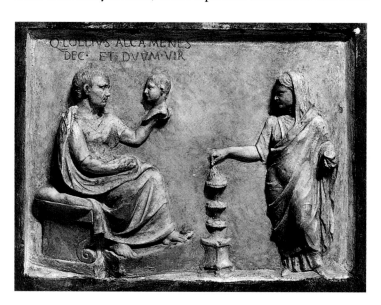

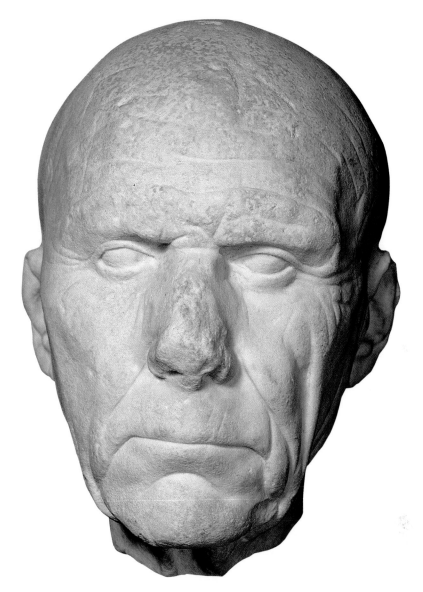

11. Head of a man from Scoppito, first century BC. Marble, h. 11″ (28 cm). Museo Nazionale, Chieti.

The veristic Republican portraits celebrate the unsightly marks of aging and graceless features that a modern sitter for a portrait might wish to camouflage: yet it is precisely frankness, integrity, and lack of guile that the portraits project.

12. A denarius of C. Antius Restio depicting his father, 47 BC. Obverse, silver. British Museum, London.

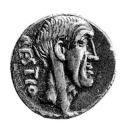

C. Antius Restio was a tribune of the Roman people in 74 BC: it was not uncommon in the Republic for leading citizens to mint coins glorifying their ancestors, although mythological or heroic attributes rather than commanding features frequently enhanced the images. The Roman coinage provides crucial evidence in that such portraits are often identified by names and titles, information that allows close dating.

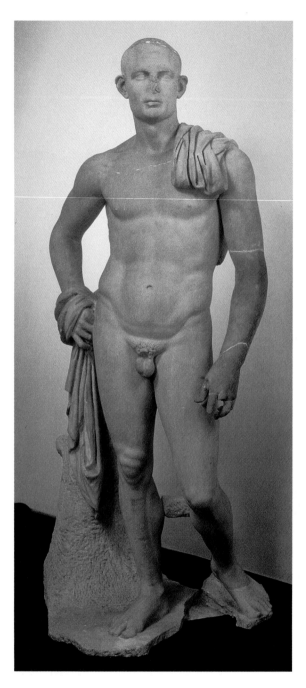

that the portraits record the physical appearance of individuals. The signs of age indicated that the subjects were men who had devoted their lives to public service in the pursuit of politics. High offices were reserved for those of more advanced years, and only with the tumultuous turn of events in the late Republic could a younger man achieve the consulship. The hardened expressions and unflinching stares of the portraits demonstrate the subjects' devotion to duty and their unflagging patriotism. In other words, the veristic portraits conform to a type that asserts the character or virtues of the ruling elite without sacrificing the appearance of individuality: the portraits represent leading men in the state (despite our inability to recognize them now) whose features present a facade of unity, of common values, and a shared sense of mission. It is significant that the portraits affirm the very attitudes that were under attack in the middle of the first century BC.

Veristic portrait heads could be used for other purposes also: the "Pseudo-Athlete" (FIG. 13), consisting of a veristic portrait head and a nude body, stood in a house owned by a Roman on the Greek island of Delos. Rather than wearing clothes identifying him as a Roman citizen, the figure possesses a physique that is not his own but derives from Classical Greek sculpture. The nude is considered to be heroic in this statuary type of an athlete or war-

13. "Pseudo-Athlete," first century BC. Marble, h. 7'5" (2.25 m). National Archaeological Museum, Athens.

The statue was found in the House of the Diadoumenos on the Greek island of Delos. In the central courtyard of the house stood another athlete statue, copied from Classical sculpture, and a female portrait in a realistic style. These works offer a glimpse of a private collection of sculpture in the house of a Roman businessman who had settled on Delos, the hub of trade in the Aegean Sea.

rior, whose well-built body stands with the weight on one leg and the shoulder and hip tilted at opposing angles (contrapposto). In contrast, the head conforms to the veristic type, with its receding hairline, furrowed brow, deep-set eyes, heavy jowls, and prominent ears. The statue may seem like an awkward hybrid to modern viewers, but it is not clear that Romans, particularly Roman businessmen in the Greek east, would have been anything but proud to have been portrayed in a manner redolent of Classical culture and its sophistication.

Female portraits of the first century BC have been classified as idealized, as polar opposites of the veristic style of the male portraits, although this generalization cannot be maintained upon close study. Women are depicted in the stages of life as maidens, brides, or matrons to reflect their accomplishments in terms of marriage and motherhood, the social roles of women in antiquity. A female portrait known as the "Torlonia Maiden" (FIG. 14) represents a type that projects an image of pristine adolescent beauty. Idealization is present in the simple oval of the face, the crisp contour of the eyebrow extending down the line of the nose, and the smooth planes of the forehead and cheeks. The bust, including a section of tunic carved to show a delicate fabric, is thought to have been adorned with jewelry. As an image of a girl on the cusp of womanhood, it would have made a vivid, even glittering impression with its flashing eyes, gold necklaces and earrings, and fashioned coiffure. The obvious intention to display such costly finery seems to go against the principles of austerity and self-sacrifice enshrined in the male veristic portraits; but it was proper for parents to honor their beloved daughter in, perhaps, a self-indulgent manner that called attention to their wealth. This portrait and other examples also attest to styles based not only on the gender of the subject but also on the subject's stage of life. The care taken to emphasize the subject's beauty and elegance suggest that the bust commemorated a girl who died before she had the opportunity to marry, whose funerary portrait, therefore, endows her with the accoutrements of a bride.

The images of both the ruling elite and its subjects change with the events leading to

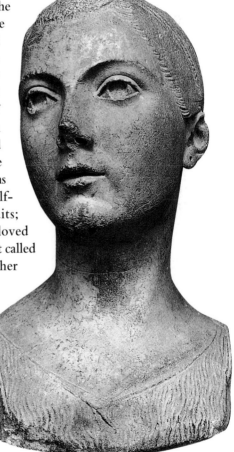

14. "Torlonia Maiden" from Vulci, first century BC. Marble, h. 13½" (34 cm). Villa Albani, Rome.

This exquisite portrait bust of a girl once had eyes with irises of glass paste and adornments that were originally attached to the severely styled and finely braided coiffure, probably a jeweled plaque placed over the central part and ornaments at the sides and back. The ears are pierced for earrings.

the rise of Octavian, whose victory in the civil wars in 31 BC over Mark Antony and Cleopatra led to the governing system known as the Empire, which lasted more or less intact until the early fourth century AD. The career of Octavian was exceptional in its early training and pace: he benefitted from being the grand-nephew and adopted son of Julius Caesar, and he emerged as a political force when he was still a mere youth (he marched on Rome at the age of nineteen and ruled the Roman Empire when he was thirty-two years old). Once in power and having taken the name of Augustus as an honorary title in 27 BC, he embarked on a course of political and social reforms that irretrievably altered the nature of power and led to an accumulation of offices in the person of the emperor (or first citizen, *princeps*) within a constitutional framework. Always careful to camouflage his policies with the traditional rhetoric of the Republic, he managed to rebuild the conservative senate with the introduction of new men from the provinces, to reorganize the civil service with men who had the necessary skills, and to reinvigorate the religious and moral life of the citizenry (this last initiative did not meet with the success of the previous two, as the ancient sources attest). Art and architecture came under Augustus's scrutiny (or that of his advisors) in order to realize his vision of a new society fitted out with the urban amenities of the Hellenistic cities of the east; the city of Rome provided the raw material for the creation of an international capital with renovated temples, spacious porticoes, and an uncluttered forum.

Augustus found that different Greek styles were appropriate for different messages. His portraits show subtle manipulations of style while never obscuring the consistent and recognizable features of a radiant youth: this is what separates the portraits of Augustus from those of the politicians of the late Republic. Again, realistic depiction is only partly responsible: although Augustus's youth became a staple of the legend of his meteoric ascent, his portraits throughout his reign never show any signs of aging, probably as a deliberate break with the veristic style of the senatorial elite. In his attempts to establish a new vision for his regime, Augustus tried different styles, the earlier types borrowing dramatic or dynamic Hellenistic features. For the mature types the appeal of Classicism was undeniable because of its associations with the famed Athenian empire of the fifth century BC.

15. Augustus as Chief Priest, after 12 BC. Greek marble for head and neck, Italian marble for torso, h. 6'9½" (2.07 m), without base. Museo Nazionale delle Terme, Rome.

Classical style combines with a religious subject in the portrait statue of Augustus offering a sacrifice (FIG. 15). The veiled head of the emperor indicates the religious context, probably the offering of a sacrifice (the right arm perhaps held out the sacrificial dish). The statue evokes a sense of restraint or an attitude of modesty before the gods. Many scholars have identified this statue as commemorating Augustus's appointment as chief priest (*Pontifex Maximus*) in 12 BC and date the statue accordingly. Other portrait statues capture the emperor as a military general, orator, and godlike hero, yet the image of Augustus as a priest of the state religion resonates with the sanctity of one of the most venerable offices and of the tradition of old-fashioned Republican values. That Augustus was otherwise engaged in dismantling many aspects of the Republic need not contradict his image as a defender of its founding principles, especially when he committed himself to a revival of traditional cults and the restoration of temples as part of his wider policy of social reform. As Augustus knew all too well, expressions of piety mattered – the Latin word *pietas* stands for the respect and duty owed to authority, whether one's father, the state, or the gods.

The toga, in which Augustus is enveloped, the white wool, dress uniform of a Roman citizen, appears to be an imposing garment, bulky, weighty, and restrictive. The burdens of wearing the toga on one fastidious citizen are noted by Macrobius, writing in late antiquity (early fifth century AD):

> To go out well-dressed, he checked his appearance in the mirror, and so draped the toga on his body that a graceful knot gathered the folds, arranging them not randomly but with care, so that the sinus [the long fold below the right arm] was composed to flow down the side, defining its outline. On one occasion when he had arranged it with elaborate care, he charged a colleague who brushed against him in a narrow passage, destroying the structure of his toga. He thought it a crime that folds should be moved from their place on his shoulder.
>
> (Macrobius, *Saturnalia*, 3.13.4)

Yet the stance of the statue of Augustus, one leg flexed and the other supporting the figure, demonstrates a sense of poise in spite of the heavy drapery. As in many imperial statues, the carriage of the figure – its stately bearing and self-possession – conveys the subject's power; there is little else to signal the immense authority of Augustus.

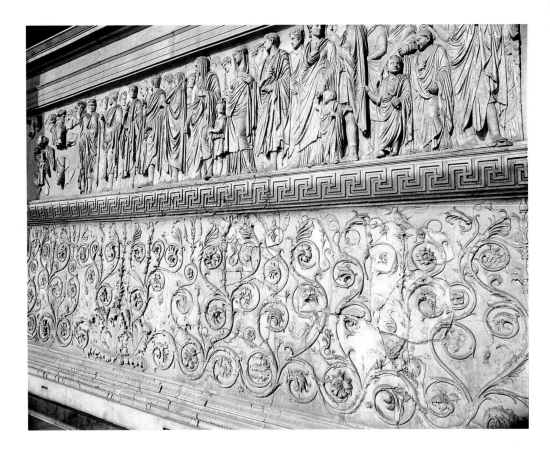

The portrait conforms to many others of this type: the face appears youthful with smooth skin, the head is broad at the crown and tapers to the chin with a sharply chiseled nose, prominent cheekbones, and thin lips. The signature hairstyle is arranged with a fringe slightly parted so that the locks separate and are combed in opposing directions. The portraiture of Augustus presents a consistent and recognizable image to his subjects – a prepossessing, clear-eyed, and intense young man as chief executive of the Empire.

State relief sculpture, considered as characteristically Roman as realistic portraiture, adorns the most celebrated Augustan monument, the Ara Pacis (Altar of Peace; see FIG. 5 and FIG. 16). The altar (only partly preserved) is enclosed by unroofed marble walls articulated with relief sculpture on the interior and exterior; access to the altar is gained by doors on the east and west sides. Motifs of religious ritual prevail: processional scenes of sacrifice ornament the altar, while the interior of the precinct walls gives the illusion of a simple sanctuary constructed of a wooden fence and supplied with hanging garlands, *bucrania* (bulls' skulls), and sacrificial plates. On the exterior, the lower relief panels depict

intertwined acanthus plants in full flower with other vegetation and wild life, all flourishing as a result of the Augustan peace. The precise geometrical design of the curling shoots and tendrils shows nature under control and carefully tended, just as the depictions of the Augustan elite in the friezes above the acanthus scroll on the walls' long sides contribute to a portrait of a regime in which the top and bottom ranks have their proper places in a well-ordered society.

The figured friezes on the long north and south sides depict processions moving in parallel files toward the west end. They have been interpreted as representations of a historical event, the ceremony marking the laying of the altar's foundation stone on 4 July 13 BC. Protagonists such as Augustus and his wife Livia can be recognized, but the other figures of the Julian family on the south frieze have been depicted with features frozen in Classicizing masks so they are not easily identifiable. The idealizing style prominent in the Augustan period may also have augmented the family likeness to give the semblance of unity. In reality, the marriage of Augustus and Livia produced no children; Augustus's daughter by his former marriage, Julia, was married several times in order to provide her father with heirs; Livia's son Tiberius, from her former marriage, eventually became Augustus's successor in AD 14. The family groups, couples with children tugging at them, are unique in the early history of the state relief, which tends to represent scenes of military and ceremonial significance with limited roles for women and children. The depiction of families on the Ara Pacis projects the imperial family as a model of the cornerstone of the traditional society that motivated Augustus's program of social renewal: he called for increased vigilance of domestic life, official encouragement of the birth of citizens, and legal punishment for wives caught in adultery.

The parade of the inner circle of the imperial court and priests is interrupted by relief panels of mythological subjects on the west side and by personifications on the east side. The panels on the west end are devoted to the two legendary founders of Rome, Romulus along with his brother Remus and their father Mars on one side and Aeneas performing the first sacrifice on Italian soil on the other (see FIG. 5). The sacrifice evinces the *pietas* of Aeneas as witnessed by his household gods who look down on the rocky altar from a miniature temple. Aeneas, with veiled head, beard, and solidly built chest, appears as a stately ancestral figure, appropriate for one descended from the goddess Venus. His gesture with arm outstretched in the act of offering is mirrored in the figure of Augustus on the south frieze offering a sacrifice to

16. Ara Pacis, Rome, south frieze, 13–9 BC. Marble, h. 5'3" (1.6m).

Augustus is depicted near the beginning of the procession on the left, with wreathed and toga-clad head and hand extended to sacrifice; he is framed by lictors (guards) who turn toward him; further behind him are Agrippa, his close friend and advisor shown with his head veiled in the center, and Livia, his wife also with head veiled and separated from Agrippa by a child, and relatives arranged by family with small children on the right. The identity of the child next to Agrippa is unknown: is he Gaius Caesar, the child born to Agrippa and Julia and adopted by Augustus as his successor, or a barbarian prince being raised in the imperial court as a privileged hostage to ensure that client kings abroad will obey Rome? The former identification emphasizes the dynastic theme of the Ara Pacis, the latter that of the wide scope of imperial authority.

Pax (Peace). Furthermore, the youth assisting in the sacrifice or the figure standing behind may represent Aeneas's son. The juxtaposition of historical and mythological scenes, of the idealized present and the imagined past, establishes the importance of the next generation: it was the male heirs who had to maintain the perfect balance in the world among gods, man, and nature. The sculpture of the Ara Pacis implies that the fulfillment of Rome's historic destiny depended on Augustus, who was seen as a successor of Aeneas, another founder of Rome and guardian of its empire.

Many consider that Roman art reached its apogee in the Ara Pacis with its Classical style and its complicated theme of Augustan propaganda. It is exceptional in these aspects and although its relief sculpture is frequently invoked by scholars, no doubt because of the quality of the monument and the wealth of source material for the Augustan period, it did not exert a strong influence on the development of state art. Another, earlier, type of state relief sculpture – the Republican reliefs from the Piazza della Consolazione (FIG. 17) – shows objects arranged against a blank background as if in a still-life abstracted from any context or human presence. To the left the motif of the warrior's uniform is repeated in a larger breastplate with the gorgon's head (the mythological device that averts evil) and personifications of victory on the shoulder straps. In later reliefs, captured enemy weapons are displayed in great piles as if to emphasize the sheer quantity of confiscated gear; in the reliefs of the Piazza della Consolazione the

17. Relief (fragment A) from the Piazza della Consolazione, second–first century BC. Marble. Capitoline Museums, Palazzo dei Conservatori, Rome.

These trophies of war may come from a pillar near the Capitoline hill in Rome that commemorated the dictator Sulla's victories in the east. The style too may show eastern influence: monuments in the Hellenistic city of Pergamon in the second century BC depict similar ensembles of armor. The shield bears the personified head of Roma, flanked by the spoils of victory, suits of enemy armor displayed on tree trunks.

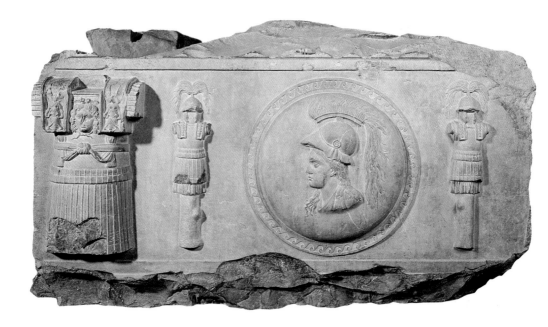

motifs are rendered individually, contrasting the headless figures of the two shrunken enemy trophies with the potent and threatening heads of Roma on the shield and of the gorgon on the large breastplate. Rather than a concentrated decorative treatment of military insignia, the relief offers meaning through a limited repertory of motifs, modulated in scale and design to evince Roman supremacy. With its static composition and display of hollow armor as traces left on the battlefield after victory is declared, the relief amply demonstrates an obsession with recording the facts of imperial conquest without supplying the drama inherent in images of battle or the conquered. Without the panoply of historical or mythical subjects (as in the Ara Pacis), it flatly states a catalog of military hardware as evidence of Roman might and only obliquely refers to the carnage on the battlefield.

The consequences of imperial expansion are represented in the art of Augustus in the provinces. Gallia Narbonensis (southern France) was considered the most civilized and peaceful part of Gaul; the historian Cassius Dio called it *Gallia Togata* because "the inhabitants already employed the citizen garb" (*Roman History*, 46.55.4–5.). There, in the relief on the east face of the Arch of Carpentras (FIG. 18), two prisoners of war are shown chained to a trophy fashioned from a tree trunk decorated with swords, war trumpets, helmets, and the fringe of a breastplate at the top. At the base of the tree trunk are displayed a double axe and a scimitar with sheath and sword belt, incised in contrast to the heavily textured forms in relief above. The costumes of each prisoner identify them: the bearded one with the fur is a German prisoner, the unbearded figure wearing a cap with ear flaps is probably a Dalmatian. Both prisoners express suffering, with faces turned outward, gaping mouths, and listless stares.

It is interesting that the relief commemorates one of the military actions of the Augustan "peace," Augustus's campaigns against the Dalmatians and Germans in 13–9 BC, rather than a local event. Carpentras (the ancient Colonia Julia Meminorum Carpentorate), a trading center and marketplace in the Rhone valley near the city of Orange, was colonized, rather than conquered, under Augustus (see pages 6–7). The arch erected in honor of the colony's foundation showed the brutal results of Roman conquest not experienced by the local population. By displacing the effects of Roman aggression onto other peoples in distant lands, the imagery implies that the people of Carpentras were allied with Rome and immune from such treatment. The captives are carved as rather foursquare plank-like creatures attached to the trophy like the other objects. They face the direction of their homelands,

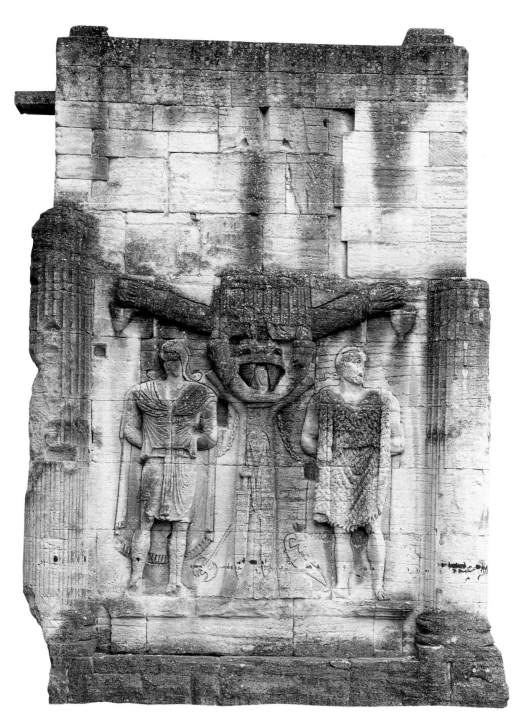

18. Prisoners of war and a
trophy on the Arch of
Carpentras, France, 9 BC.
Limestone, h. 32'10" (10 m).

the German to the northeast, the Dalmatian to the southeast, so that the viewing colonist is situated near Rome and cast as an insider whose interests are served by Rome, as opposed to the spectacle of the degraded foreign enemy. The relief not only pronounces the power of Rome and its annihilation of opposition, as is frequently said of triumphal imagery, but also makes a seductive appeal to those under Roman protection of the benefits of such an affiliation. In an area heavily Romanized from its resident Roman citizens and within earshot of fluent and cultivated Latin, the message of the absolute domination of Rome's armies was not so pertinent as was the impression on the viewer that identification with Rome could be acquired through loyalty and the proper course of action and that the distinction between Roman and non-Roman was open to question.

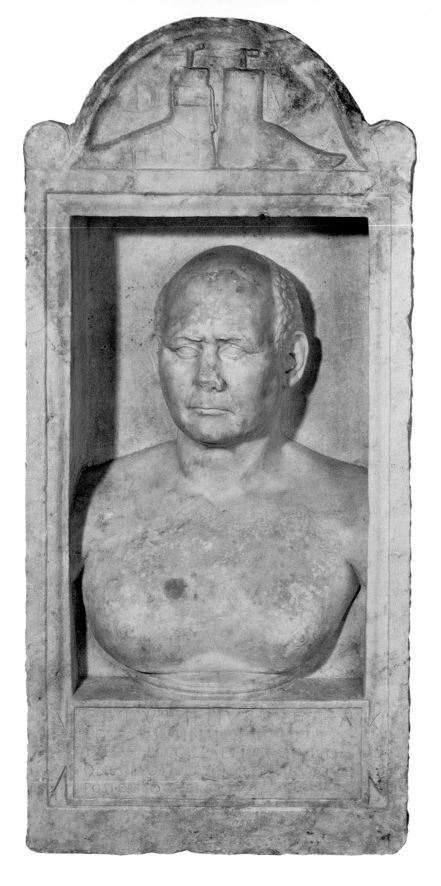

The Social Order

19. The Stele of the Shoemaker, C. Julius Helius, AD 120–30. Marble, 23½ x 14¼" (60 x 36 cm). Capitoline Museums, Palazzo dei Conservatori, Rome.

Helius is not shown at work, but the inscription implies Helius's status as a freedman with a daughter who was born after he had been freed. Two shoe lasts with handles, insignia of his trade, fill the pediment of the stele. Placed opposite one another, heel-to-heel, the wooden forms demonstrate how they are used to shape shoes: the one on the left fills a sandal, the other is bare.

The Roman social pyramid consisted of a narrow pinnacle for the emperor and the imperial court, a slightly wider shelf for the senate and equestrian elite, and the rest of society fanning out beneath in a dizzying descent. It is better to speak of orders than classes because membership in the elite ranks of the senators, equestrians, and *decurions* (those who sat on the local town councils) was legally defined by minimum income, some requirements of birth, and the necessary moral qualities. The typical city in the Roman Empire was one in which those in power knew one another, dined with one another, and no doubt were related by marriage to one another; they were also few in comparison to the unknown crowds toward the bottom of the pyramid. These are the freeborn citizens and former slaves freed to become citizens and, at the very bottom, slaves. In this chapter we look at how identity depended on one's place in the social order; we also discuss the interests of social groups and how they expressed their identity through art and architecture.

Identity and Status

Despite the rigidity of the ranks, there was notable social mobility for certain groups, an exception not permitted in ancient Greece. Equestrians could move up to the senatorial order through merit or by imperial fiat, and slaves could be freed by their masters to become citizens, although with some restrictions in rights and privileges. The latter procedure caused reaction and resentment among the elite, who either found themselves snubbed by the emperor's notoriously arrogant freedmen or suspected that wealthy freedmen were buying political influence. This snobbery surfaces in Seneca's opinion (c. 4 BC–AD 65) that affluence was not equivalent to good taste and refinement: "Within our time there was a certain rich man named Calvisius Sabinus: he had the wealth and spirit of a freedman. I never saw a man whose good fortune was a greater offence against propriety" (*Epistles*, 27.5).

20. Plan of the House of the Menander, Pompeii, late first century BC.

The plan of the aristocratic townhouse exhibits the typical axial view from the street entrance (1) through the atrium to the large colonnaded courtyard and the recess (9) beyond it, but here there are also secondary axes across the courtyard from the large dining room (4) to the bath suite opposite and from oecus (7) to the altar of the ancestral cult (11). These vistas show off the indoor–outdoor complex of views that connect the grand rooms devoted to dining and entertaining clustered around the garden courtyard. Kitchens, slave quarters, and stables, were tucked into the corner.

Key

1	fauces
2	atrium
3	tablinum
4	large triclinium (dining room)
5–7	oeci (reception or dining rooms)
8–10	exedrae (recesses or niches off the peristyle)
11	exedra with altar for ancestor cult
12–18	kitchen, latrine, slave quarters, stables, and storage on a lower level

On the one hand, strict legal definitions governed one's place in society and, on the other, disparities were perceived – impoverished nobles, rich and influential freedmen in the imperial court, masters marrying slave women whom they had freed, and even slaves owning their own slaves (because some urban slaves in prosperous households were allowed to earn money and have property), whose status seems to defy the tidy categories outlined above. Furthermore, the degree of dependency and familiarity among the different social orders is striking. In the townhouse (*domus*) of the propertied Roman (FIG. 20), the owner's family lived along with their household slaves, and the visitors to the morning *salutatio* – the ritual in which clients came to show respect and extract favors from a great man – included the freedmen, the master's ex-slaves, who might have been familiar presences in the household. Members of the upper and lower orders may not have mingled in the crowded houses of the prominent, but they necessarily came into close contact.

The status of the elite Roman was measured by the house in which he lived. A house filled with clients during the morning *salutatio* established his importance. When the doors to the

street were open in the morning, the clients could crowd into the atrium (the central skylit hall), to wait for the master. Rather than being a haven from the unruly life of the street, the house stood open to the street at certain hours and the prestige of the household required that passersby have a glimpse of the crowd within. The architecture of the house also ushered the visitor through a sequence of spaces arranged in function from public halls to more intimate rooms. The architecture and plan have less to do with privacy than with the hospitality and hierarchy that marked distinctions of status.

The category of gender runs through all the orders, in which women are identified primarily through domestic roles. Although they enjoyed greater visibility and more substantial legal privileges than Greek women, their status accrued through their relationships to men. Roman women could marry higher up the hierarchy, as when slave women freed by their masters became their wives. Despite the emphasis on women's biological role as mothers and their exclusion from political life, some elite women took active roles in civic affairs and some women of the lower orders worked outside the home to support their families.

The public display of imagery in the city and its traditional function of honoring deserving citizens indicate that works of art bestowed status or, at least, indicated social aspirations. The formulas of imperial art allowed the self-fashioning of individual identity into traditional ideal types – the orator, general, priest, mythological heroes or heroines. It is difficult to ascertain at what point these borrowings from state art reflect conformity to dominant values or personal choices on the part of private patrons. Perhaps some imperial motifs might have become empty clichés through their repetition. We need to consider whether there was a hierarchy of styles and subjects; whether non-elite patrons preferred art that might have been considered superior because it connoted prestige otherwise denied to them. And was such imitation the only means to signal one's arrival in society?

We also need to think of art in the provinces, where the emulation of imperial models counted for little. Could style and subject matter be developed into new modes of expression, not entirely dependent on the art of the imperial court? It has been argued that there was only one artistic form in which to assert membership in elite society, and any deviations from Hellenized imperial art represent errors on the part of the artist or the patron's bad taste. This theory of one official language and zero tolerance of dialects – and of influence exclusively going from top to bottom – cannot be supported if we look carefully at the art

and architecture of those lower down in society and on the periphery of the Empire, not to mention the late imperial art in the capital that shows influences from these styles.

Elites

The senatorial order at the top of the elite was no longer officially hereditary by the Augustan period, although the *princeps* favored senators' sons for admission in order to encourage the tradition of public service in the old aristocratic families who composed the highest rank. Augustus wished to reduce the senatorial ranks and sharpen distinctions between the senatorial and the lower orders while limiting the honors and prerogatives of leading men. In numbers the equestrian order (so named because of the imperial grant of the "public horse") was by far a larger group and less exclusive in birth, wealth, and moral character than the senate. The two most prestigious orders subscribed to an aristocratic ethos attributing civic duty, responsibility, and nobility to those who served as custodians of the state. Their clothing marked their rank: as the toga denoted a citizen, so togas emblazoned with broad purple stripes marked senators, while narrow purple stripes marked equestrians.

The town councillors (*decurions*) had lesser qualifications of birth, wealth, and character, but wealth was often the determining factor since the job carried no pay and *decurions* had to contribute to the public treasury and fund games and other public events. The practice of lavishing one's city with entertainments or gracing it

21. Statue of M. Holconius Rufus, from Pompeii, late first century BC–early first century AD. Marble, h. 6'7½" (2.02 m). Museo Nazionale Archeologico, Naples.

The decoration of the armor with a gorgon head and two griffins reflects the cult statue of the temple in the Forum of Augustus in Rome, and this statue may have been made in a workshop in the capital. Traces of paint remain in the red hair, purple mantle, and black sandals.

with new buildings out of one's own pocket forged the aristocratic ethos in the local municipalities and the capital (in the Republic). Spending sizeable sums to improve the quality of life in one's city had its rewards: besides the gratitude and respect rendered to civic benefactors, the donor might also accumulate political capital of use in winning local elections or even offices in Rome.

A statue of the leading local man M. Holconius Rufus of Pompeii in the late Augustan period (FIG. 21) was erected by the citizens of Pompeii in a prominent position in front of the Stabian Baths in honor of his civic service and as a model for others. It represents Holconius Rufus as a military man in reference to the honorific *tribunus militum a populo*, bestowed by the emperor on notable Italian citizens who were granted equestrian rank in the capital. The portrait head (recarved) may show the severe and commanding features of a man who held numerous public offices, was named the patron of the colony (*patronus coloniae*), and had close ties with the imperial court in Rome. This type of armored statue in a pose of stately victory is a staple of imperial statuary, which evokes the accolades given to military heroes and the tremendous prestige granted to victorious generals. Holconius Rufus's high honors allow his image to partake of *virtus* (military valor) and glory, even if these particular qualities seem to inflate a senior magistrate and benefactor (he paid for renovations to the theater). The casting of municipal bureaucrats in such roles does not diminish their contributions to civic life, but the imagery of the military hero makes for more compelling art. The rhetorical effects of the statue are increased to indicate the participation of the elite of the towns in the imperial rule.

The man of letters was also highly regarded in a society with overwhelmingly high illiteracy (drawing up a simple document or ordering an inscription for a tombstone meant hiring a scribe for the majority of the population). A scroll held by a togate man indicated that he had access to power through his mastery of rhetoric, law, and administration; in early imperial art such a figure was usually a public official and in late imperial art, a philosopher. The intellectual in Roman society had power in as much as his skills were required by the political elite.

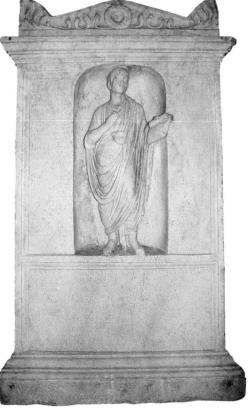

22. Funerary altar of Q. Sulpicius Maximus, AD 94–100. Marble, 5′3½″ x 3′5¾″ (1.61 x 1.06 m). Capitoline Museums, Palazzo dei Conservatori, Rome.

The altar was placed in front of the tomb entrance. The boy Quintus Sulpicius Maximus was only eleven years old when he died from studying too much, according to the epigram inscribed below.

A funerary altar for a young boy of eleven years demonstrates parents' ambitions for their sons (FIG. 22): Q. Sulpicius Maximus is commemorated by a relief figure wearing a long toga and holding a scroll and an exceptionally long inscription in Latin and Greek. Sulpicius Maximus's status was elevated by his early accomplishments – he was not merely a good pupil but had won an honorable mention in a poetry contest sponsored by the emperor Domitian in AD 94. The state sponsorship of poetry competitions was motivated by the belief that some literary training developed a politician's oratorical style and ultimately the quality of public service. Yet poetry also became a fashionable pastime among aristocrats in the first century AD. The dignified pose of declamation with the half-opened scroll implies the boy's potential to have achieved even greater public acclaim in the political sphere. By celebrating the talents of a child, the parents who commissioned the altar mourned not only their son but also the loss of a superachieving and quickwitted member of the next generation.

Relatively little space is given to the relief portrait; instead, most of the surface is covered with a lengthy inscription – an epitaph and the boy's prize-winning poem in Greek on a mythological subject about the dangers of reckless and bold youth (a lesson perhaps not wasted on Sulpicius Maximus), the last lines of which are inscribed on his scroll. Evidence of the boy's talents, his erudition not only in Latin but also in Greek, the language of the cultivated Roman, are displayed for visitors to the tomb. They would read the parents' epitaph and the boy's poem, which is matched in style by the relief portrait of a poised youth wearing the full toga of adulthood and holding the scroll, an attribute of his achievement and promise.

Both image and text of the altar are replete with aristocratic allusions, yet the father of Sulpicius Maximus may have been a freedman. If this is correct, then the father's ambitions would have been transferred to the son because the latter's free birth allowed him certain privileges denied to the freed father. The pride with which the parents commemorated their son indicates that freed status lasted for only one generation: the freeborn children of a freedman experienced none of the formal restrictions of freed status and were capable of advancing in society if they were well connected and well off. The funerary altar of Q. Sulpicius Maximus may have passed for the monument of a Roman of the upper orders because of its subject and style – it demonstrates how the signs of elite culture were appropriated by those who desired to better themselves by moving upward.

Urban Working Classes

Beneath the elite orders, the vastly larger group of city dwellers fills out the lower section of the social pyramid. There was no middle class in the modern sense of the term. Distinctions between citizen and non-citizen within this group were later eroded with the gradual extension of citizenship privileges beginning in AD 212, but long before that the distinction that mattered most was between those in the elite and those lumped together in the bottom ranks. Yet from this group of slaves, ex-slaves, and freeborn poor, the ex-slaves or freedmen had opportunities for advancement if their masters favored them with capital to invest in their businesses or legacies upon their death. The ancient sources single out the freedman as a social type, often set up as a target for satire or scorn, whose character was beset by instability and insecurity because of his split identity: he was indelibly marked by his early experience as a slave under the control of a master and challenged by his later incarnation as a master with his own slaves and household to manage. The bonds of the freedman's past were so strong that in designing their tombs many freedmen chose to be represented in group portraits with the men and women with whom they had been enslaved.

It has been argued that the freedman, as enfranchised citizen and head of a family, was motivated by pride to display his improved status and affluence. In the late Republic and early Augustan periods (late first century BC), it is thought that freedmen erected a proportionally greater number of tombs and epitaphs than freeborn Romans to assert their stake in this society and their familiarity with its venerable customs of honoring the dead. Group portrait reliefs, representing both the deceased and

23. Funerary relief of a freedman's family, late first century BC. Marble, 29¼ x 72¾" (74 x 185 cm). Ny Carlsberg Glyptotek, Copenhagen.

The heads and upper torsos of these figures from a relief that originally adorned the facade of a tomb are placed frontally in a row with all the formality and stiffness that the family group genre implies. The deceased is probably the younger man in the center who is flanked by his parents on the right and his brother and sister, perhaps, on the left. The young man's nudity, in contrast to the prim togas and tunics of his family, gives him a heroic air, even if the physique appears scrawny.

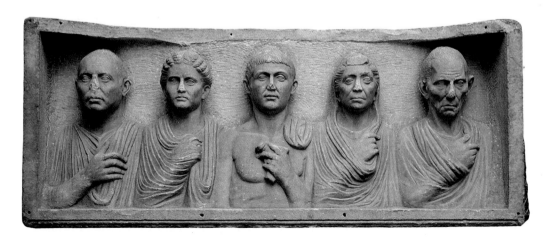

24. Funerary relief of a midwife, from Ostia, mid-second century AD. Terracotta, with traces of red and blue paint, 11 x 16½" (28 x 42 cm). Museo Ostiense, Ostia.

The relief comes from the facade of a tomb in the Isola Sacra Necropolis near Ostia, a cemetery maintained by the merchants, craftworkers, and professionals who made their living in Rome's port. Its inscription states that Scribonia Attice erected the tomb for herself, her husband, and her mother. It is most likely that the scene shows a moment in the professional career of Scribonia Attice. The midwife has turned toward the viewer, as if momentarily interrupted from her duties. Her glance also undermines the unity of the scene by implying that she is appealing to the viewer as well.

still living members of families, provided lineages for the freeborn children, who could integrate themselves into society to a greater degree than their parents. The attributes of the deceased young man in the center of an Augustan relief (FIG. 23), the edge of a mantle draped over the shoulder and the short sword (*parazonium*) that he grips, may identify him as a soldier. If this is correct, then the deceased was of free birth – born after his enslaved parents had been freed – because freedmen were not permitted in the army at this time (and it is assumed that the families of the group portraits were freed also). A military career gave many men a good start in life, a way out of poverty or lowly occupations. This scenario illustrates a classic case of social mobility in which the younger son embodied the family's ambitions – and attempted to realize them in a most Roman way – until fate intervened. Every detail of the relief demonstrates a concern to present the family as respectable, fulfilling their duties as citizens by making the best of themselves. Their stern and somber faces are the demeanors of reserved and dignified Romans. The portrait of the father on the extreme right is in the veristic style of the Republic with its gaunt cheeks and sagging chin – no type could be more appropriate for an ancestral image, to summon the virtues of earlier Romans. This is all the more poignant for a family whose enslavement denied them any history at all.

Such reliefs conform to the art of the elite in many respects – the physiognomies reflecting Republican or Augustan types, the hairstyles popular in those periods, the venerable toga. It was as if the freedmen achieved respectability simply by manipulating the external signs of status.

Another type of representation defines its subjects through their trades or professions. The scenes of workshops or professional exchanges ignore many of the conventions of court and elite art and demonstrate their own values in artistic forms. Without any tradition of representation – the work scenes document a world apart from the administrative or intellectual preoccupations of the political elite – these scenes of labor recall the declarative and simplified imagery of shop signs. In many of these works, however, the bonds of family are not as readily apparent as in the group portraits of freedmen.

The cemeteries of Ostia, Rome's port, contained reliefs with work scenes on the facades of tombs from the middle

of the second century AD. Many inscriptions above the tomb door state that the tombs were erected by a husband on behalf of his wife (or vice versa) for themselves and the couple's freedmen and freedwomen. Such epitaphs provide evidence for the social mobility of freed slaves who had achieved the means to build tombs that would also house the remains of their own freed slaves (by the second century most of the urban population in Rome and environs would have had freedmen or freedwomen in their lineages). The facade of a tomb from Ostia is adorned with two reliefs that represent the related professions of a husband and wife team of surgeon and midwife. One of the reliefs represents the midwife in the act of delivering the baby of a woman seated in a birthing-chair (FIG. 24). An assistant supports the woman under the arms and the midwife herself sits on a low stool in front of the woman in labor. The scene emphasizes the intimacy of midwife and mother through the midwife's gesture, her probing but gentle touch of the woman's genitals. Soranus, a physician and gynecologist in Alexandria and Rome in the second century AD, recommends that midwives keep their hands soft for precisely this reason and that they possess a quiet disposition because of the secrets they will share.

The style of the terracotta relief eschews the classical treatment of the figure in its schematic rendering of bodies under shapeless garments or, conversely, of the loose skin of the woman in labor who might as well be draped in sackcloth because her body lacks any articulation of flesh or musculature. There is no attempt to depict the figures as portraits; a few expressive marks on the heads are enough to convey the facial features. Settings also count for little and the only equipment present is the birthing chair. This sets the midwife's relief apart from those commemorating many male professions: the tools of the trade have to be identifiable and are often prominent.

Not all depictions of professionals or craftworkers emphasize the inorganic forms at the expense of the organic nor do they abandon classical styles. The funerary stele (an upright stone marker) of a shoemaker, C. Julius Helius, combines the motifs of the classical portrait bust with those of his trade (see FIG. 19). In the main relief Helius is portrayed in a bust that includes the nude chest set on an elegantly turned stand. The full fleshy chest and broad shoulders give the truncated form a substantial physical presence; the nude bust also recalls heroic portraiture that connotes the subject's elevated standing as a triumphant general or charismatic ruler. In contrast, the portrait features cast Helius as a middle-aged and balding man with a large hairy wart on his squar-

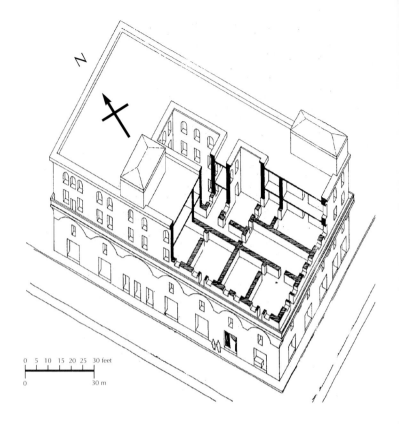

25. Axonometric reconstruction drawing of the House of Diana, Ostia, second century AD.

The apartment block had shops below and balconied windows above.

0 5 10 15 20 25 30 feet

0 30 m

ish jaw, thickset features, and creases around the brow, eyes, and jaw. This physiognomy and dour expression do not match the vigorous physicality of the bust. The representation of a three-dimensional work of art on the stele suggests that the relief is a substitute for the portrait bust that was beyond the family's means. Whereas the busts in the group reliefs were rather conservative in style (see FIG. 23), the nudity of this bust aspires to a different ideal of a heroic, divinely inspired power – but the allusion seems gross for the commemoration of a shoemaker.

The shoe lasts in the pediment indicate Helius's occupation in the form of humble insignia or artisanal heraldry in place of the sacred utensils or wreaths in funerary art that emulate imperial models (see FIG. 22). At first glance, the lasts may appear as disembodied feet placed atop another body fragment, the bust. Yet the composition and motifs of the stele draw on diverse sources: the bust evokes the patrician obligation to honor the dead by commemorating them properly, while the work motif demonstrates the use of symbols, here the tools of the trade, to evoke meaning.

The lower orders, including both the shiftless or unemployed and the owners of profitable businesses, lived in a range of houses

from tenements or apartment buildings to townhouses similar to elite residences. Ostia has a selection of extant apartment houses, brick and concrete structures that often fill an entire city block (FIG. 25). The interiors are arranged around a central court, many furnished with latrines and cisterns, and the upper floors are broken up into small units of a couple of modest rooms each, for living and sleeping. Although care was taken to provide ventilation via windows and terraces, it is difficult to estimate the number of inhabitants of each apartment from the plan or to get a sense of the quality of life to be had here. Were the quarters crammed with workers who flocked to Ostia for jobs on the docks or was the population more stable and the apartments,

26. Garden dining area of the House of the Ephebe, Pompeii, AD 62–79.

therefore, more comfortable? It is likely that those who lived here used their apartments as dormitories and spent most of their time outside, at taverns, the tables of their patrons, baths, and their places of work.

Some freedmen bought townhouses and realized their ambitions to lead lives in imitation of their ex-masters. The freedman Cornelius Tages bought several adjoining houses in Pompeii in order to make one sizeable *domus* known as the House of the Ephebe; it has also been proposed that the property remained as separate houses with a common garden. The garden (FIG. 26), which can be entered directly from the street, has decorated sloping couches for dining outdoors beneath an arbor and a stepped fountain directing the water in a canal between the couches. The bases of the couches are painted with exotic scenes of the Nile (now protected by glass covers), several of which depict pygmies banqueting and performing erotic acts, while one wall was painted with wild animals rampaging (an allusion to the animal parks of grand estates). Bronze and marble statuettes of woodland deities and animals formerly graced the surroundings. This garden *triclinium* (dining room) of the House of the Ephebe was for entertaining at the *convivium* (banquet) in which guests would have felt that they were reclining on an island in an exotic locale, such as the Nile. Here Cornelius Tages as host delighted his friends and associates with the natural and painted scenery of his garden and the cool splash of the fountain and canal. Tages succeeded in creating a luxurious and licentious atmosphere of pleasure in his mock villa by transforming a small garden into an elaborate dining terrace. A self-made man such as Tages aspired not only to be the master of a fine house but to indulge his guests in lavish dinners and entertainments in an artfully contrived setting.

Women and the Family

Women's roles varied according to their place in the social hierarchy. Roman women had the right of citizenship, but their activities in the public sphere were limited because they could not vote or run for elected office. In private life, however, they had considerable advantages derived from family custom rather than the law. In early Republican Rome the bride came under the control (*manus*, literally, the hand) of her husband. Her property was transferred to him, and she stood to inherit from him as if she were his daughter. By about 100 BC women no longer entered into marriages with *manus* but, instead, stayed under the authority

of their fathers. The father's powers over his children, *patria potestas*, were absolute and above the law, giving him even the right of life and death over his children, although this had long been tempered by custom. Women in marriages without *manus* kept their income and property separate from those of their husband, but were not necessarily burdened by paternal interference.

Demographics played a part in this: not many women, usually married in their late teens (the elite married earlier), would have had living fathers by the time of their first marriage; husbands, eight to ten years older than their wives on average, also left young widows who would remarry. A woman independent of husband and father would be assigned a guardian to look after her financial interests, yet Augustus permitted women who had three children (and four for a freedwoman) to be free of guardianship. It also appears that a guardian's permission was a mere formality for a woman drawing up a will or selling land.

Elite women wielded power through their husbands and sons. Livia (58 BC–AD 29), the wife of Augustus and mother of the second emperor Tiberius (r. AD 14–37), was celebrated as a model for Roman women although her position was exceptional in bridging civic and domestic spheres. Women who did not hide their political ambitions, like the younger Agrippina (great-granddaughter of Augustus, AD 15–59), who is cast in the ancient sources as an unnatural woman who dared to don military attire and preside over the Roman standards in the field, risked censure, exile, or death. Other less notorious women were honored in epi-

27. Funerary relief of a butcher and woman from Rome, mid–second century AD. Marble, 13½ x 26½" (34.5 x 67.3 cm), Staatliche Kunstsammlungen, Dresden.

28. Portrait statue of Plancia Magna from Perge, Turkey, c. AD 120. Marble, h. 6'5¼" (2.01 m). Antalya Museum, Turkey.

The draped female figure, with a long tradition in Classical art, summons the modesty and respectability of women. Even the facial features belong more to an ideal type of womanhood than an individualized portrait of Plancia Magna.

taphs that enumerate their virtues of obedience, self-sacrifice, and devotion to domestic tasks. In particular, wool-work summoned domestic industry and the matron's chastity and fidelity to husband and hearth. A typical Republican epitaph commemorates one Claudia as a faithful and devoted wife who gave her husband two children and whose "speech was delightful, her gait graceful. She kept house, she made wool..." Images that correspond to the epitaphs are the freedmen's portrait reliefs in which women are granted an austere dignity as citizens of a recent vintage (see FIG. 23); they are often shown clasping the hands of their husbands, a gesture that recalls the marriage ceremony, or are placed next to their children to form a family portrait.

The idealization of female figures also occurs in reliefs of work scenes. In a relief from Rome (FIG. 27), a butcher is shown at work in his shop cutting chops of meat that hang from an overhead rack, while on the left, a woman seated on an elaborate chair with a footstool is writing on a wax diptych (hinged writing tablets). The throne-like chair and the act of writing distinguish the woman, who may be either the patron (ex-owner) of the freed butcher or his wife who manages the accounts of the shop for him. The female figure represents motifs from another genre, that of the learned and sophisticated matron of the elite orders who shared her husband's literary interests. Pliny the Younger (AD 61 or 62–113) describes his young wife as highly intelligent and so devoted to her husband that she "keeps copies of my works to read again and again and even learn by heart" (Epistles, 4.19). Of course, the exclusive circle of the well-connected Pliny was far from that of the butcher but the image of the seated woman keeping accounts summons an air of gentility and privilege to which the butcher aspired. As in the relief of the shoemaker (see FIG. 19), the juxtaposition of two different genres elevates the craft scene with a motif that displays the elite code of achievement and culture. This combination would probably have signaled the success and ambitions of the butcher.

Elite women were also commemorated for their role in civic life. Plancia Magna, from a family prominent in local politics in the town of Perge, Turkey, in the second century AD, funded public building projects, one of which was the rebuilding of the city gate with a magnificent courtyard decorated with statuary. Among the statues of the emperors Trajan (r. AD 98–117) and Hadrian (r. AD 117–138), the mythological founders of Perge, and Plancia Magna's father, was a figure representing Plancia herself (FIG. 28).

She is fully draped in tunic and voluminous mantle, which forms a tight sling around her right arm as she pulls the rest of the fabric in crisp diagonal folds across her torso. Her head is also covered with a veil and a crown, which identifies her as priestess of the imperial cult through the four imperial busts that originally adorned it. The inscription on another statue erected by the city in her honor enumerates her religious offices: "Plancia Magna/Daughter of Marcus Plancius Varus/and Daughter of the City/Priestess of Artemis/and Both First and Sole Public Priestess/of the Mother of the Gods/For the Duration of her Life/Pious and Patriotic." Daughter of a senator, Plancia also commanded the respect of the public by holding a magistracy – contrary to the customs of the western Empire, women did hold offices in Greece and Asia Minor (western Turkey). Not only the crown identifying her as priestess of the imperial cult, but also the portrait give a sense of Plancia's public role. Her features are filtered through an ideal that glosses over the individual traits of a proud and formidable woman and casts them in the formula of the oval face with full cheeks, almond-shaped eyes, and wavy strands of hair parted in the center – conventional features for goddesses or mythological figures. Rather, the statue identifies Plancia Magna through her clothing, crown, and the lengthy inscription on the base. As with the portraiture of men, the insignia of rank take precedence and the portrait conforms to convention as much as the phrases in the honorary inscription just cited: Plancia Magna is depicted as befits a pious and patriotic woman.

Outsiders and Insiders

In the course of its history Rome crushed enemies who refused to surrender to its armies; yet the appeal of being Roman exerted a strong but subtle pull on peoples far removed from its civilization or those unscathed by its onslaught. In the early days of expansion on Italian soil, Rome gave some rights and partial citizenship to those that she conquered; this policy of enfranchisement was gradually expanded to embrace veterans and the residents of colonies in the provinces. The system of rights established ranks of people with greater or lesser privileges and responsibilities arranged in a spectrum from relative insiders (those with full citizenship) to outsiders (peoples beyond the frontiers). Yet even barbarians were introduced to the finer aspects of Roman life, as the historian Tacitus (c. AD 56–115) tells in his account of the pacification of Britain by the governor Agricola (AD 40–93):

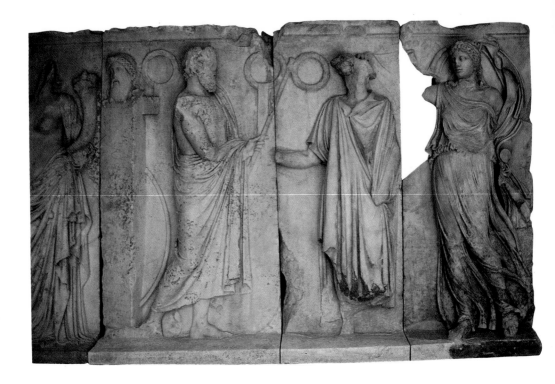

29. Frieze from the tomb of Zoilos, from Aphrodisias, southern Turkey, 20s BC. Marble, h. 6'¾" (1.85 m). Aphrodisias Museum, Turkey.

The tomb formed a square mausoleum with the frieze adorning the podium. The detail shows Zoilos as an ambassador in traveling clothes of hat and Greek cloak (*chlamys*), being greeted by the personification of the people (*Demos*) and being crowned by that of the city (*Polis*) on his return. A *herm* (a sculpted head atop a pillar) marks the boundary of the city; wreaths hanging in the background may indicate the high civic offices held by Zoilos.

To induce men who were scattered and uncivilized and so swift to war, to take to the pleasant ways of peace and leisure, he gave private encouragement and public assistance to the construction of temples, fora and houses... Gradually they were led astray to the temptations of vice, porticoes, baths and elegant dinners.

(Tacitus, *Agricola*, 21)

To outsiders the elite Roman way of life, the luxuries – wine, in particular – bought with its gold and silver coins, was synonymous with the good life and its pleasures.

Although the offer of citizenship proved attractive, the assimilation of foreigners can be seen as the byproduct of the Roman tendency to make use of existing conditions or local institutions to govern outposts of the Empire. Gaining the cooperation of a city's elite was of the utmost importance, and these local notables frequently became part of a cosmopolitan society of prestige and influence or the middlemen for their Roman masters, depending on circumstance. Another route of incorporation was the army, which rewarded auxiliary soldiers with citizenship and a stipend payable upon discharge, and offered members of the old warrior class positions of authority when they took

commissions as officers. The Greek orator Aelius Aristides (AD 118–80) praised the system of recruitment:

> This possibility was provided for you by the policy you have for the whole Empire: you classify no one as an alien, when you accept him for any employment, where he can do well and is then needed... On the day they [the recruits] join the army, they lost their original city, but from the very same day become fellow-citizens of your city and its defenders."
> (Aelius Aristides, *To Rome*, 26K. 74–7)

The municipal councils also gave leading men the opportunity to demonstrate their worthiness by funding public buildings and distributing largesse in the name of Rome. The issue of the assimilation of outsiders to insiders has usually been cast as either Romanization – the export of Roman technology and culture through conquest – or resistance – the adherence to indigenous traditions instead of a wholesale embrace of things Roman. But Rome had no master plan for cultural domination: the patterns of cultural exchange fall somewhere in between these two extremes. Discussion of a few works of art indicates the complexities of this exchange.

Imperial imagery of honor and status could be manipulated to indicate dual allegiances to hometown and the Empire. The tomb of C. Julius Zoilos (FIG. 29) was constructed by the city of Aphrodisias in southern Turkey, in the 20s BC. His career followed a peculiarly Roman path with origins in slavery and subsequent eminence as a freedman and agent of Octavian (later Augustus). Zoilos never abandoned his hometown and used his wealth to improve his city by donating buildings, such as the stage of the theater. For these benefits he was given the honor of having his tomb built at public expense. The frieze round the tomb's base shows Zoilos twice (both figures have damaged or non-extant heads) in scenes juxtaposing Roman and Greek contexts: he is depicted in Greek dress among personifications of civic life and in Roman attire among personifications of military valor. Zoilos is thus a man granted exceptional honors because of his skills in warfare and diplomacy. A consummate cosmopolitan, he is at home in both the agora (marketplace) of Aphrodisias and the forum in Rome. The citizens of Aphrodisias were familiar with personifications not only from Hellenistic and Roman statuary but also from the coins in their purses. The line-up of personifications establishes a stately and official tone with its poised figures, comely whether draped or semi-nude, gathered to honor

30. Funerary relief of the Roman soldier Longinus, from England, first century AD. Colchester Museum.

Zoilos with the symbols of distinction and glory. They celebrate his service to his city and its civic life, but his ultimate allegiance to Rome is represented by the figure of Rome, a seated female warrior, in another panel of the frieze.

A different response to imperial imagery is found in the northern provinces whose inhabitants' ethnicity seemed barbaric to Romans. On the funerary stele of a Roman soldier in Colchester, England (FIG. 30), the deceased is seen on horseback trampling a barbarian underfoot. The image emulates a staple of imperial iconography in which the emperor subjugates an enemy in this fashion (see Chapter Two): it is the style that has been considered provincial, in its reliance on bold graphic forms with textures indicated by linear hatching. Both the soldier and his mount share a muscular and compact physique with swelling rounded contours; the chain mail of the soldier's breastplate and the details of the saddlery are rendered with thick incised lines and simple geometry. The barbarian huddled on his shield beneath the horse is in an impossible position, literally and figuratively: his head is twisted around as if it were not attached to the neck and the nakedness of his coiled body matches the wretchedness and horror in his opened mouth and bulging eyes. It is unfortunate that the soldier's head is missing because it would form a telling contrast with that of his opponent, whose face is like the two lions' placed as sentinels on top of the stele. Stylistic devices, such as the deep gouging of hair and manes or the bulbous forms of nose and muzzles, imply that the defeated barbarian is closer to a beast than to a human and, therefore, deserves the rough hand of Roman justice. Caesar describes the peculiar, uncivilized appearance of the Britanni, the people of ancient England: "Indeed all the Britanni dye themselves with woad [a plant], which produces a blue color, and by this means they are a more horrible sight when they go into battle; their hair is long and flowing, and every part of the body is shaven, except for the head and upper lip" (*De Bello Gallico*, 5. 14.3). Although the barbarian depicted on the stele does not conform to this description in every detail, the image and

text dovetail in their representations of the barbarian as a vision alien to Roman eyes.

While the crushed enemy must serve in some ways as a cipher, explicit information is given about the soldier in the inscription. The epitaph on the stele records his name as Longinus, his position as a soldier receiving double pay, and his age at death as forty years. Longinus was a native Briton in a unit of auxiliary troops and he served fifteen years of the twenty-five required for a grant of citizenship – his forebears could have been those represented by the figure beneath the horse rather than the one astride it. The army provided Longinus the means to succeed. With his assumed Roman name he is identified as a protector of Roman civilization, as an efficient and virulent predator. What remains less obvious is the army's role in acculturation – the halting Latin of recruits, its popularization of elite culture, its offer of a good living to those without other means, and its contribution to urban development in remote zones.

That art and architecture could advertise one's membership in the exclusive ranks of Roman society was only one use. For some patrons, reliefs on the tomb facades displayed their humble trades and their pride taken in jobs well done. For others, with ambition and money to spare, graceful statues or elegantly landscaped dining terraces allowed them to appear more distinguished than they actually were. Although the images may disguise or distort the social reality, the Roman social system was a superb instrument that kept people in their places while allowing some to be promoted to higher positions and many more to be assimilated into the bottom rungs. Art articulated these patrons' aspirations and desires for recognition, respectability, or power.

The City and Urban Space

31. Library of Celsus, Ephesus, Turkey, AD 117–20. Marble (facade restored), 36 x 55′9″ (11 x 17 m).

Pairs of marble columns, perched on high pedestals, support projecting entablatures (the horizontal lintels or beams above the columns). The columns of the upper story straddle those of the lower to create an interlocking rhythm. Alternating triangular and curved pediments crown the top entablatures, and the whole ensemble sparkles from its crystalline and finely veined marble from rich local quarries.

T he Roman Empire was an urban civilization, a network of cities mostly located on or near the coast of the Mediterranean because the sea provided easy routes for travel and commerce. Although the ancient city lived off the resources of the surrounding countryside, the hinterlands of the Mediterranean were somewhat lonely and impoverished in comparison to the bustling towns. There would have been no question that the urbanite possessed innumerable advantages besides economic benefits. The cityscape also provided for a social life, from the buildings housing the government to those of popular entertainment.

The city was the primary building block of Roman civilization to the extent that cities in newly conquered territories gained the requisite buildings for administration and the amenities (amphitheaters, theaters, racetracks, and baths) that lessened the hardship of service abroad for Roman soldiers and bureaucrats. These urban institutions also attracted those not yet under Roman control and exemplified the privileges of assimilation or alliance. Even the city plan, with its more or less regular grid and main arteries emptying into a forum, came to signify an orderly and secure system of authority and control.

If the city can be seen as the work of art of Roman civilization, then we might have expected the state to have organized and funded the planning, building, and decorating. But the state as an entity did not erect monuments; rather, prominent citizens and emperors put up buildings and tore down eyesores to improve their cities. It is obvious why emperors spent fortunes on urban renewal in the capital, for example, but less clear why individual citizens felt compelled to take on the expense of erecting theaters or monumental gates in their home towns.

In many cases, competition for political posts, along with civic pride and a deeply ingrained sense of obligation, motivated leading citizens to spend their own money on public buildings and to decorate them with sculpture, painting, or mosaic. This civic competition resulted in a fairly uniform architecture throughout the Empire; for the citizenry it provided street scenery with distinguished architecture and, better yet, buildings for mass entertainment.

The City as Civilization

The city provided the arena for ambitious men, and urban living was frequently condemned by moralists for its easy opportunities for corruption and extravagance. Martial, the satirical poet (*c.* AD 40–101), recounted the inconveniences of urban living:

> Schoolmasters in the morning do not let you live; before daybreak, bakers; the hammers of the coppersmiths all day. On this side the moneychanger idly rattles on his dirty table Nero's coins, on that the hammerer of Spanish gold dust beats his well-worn stone with burnished mallet... Whenever, worn out with worry, I wish to sleep, I go to my villa [in the country]."

(Martial, *Epigrams*, 12.57)

Yet he would never consider giving up the dinners, salons, and gatherings of his circle in Rome to live full-time in the country. A relief (FIG. 32) from the second century AD depicts the clash

32. Relief representing city versus country vistas, from Avezzano, second century AD. Marble. Palazzo Torlonia, Avezzano.

City in the country and country in the city: the countryside is punctuated with architecture in the form of porticoed villas, just as actual towns incorporated patches of open ground and enclosed gardens. In contrast to the tidy division of town and country pictured here, the Roman metropolis at the height of the Empire was surrounded by a sprawl of tombs, farms, vineyards, and small plots rather than open land.

between town and country literally, with the city walls dividing the regular blocks of tall buildings within from the sprawling grounds of country villas beyond. Despite the difference between the hard-edged geometry of the town and the winding path of a river and full trees in the country, the two are set side by side as if to imply their dependence on one another.

In Rome, the neighborhoods and monumental quarters in many respects provided the model for all others in the Empire (FIG. 33). The grid plan that determined the rational form of many newer cities is lacking in Rome because of its early unplanned and irregular growth. In Republican times, the Forum (FIG. 34), in the valley below the Capitoline, Palatine, and Quirinal hills, was synonymous with the center of political life, with its places of assembly and speaker's platform; whereas in the imperial period, it developed into an open-air museum crammed with triumphal monuments and shrines to deified emperors, which offered significantly less opportunity for political participation. A character in one of the comedies by Plautus (254–184 BC) characterizes the neighborhoods of the Forum by the people who frequent them:

> In the lower forum citizens of repute and wealth stroll about; in the middle forum, near the canal, there you find the merely showy set. Above the lake are those brazen, garrulous, spiteful fellows who boldly decry other people without reason and are open to plenty of truthful criticisms themselves. Below the old shops are those who lend and borrow upon usury. Behind the Temple of Castor are those whom you would do ill to trust too quickly.
>
> (Plautus, *Curculio*, 475–482)

The playright gives a vibrant sense of the city center as a place where citizens gathered for business and competed for political or economic advantages with their peers. At the end of the Republic, as the markets were cleared out for government buildings, the Forum became a backdrop for bureaucratic administration and grand ceremony (gladiatorial games were also held there until about 29 BC). Law cases and some politics took place in the adjacent Imperial Fora, the first begun by Julius Caesar in 54 BC to accommodate the requirements of the government of a vast empire and to restore dignity to the old Roman Forum. As the stage for the appearances of emperor and senators attended by masses of white-togaed citizens, the Forum demonstrated the grandeur and wealth of empire with its gleaming marble buildings and burnished bronze statues.

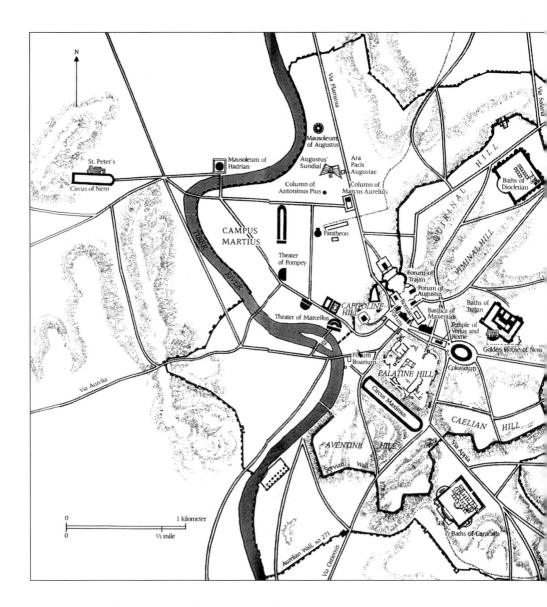

33. Topographical map of the city of Rome, early fourth century AD.

The plan of Rome shows its dependence on the Tiber river with
the heart of the old city, the Capitoline hill and the valley of the
Forum, in close proximity to the crossing at the Tiber Island.
The city's major monuments are shown here, along with the
routes that connected Rome to other cities and the streets that
crisscrossed the neighborhoods within the walls. The
entertainment facilites of the early city, the Colosseum, and the
Circus Maximus, are located near the city center, while the
baths of the late Empire, the Baths of Caracalla and of
Diocletian, are at the edges because of the lack of space in the
dense, overbuilt center by this period.

34. Aerial view of the Roman Forum, with the Colosseum in the foreground.

The Forum stood on a marshy burial ground used by the people who had lived on the surrounding hills. Before Rome's arenas were built, it witnessed gladiatorial combats, heard the eulogies for the outstanding men whose funeral processions stopped before the rostra, and saw the chance encounters of citizens who caught up on business here. Under the Empire, the neighboring fora and enclosed colonnaded courts with temples built by the emperors Augustus, Vespasian, Domitian, and Trajan in the first and second centuries AD, assumed some of the legal and ceremonial functions of the Roman Forum.

The markedly different neighborhoods surrounding the Capitoline hill and those on the slopes of the Quirinal and Esquiline hills consisted of narrow, winding lanes hemmed in by cramped tenements. The business of one's neighbor was by necessity one's own when these apartment blocks shared latrines and ovens in courtyards below, where light and fresh air were at a premium. The tight quarters forced many lives to spill into the streets. Barbershops, booksellers, and hawkers of fresh produce filled the dusty streets with shrill and frenzied bargaining. No wonder Martial complained of a city that never slept.

The Palatine hill, with views to the Forum on one side and Rome's racetrack, the Circus Maximus, on the other, had long

been the most prized residential district in Rome. Romulus was said to have enclosed his city on the Palatine with walls in the mid-eighth century BC, and excavations have found evidence of early settlement on the hill, with aristocratic townhouses on the slope overlooking the Forum from the sixth century BC. Augustus lived here in a mansion that was expressly not a palace: the only element of grandeur resided in the adjacent Temple of Apollo. In the mid-first century AD Nero (r. AD 54–68) erected a structure to connect his properties on the Palatine with those on the Esquiline, and Domitian (r. AD 81–96) built a sumptuous and sprawling palace on several levels that was enlarged in the late second and early third centuries AD.

Theaters, baths, fountains, and porticoes filled the Campus Martius, the quarter of the city in the bend of the Tiber and considered by the Greek geographer Strabo (64/3 BC–AD 21) to be more elegant than the city. Here Augustus's Ara Pacis stood, not far from a huge sundial, its bronze markers fixed to the ground, and, further north, his monumental tomb planted with cypress trees rose from the banks of the Tiber. The Baths of Nero, Domitian's stadium, and Hadrian's Pantheon, together with the baths, canal, and artificial lake built by Augustus's friend and general, Agrippa (c. 64–12 BC), were all located in this quarter. People came here to stroll and take in the paintings and sculpture of the splendid porticoes.

The Forum in Pompeii, a prosperous town on the bay of Naples (see FIG. 2) that was destroyed by the eruption of Mt. Vesuvius in AD 79, illustrates the clarity and order of the civic center (FIG. 35). The business of government, religious worship, and commercial exchanges all had their place in the Forum. The Temple of Capitoline Jupiter, situated on the axis of the Forum, dominated the space from its high podium; opposite stood three narrow local government offices. Besides the state temple, an older Temple of Apollo (predating the Forum) joined the colonnades around the Forum. Another place for the business of the state was the Basilica, whose colonnaded interior housed law courts and public meetings. Opposite this stood a complex erected by a prominent Pompeian woman, Eumachia, that may have provided a sheltered and landscaped retreat from the busy Forum, although this is debated. As a public priestess, Eumachia took part in local politics and served as a benefactress to the trades – the cloth-cleaners dedicated a statue of Eumachia in her building.

Rather than having vendors' stalls cluttering the open space of the Forum in Pompeii, a central market was constructed in the corner next to the Temple of Capitoline Jupiter. The mar-

35. Aerial view of the Forum in Pompeii, first century AD.

The buildings surrounding the Forum are, from top clockwise: the Temple of Jupiter Capitolinus, the Macellum, the Sanctuary of the Lares, the Temple of Vespasian, Eumachia's Building, the Comitium, three administrative buildings, the Basilica, and the Temple of Apollo. Statues of the Julio-Claudian emperors would have stood in the center of the Forum. International teams of archeologists continue to excavate and study Pompeii from the Forum to individual houses.

36. The oval Forum and thoroughfare in Gerasa (modern Jerash), Jordan, late first century AD. L. 300′ (91.4 m).

Perhaps it is better to call the Forum a piazza because of its location near the city gate rather than the central district. It is bordered by an Ionic colonnade and stands near the South Theater built by the emperor Domitian (r. AD 81–96).

ket consisted of stalls for the different concessions and a central fountain that, no doubt, washed away the debris. The commercial functions did not clash with the worship that took place in a shrine to the imperial house: here a gallery of statues of the emperor and his family watched over the business of the central market and received offerings from those that stopped in the midst of the bustling activity to demonstrate allegiance and respect to the Julio-Claudian dynasty (31 BC–AD 68).

Fora came in different shapes, as seen in the city of Gerasa (modern Jerash) in Jordan with its oval piazza (FIG. 36). The piazza may have served as a kind of holding area where pedestrians and carts could gather after entering the city from the south gate and before making their way down the major street. The radial plan, like the axial plan of the Pompeian Forum, demonstrates how the focal points are integrated into the street system. The sweeping curves of the oval piazza, however, suggest a different kind of street life from that of the rectangular Forum of Pompeii and other cities; the space of the more traditional rectangular or square forum is oriented toward the dominating temple; this forces encounters among citizens to occur among buildings, colonnades, and the statues populating the center. In the oval shape, the irregular curves exhibit a space unobstructed by buildings or monuments because it is a place of passage, room to pause at the city's edge before going down the colonnaded avenue to the city center. It may have served as a market for the caravans entering the city, a convenient place for stalls and wagons to set up shop because of its accessibility. It is tempting to see this shape as a local phenomenon of the eastern or north African provinces (where it also occurs), but it may reflect a wider experi-

mentation with curved forms in the architecture of temples, baths, and villas, and represent an attempt to define the edge of the city differently from the angled geometry of the grid plan.

A focus of urban life was the temple located in the city center, usually in or near the forum. An excellently preserved early example is the Temple of Gaius and Lucius Caesar in Nîmes, southern France (FIG. 37), dedicated to the boys Augustus adopted as his heirs and therefore serving the imperial cult in the provinces. It forms a typically Roman tall, narrow, and deeply gabled box on a high podium. The freestanding columns of the porch become half-columns like ribs against the limestone sides and back, another Roman characteristic that emphasizes the solidity of the temple. The stonemasons exhibited skill in carving the rich Corinthian capitals that evoke those of the temple in the Forum of Augustus in Rome, and in the frieze with its vine tendrils that recalls the Ara Pacis – so much so that archaeologists have speculated that artisans from Rome constructed this temple. The allusions to the natural world in the deep undercutting of the acanthus leaves on the capitals and the endlessly intertwining vines of the frieze are held in check by the austere form of the temple. Roman temples were meant to be seen from the outside, where the sacrifices were held on altars in front of the temple or on its steps.

37. The Temple of Gaius and Lucius Caesar, Nîmes, France, AD 1–10. Marble.

Better known as the Maison Carrée (the square house), the temple was replete with inscriptions honoring local priests of the imperial cult. Such priests were magistrates or other men of influence, who carried out sacrifices and offerings in honor of Augustus and his family. The imperial cult allowed provincials to demonstrate their allegiance to Augustus and to partake in the public ceremonies that indicated privilege and status.

38. Aqueduct, in Segovia, Spain, first century AD.

The rough, unfinished blocks contrast with the attenuated and elegant proportions of the piers, which rise to 300 feet (91.4 m) and reach 900 yards (822.9 m) in length. The conquest of Spain required Augustus to fight a series of difficult campaigns. The extant Roman architecture in Spain dates mostly to the period of his reign and the Julio-Claudian emperors (31 BC–AD 68): models from Rome were followed but at the same time indigenous traditions created local developments. The Segovia aqueduct still carries the city's water.

Besides fora and temples, cultural institutions also graced cities, many built at the expense of their leading citizens. The library as a place of intellectual activity, as opposed to the record halls of the administration, began with aristocratic collections of papyrus scrolls housed in public buildings, such as the Palatine Library in Rome, rather than in private villas. Perhaps the most prominent were the Greek and Latin Libraries flanking the Column of Trajan in the Forum of Trajan; the bilingual collection points to the cosmopolitan culture that demanded fluency from the elite in both languages. We should probably think of these buildings as storehouses for the scrolls that constituted the knowledge of the ancient world, rather than the reading rooms of modern public libraries. In the city of Ephesus on the Aegean coast of Turkey a magnificent library was built by AD 120 as a funerary monument for Celsus, a distinguished citizen who had been a consul in Rome and a proconsul (governor) in Ephesus early in the second century (FIG. 31). Celsus was accorded the exceptional honor of being buried within the city, in fact beneath the library apse.

The Library of Celsus displays a columnar facade, an architectural style that pervaded the Empire in the second century AD. Three entranceways are flanked by niches holding statues of personifications of Celsus's moral character: Wisdom, Know-

ledge, Thought, and Virtue (the virtues of Celsus are cerebral in comparison to the civic virtues of Zoilos on his tomb in Aphrodisias; see FIG. 29). The interior consisted of a rectangular hall with a central apse, which probably contained a statue of Celsus. The scrolls were kept in rectangular niches with stairs to galleries above. From the burial beneath the building to the statue in the apse and the personified virtues on the facade, the whole building is devoted to the memory of Celsus.

Public works projects were vital to the interests of cities and nowhere is this more clearly seen than in the aqueducts spanning the countryside (FIG. 38). Providing cities with water from country springs by channeling water underground and along the narrow troughs of tall aqueducts over great distances remains an engineering feat that warrants respect today. The Romans mastered the technology of hydraulic engineering to survive in arid landscapes, encouraging standards of hygiene from its masses and supplying the great public baths and fountains with water. We might consider aqueducts part of the urban infrastructure but they were most visible in the landscape, where they defined a Roman presence by their simplicity and grandeur, the arch extended in a seemingly limitless series. Constructed of local stone squared and fitted in horizontal courses, the aqueduct bridged the country and the city, and revealed the city as a parasite on the country.

The water carried by aqueducts was not all for drinking, cooking, or bathing – much of it was used for show, that is, the waterworks that animated city streets. In the second century AD, the city of Perge in southwestern Turkey (see pages 6–7) boasted a colonnaded street with a water channel down the center (FIG. 39). The colonnaded street, a feature of many Hellenistic and Roman cities, provided shelter from the sun or rain and also formed the entrances to the shops within them. Mosaics on the floors in front

39. Colonnaded street and water channel, Perge, southwestern Turkey, second century AD.

The six-foot (2 m) wide channel ran down the middle of the main street from the city's gate to the nymphaeum (grotto-like fountain) at the foot of the acropolis, the hill overlooking the city; the nymphaeum also supplied the water for the 330-yard (300 m) channel with its cascading pools. As a traffic divider, the channel worked admirably well, but it did more than that. The flowing water altered the urban atmosphere with sound, light, and temperature: its gurgling soothed ears more attuned to wagon wheels scraping against the stone paving, its shimmering reflections played off the street's marble statues and columns, and its coolness attracted weary people and thirsty animals alike.

of the shops display some of the merchants' names; perhaps the colonnades served as a shopping arcade, organized by the local authorities and creating a uniform appearance with standard doorways and interior spaces. Colonnades provided spaces too for itinerant merchants to display their wares, if only on the pavement. The lining of a street with covered corridors changed the ambience of that street by encouraging pedestrians to wander in and out of the shops and colonnades or to refresh themselves with water from the channel. It transforms the street with the animation of its sparkling and murmuring cascades.

Civic Spectacle

Cities offered their residents entertainment in the form of dramatic performances, staged combats, and athletic events. Cultural or sporting events required mass gatherings of citizens, and the reactions of the crowd to the marvelous sights of the theater or the gruesome slaughter of the arena often had a galvanizing effect on the audience. The heightened reality and emotions of the spectacles no doubt provided heady experiences for the masses whose role in public life was limited to these events. It may be overstating the case to speak of the empowerment of the marginalized and disenfranchised in the crowd but both workers and the unemployed participated from the stands, cheering, chanting, or booing. The grandeur of the spectacle depended on the presence of the crowd, which was granted force and anonymity by virtue of its size.

The theaters, amphitheaters, circuses, and stadia in which these events took place were erected in most cities of the Empire and set the standards for Roman urbanism to the extent that their contruction in remote outposts gave provincial cities a cosmopolitan character. Cities graced with the requisite cultural amenities exemplified the benefits of Roman rule and its highly desirable quality of life. The distribution of these buildings across the Empire also points to the resources expended by local elites for the shows and games, a display not only of dramatic flair, wondrous sights, or athletic prowess, but of the wealth and administrative skills of those who paid for and organized the entertainment.

Besides their role in cultural diffusion, these institutions reinforced social practices in features such as the seating arrangement in the theater or amphitheater based on rank and status. The spectator's appreciation of the event and the building in which it was performed depended on position in the pecking order. The great gatherings of the citizenry in these buildings also permitted

communication between the powerful and powerless. When the emperor took his place in the imperial box in the theater or arena in Rome, not only was he visible to most of the crowd, he was subjected to their acclaim or disapproval. The emperor played the leading role in the performances or games that he sponsored.

The extraordinary character of these events also allowed for some suspension of the rules of the hierarchy. Common criminals were given the spotlight, so to speak, by enacting mythological scenes in the arena that climaxed with their deaths: in other words, their executions were staged with costumes and props like dramatic vignettes from the best of Greek mythology. Emperors, such as Nero, took to the stage as actors and singers, roles that threw them in with the lowlife of Rome's back alleys and degraded the honor of their positions. Other emperors,

40. Stage facade of the theater at Sabratha, Libya, AD 180. Sandstone, l. 302′ (92 m).

The restored design of 108 columns emphasizes the effects of color, texture, and fine details: columns of violet and green marble screened the stage wall on the first two stories; the third had black granite columns. The column shafts also varied from the traditional fluted forms (that is, with vertical channels) to those with spiral flutes or none at all. Reliefs in the niches depict theatrical entertainments, one of which may represent a popular mime about a rich woman who manages both an ignorant husband and a fashionable lover—Roman comedies and mimes featured stereotype characters and formula plots.

41.
"Colchester Vase," first century AD. Decorated red gloss ware. Colchester Museum.

The beaker was produced in the popular medium of *terra sigillata* (clay decorated with small images) in Gaul. The figures in relief depict two gladiators, their specialities identified by their armor and weapons: the *secutor* ("chaser") and *retiarius*. The former is a Samnite gladiator who carried a rectangular shield, helmet, and greaves; he usually fights the *retiarius,* a lightly-armed and bare-headed gladiator with a fisherman's net, trident, and dagger. The climax of the combat is represented with the *retiarius* holding up his finger as an appeal for mercy. The *editor,* the sponsor of the games, could spare the life of a gladiator if he or the crowd so desired.

such as Caligula (r. AD 37–41) and Commodus (r. 180–92), even fought as gladiators in the arena – but perhaps this performance toughened the imperial image and reputation. That the theater and arena encompassed the extremes in the popular imagination may have encouraged this blurring of reality and fiction.

The theater was a Greek import; at first, troupes of traveling players performed on temporary stages in Roman fora and only later did cities erect stone theaters. The Roman theater differed from the Greek model by its site on flat ground in cities and the consequent need for concrete vaulting to raise the tiers of the auditorium. The shape of the Roman theater also differed, with its semi-circular orchestra (the space between the stage and the seating) and its auditorium connected to the stage, thus enclosing the theater from the outside world. Roofing, either a timber structure or canvas awnings, enhanced the illusion of the Roman theater being a world unto itself. Collapsible sets, scenery disappearing through trap doors, and scented sprays or saffron mists to perfume theater-goers added to the heightened reality of the performances.

The most spectacular part of the theater was the columnar facade of the stage building, the *scaenae frons*, that framed the actors: it displayed pavilions, superimposed stories, and niches for statues, like the facade of the Library of Celsus (see FIG. 31). The best-preserved example is at Sabratha in Libya (FIG. 40). Located on the coast of north Africa, the town provided a market for the ivory trade of the continent's interior and, like many other cities, benefitted from the prosperity and stability achieved in the Antonine period (AD 138–92), seen by Roman historians as the golden age of the Empire. The effects of a columnar facade depend on the repetition of artfully arranged components, whether staggered vertically to contrast open and closed sections as in the facade of the Library of Celsus or in the alteration of projecting or recessed pavilions as in the *scaenae frons* of Sabratha's. The theater "backdrops" were not really architecture so much as screens in which the rows and stacks of columns alluded to the cityscape and its fora, meeting halls, and law courts. Greek stage scenery represented royal palaces with doors for the entrances and exits of the kings whose downfalls were enacted in the tragedies; the Roman "backdrop" alluded to the colonnaded street and the popular plays, mimes, and pantomimes were performed against a decidedly urban and familiar facade.

The amphitheater is most often associated with gladiatorial games but its shows also consisted of wild beast hunts and the execution of criminals. A typical program usually featured animal hunts in the morning, executions at midday, and gladiators in the afternoon (FIG. 41). The orchestrated killing of savage beasts, convicted felons, and enslaved gladiators celebrated military valor in a civilian setting and clearly targeted those whose untamed, deviant, or degraded nature merited the abuse of the arena. Often located on the edges of cities because of practical considerations, the arena belonged to the periphery because of its bloody goings-ons and the frequent loss of life of the human and animal participants. The amphitheater consisted of an oval arena with tiered seating on concrete vaults reached by staircases and ramps as in theaters, only with more corridors to move the larger crowds in and out efficiently and safely. Its curved exterior was faced with arcades on several stories, also found on semi-circular theater auditoria. The late-Empire amphitheater at El Djem (Roman Thysdrus) in Tunisia (FIG. 42) dates from the late third century AD, almost two centuries after the Colosseum in Rome (see FIG. 34), usually given as the standard amphitheater. El Djem's size is enormous – its seating capacity of 60,000 was more than the estimated local population. It may have served as a theater for the region or for troops stationed in the area, or perhaps its size reflected the inflated ambitions of the city's leaders. That an amphitheater was larger than needed might not seem odd to us because everything about the games – the pleasure in the maiming and killing of gladiators, the numbers of species dispatched, and the obscene

42. Amphitheater at El Djem (ancient Thysdrus), Tunisia, third century AD. Area 489 x 407' (150 x 124 m), outer wall h. 131' (40 m).

Like the Colosseum in Rome, engaged half-columns frame arcades on three stories, with Composite capitals (a variant of the Corinthian order with large volutes on the corners) on the lower and middle stories and Corinthian capitals on the third. It departs from the Colosseum in the simplicity of its surfaces: few elements project in relief and the solid walls open with narrow, tall arches set at fairly wide intervals. The circular wall hemming in the arena appears taut and compact.

extravagance of its scenery and props – seems beyond all proportion. The date of construction is also odd: in a period of lower standards of living, Thysdrus prospered because of its agriculture, in particular, the olive harvest. Its value increased after the emperor Septimius Severus (r. AD 193–211) included olive oil in his distribution of food to the population in Rome. North Africa also exported the animals fought and slaughtered in the arenas of Italy; the amphitheater at El Djem may have proudly demonstrated the colony's appreciation of the games that depended on its local resources.

Popular sports included chariot and foot races. The former took place in circuses, long tracks with a course running around one hairpin turn, and the latter in stadia of a similar shape but smaller in size and particularly suited for Greek athletics. The Circus Maximus in Rome (see FIG. 33) provides the model for the building type that developed gradually and originally offered venues for sports other than chariot racing and also for amusements such as acrobats and jugglers. By the early Empire, the system of circus factions consisting of teams (driver, chariot, four horses) was established. Fairness had to be ensured because the public betted on the results of the races – passionate devotion to favorite teams, which were named after their racing colors, stirred streetcorner debates. In order to give each team equal opportunity, architects had to design starting gates that opened simultaneously and racecourse lanes that were equidistant from start to finish. In the stands the spectators sat closely packed together on tiered seating that was supported by concrete vaults. The exterior walls had arcades framed by decorative Classical orders as entrances for the spectators, as in the theater and amphitheater. Athletics provided more than pastime or entertainment because it was thought that the beautiful body endowed with grace and a stately bearing revealed superior moral qualities. Although light exercise and sports were part of the physical regimen of the cultivated elite, professional athletes in organized teams, who received public acclaim or notoriety depending on their performances, displayed a prowess that was often equated with crude power or brute force. Runners who sprinted around the dusty courses may have been far from the ideal physical specimens represented in Classical statues, but their dedicated training and competitive spirit made perfect sense to a culture dominated by a military ethos. Charioteers performed as members of teams that excited partisan passions and even politics.

Cities in the western Empire tended to have amphitheaters and circuses, while eastern cities preferred stadia for foot races. In the Greek east, the orchestra of theaters or one end of a stadium

43. Stadium in Aphrodisias, southern Turkey, probably first century AD. Marble, 860 x 194' (262 x 59 m).

The stadium was built into the city's defensive system so that the arcades and walls above the seats on the northeast side formed part of the protecting walls.

could be adapted for gladiatorial events and animal fights. The stadium in Aphrodisias, southern Turkey (FIG. 43), is the largest still standing, with about 30 tiers of seats for approximately 30,000 people. It is curved at both ends. The long walls slightly bulge out so that spectators could have better views of the ends of the stadium. Clearly, the races had a broad appeal to the citizenry of Aphrodisias who gathered in the bleachers here to cheer on their favorites and, in doing so, gave full vent to the values that shaped their world.

Baths offered backdrops for a spectacle informed by social ritual that culminated in the sensual pleasure provided by ornately appointed interiors, soothing waters, steam rooms, massages, and scented ointments. The defining experience of a Roman bath was the luxury, whether in one of the grand baths built by the emperors or one of the numerous smaller establishments tucked along city streets. The baths built by the emperors Nero, Titus (r. AD 79–81), Trajan, Caracalla (r. AD 211–17), and Diocletian (r. AD 284–305) in Rome were palaces for the people with an architecture of grand effects: vast vaulted and domed spaces, coffered ceilings with gilt ornament, statuary in niches, marble tubs, and silver basins and fittings. More modest facilities also offered delightful amenities, as Martial recounts in his description of the Baths of Claudius Etruscus in Rome: "If you do not bathe in the warm baths of Etruscus, you will die unbathed, Oppianus... Nowhere is the sunlit sheen so cloudless; the very light is longer there, and from no spot does day withdraw more lingeringly... The rich alabaster pants with dry heat, and snakestone is warm with a subtle fire" (*Epigrams*, 6.42).

44. Changing room in the women's section of the Forum Baths, Herculaneum, first century AD.

The compact, functional space is covered by a stuccoed barrel vault, marked by grooves. Brackets divide a shelf into sections for the bathers' clothes (the wooden chests and pegs that held belongings no longer survive); often slaves were stationed to protect their owners' clothes from petty thievery. The black and white mosaic on the floor depicts a triton surrounded by an octopus, squid, and dolphins. The energetic creatures with their slithery, snaky forms allude to the aquatic pleasures of the baths.

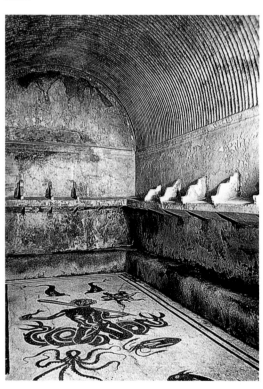

Brilliant light, reflective surfaces, and a seductive warmth create a picture of a small but sumptuous establishment. The technology of concrete construction allowed large halls to be covered with curvilinear forms, and the development of radiant heating through hollow floors and walls produced steamy hot baths and sweat rooms. A typical bather, who lived in a cramped, poorly lit room or two, must have felt extremely privileged to visit the spacious halls for a low price.

Having a bath was a daily habit for elite Romans. Besides their obvious role in promoting hygiene and health, the baths also served as social clubs in which people mingled and the less well-known sought dinner invitations from the socially prominent. People attended in the afternoon after business was finished and frequently made dinner plans while relaxing and socializing in the plunge baths or on the playing field. Although one might think that the naked exposure of bathing erased differences of status, the display of rank and privilege was present as in other arenas of public life: citizens with a reputation to maintain came with a retinue of slaves to carry their body oil, toss them balls for exercise, and read aloud to them as they strolled, for the baths offered cultivation for the mind and body. Unlike the Greeks, the Romans did not exercise in the nude, and it is not clear if they proceeded on the typical route from the warm via hot to cold baths in thin tunics or some other light covering. The virtue of modesty, so important for Roman conduct, was upheld by maintaining separate bathing chambers for men and women (FIG. 44) or by restricting the hours of bathing for each gender, yet the exhibition entailed by bathing in groups raises the possibility of suggestive or illicit behavior. Indeed, contemporary accounts do mention prostitutes of both sexes at the baths and boorish or provocative behavior on the part of some bathers. Baths were places where citizens went to cleanse themselves of the grit of the streets, to be refreshed and reinvigorated by the therapeutic effects of mild exercise, massage, and a warm soak.

The Suburban Baths in Pompeii of the first century AD contain a changing room that is decorated with images of a different sort of physical pleasure (FIG. 45). Paintings

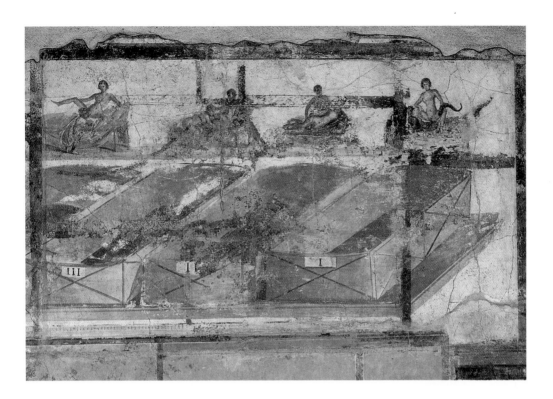

45. Locker room, upper zone of south wall, Suburban Baths, Pompeii, first century AD. Fresco.

The upper zone of the south wall depict the containers in which the bathers' clothes were kept; each box is numbered and accompanied by an erotic vignette above representing sexual acts of an increasing complexity, dexterity, and imagination. Before AD 79, the sexual scenes were repainted with fourth-style decoration, traces of which are still visible.

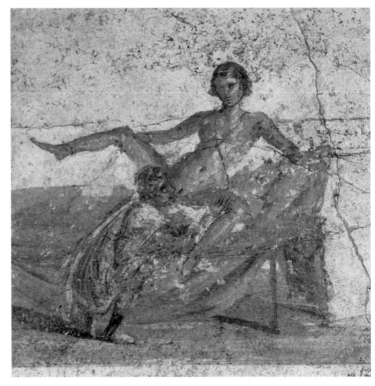

46. Statue of a dancer from the South Baths in Perge, Turkey, second century AD. Black and white marble, h. 7′4½″ (2.25 m). Antalya Museum, Turkey.

This statue is thought to be a Roman copy of a Hellenistic work (before the first century BC). The copying of Greek sculpture was a thriving trade in Rome and the provinces, producing works for private houses as well as the public baths, theaters, and temples. The collecting mania is evidenced by Cicero's correspondence asking his friend Atticus to purchase Greek sculpture for his villa gardens: rather than specifying styles or media, Cicero desires certain subjects appropriate for the setting.

of couplings in a matter-of-fact or clinical style are familiar in Pompeii in contexts varying from well-to-do houses to brothels, and it would seem that the setting of the locker room is particularly appropriate for erotic imagery in a bath house serving both men and women. Yet the combination with the numbered pictures of the clothes boxes seems odd, especially when the actual containers for clothes were located below the painting. One theory suggests that the painted numbers, lockers, and sexual acts form a sequence designed to help bathers remember where they deposited their clothes. Like obscene jokes or puns, the paintings of sexual acrobatics were intended to elicit humor from the male and female clientele, probably without the embarrassment or discomfort that accompanies such subjects today. It is remarkable that such highly charged imagery served the mundane purpose of signs for lockers.

The images in the locker room of the Suburban Baths in Pompeii derived from mixed sources, such as the explicit graffiti scratched on tavern walls and the courtly bedroom scenes in paintings from elite houses, but most of the works of art decorating bath houses reflect the canon of Greek Classical and Hellenistic art. A striking statue of a female dancer in black and white marble (FIG. 46) was found in a gallery in the South Baths in Perge, near the beginning of the colonnaded avenue (see FIG. 39). The overlife-sized figure is caught in motion with the right shoulder and leg leading and the mantle cutting arabesques on either side. The figure's poise is matched by its elegant appearance: the garments and hair are made of black marble, the face and body contrast in white marble. This polychrome technique is seen in other sculptures from Turkey but here it enhances the grace, the swinging movement of the hips, and the drapery flying away in gravity-defying angles. Grace, defined not only by beauty but also by a stately bearing and physical ease, motivated citizens to cultivate their bodies in the baths.

Other kinds of spectacles contributed to street life in Roman cities. On holidays, processions of craftworkers, merchants, and laborers filled the thoroughfares and the precincts of temples where they left offerings to their guardian deities. There are few images of these festivals, but a fragment of a painting from Pompeii shows such a procession (FIG. 47). Here, carpenters carry a tableau of the legendary craftworker Daedalus. As the inventor of carpentry and its tools, the saw and axe, Daedalus is an appropriate ancestor but the tableau alludes to a deadly rivalry among artisans rather than the *esprit de corps* suitable for a celebration of this sort.

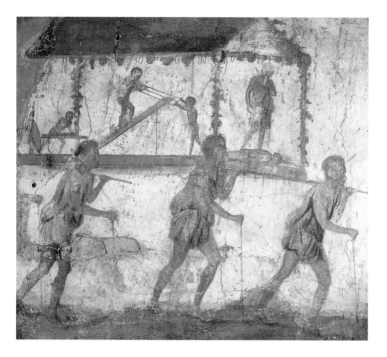

47. A procession of carpenters from a house in Pompeii, first century AD. Fresco, 26 x 29½" (66 x 75 cm). Museo Nazionale Archeologico, Naples.

The painting depicts the workers in their short tunics carrying a tableau representing a shrine with the mythological Daedalus and Perdix with Minerva (only partly visible to the left), the goddess of craftworkers. Daedalus, the artist whose statues seemed to come to life, had to flee his native Athens because he killed his nephew Perdix out of jealousy for his talent.

Festivals were probably organized by the associations (*collegia*) that represented workshop owners, who perhaps found the aggressive and competitive instincts of Daedalus attractive. Besides its glimpse of pageantry, the painting indicates how figures from Greek mythology were of use to the lower orders in Roman society.

A marble relief found in the area of the Forum Boarium, the cattle market near the Tiber in Rome, shows the goddess Minerva's patronage of craftworkers (FIG. 48). The goddess not only of heroes and emperors, Minerva also watched over those who worked with their hands. The relief may have been part of a frieze on a shrine or temple and reflects the popular devotion to the goddess that motivated the craft festivals and other noisy acts of worship filling the streets. It is important for its care-

48. Relief of Minerva visiting a carpenter's workshop, first century AD. Marble. Antiquarium Comunale, Rome.

The goddess Minerva is identified by the *aegis* (the cape with head of Medusa) on her chest, the workshop by the enlarged tools hanging above and by the products, the table with finely turned legs on the right.

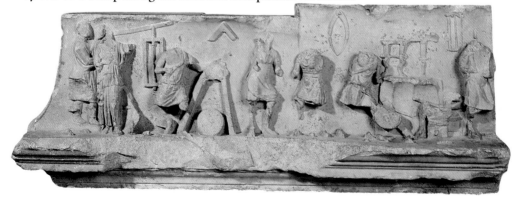

49. Altar from Vicus Aesculeti, Rome, AD 2. Marble, h. 3′5″ (1.04 m). Capitoline Museums, Rome.

The inscription on the altar misspells the name of the street, "Aescleti," perhaps an indication of the background of the sculptor and his patrons, the neighborhood wardens who celebrated the cult of the *lares* (guardians) of the crossroads and the *genius* of Augustus. In the full regalia of togas drawn over the head and accompanied by a *lictor* (the bodyguard who accompanies magistrates) on the left, the freedmen administer the rites with the pomp of a state cult. Paired on either side of the altar with a flute-player in the center, the officials participate equally in the sacrifice.

ful observation of the carpenters at work, a group rarely depicted in art – particularly in rarefied architectural sculpture – and for its style that combines realism with abstraction: the close modeling of the worker's torso and chest (especially in the second figure from the right) with the symbolic exaggeration of the tools hanging overhead. The tools seem to be invested with an iconic value often given to weapons and armor (see FIG. 17) or sacred utensils in state reliefs.

Rulers and Subjects

Sculpture was part of the cityscape in the form of full-length figures placed in niches on building facades, on high bases in front of temples, in colonnades, or at intersections. However, it was mainly architectural sculpture in relief that dressed plain masonry walls and created pictorial narratives. Reliefs transformed the precincts of temples or the piers of triumphal arches with representations of historical events or imperial ceremonies on a grand scale and with dramatic effects. They are called state or historical reliefs because of their imperial subject matter – the emperor at war or triumphant, giving clemency to defeated enemies or addressing his troops, demonstrating piety by sacrificing, giving largesse to his people. These standard scenes of an emperor's career are matched to specific events as if they document them, but their frequency in reliefs of the second century suggests that they constitute an iconography of imperial glory, which may or may not have been strictly correlated to the contemporary events. In the first half of the second century AD when Trajan expanded into eastern Europe and Hadrian consolidated the Empire, the stock motifs of the state reliefs expressed a vision of world dominance and security, of empire without end. But in the third and early fourth centuries with political chaos and frontier wars that vision could no longer be sustained, although the iconography continued. Yet, rather than read the reliefs as an illustrated history in which the images correspond to complex political circumstances, they can be appreciated for their views of the emperor's relationship to his subjects and for their images of the ideal imperial society. The gods and personifications in the reliefs also point to allegorical meanings, an old idea that has been revived as art historians and archaeologists have moved away from the conviction that the state reliefs functioned as documentaries and toward the notion that they incor-

porate abstract ideas about the responsibilities of power and the duties of citizens and soldiers.

The popular reliefs on altars placed in city streets or at crossroads (FIG. 49) demonstrate the appeal of the state reliefs to citizens of the lower orders. In 12 BC Augustus had reorganized the city into regions and *vici* (wards) for administrative purposes, and the ward officials (*vicomagistri*) were freedmen with responsibilities for the neighborhood's security in response to crime and fires, in return for the honor of sacrificing to the *genius* (guardian spirit) of the emperor at such altars. The theme of sacrifice, prominent in the state art of the Empire, is adapted here to further the self-representation of new men eager to show their allegiance to Augustus, to belong to the new society.

The state relief represents the emperor in acts of imperial authority, frequently in the company of deities and personifications who, at the least, enhance his dignity and, more commonly, elevate him to a superhuman or quasi-divine status. In this way the state relief articulates the divisions of society from the heights of power and privilege at the top to the rank and file of officers and soldiers below and, ultimately, down to the miserable representatives of captive enemies. One of the paired Cancelleria Reliefs (FIG. 50) depicts the emperor Domitian with a divine entourage followed by his troops and personifications of civilian society. The emperor, whose head has been recarved, is preceded by Mars and Minerva and is supported by an Amazonian personification of Rome or military valor (Roma or Virtus with one bare breast). Traditionally identified as Domitian's departure (*profectio*) for the battlefield, this and the wider meaning of the reliefs have long been debated, but here we focus on the personifications of the Roman Senate and of the Roman People who follow the gods in the procession.

50. The *profectio* scene (relief A) from the Cancelleria Reliefs, AD 93–5. Marble, h. 6'9¼" (2.06 m). Museo Gregoriano Profano, Vatican Museums, Rome.

Both the recarving of the head of the emperor Domitian (fourth from left) into that of Nerva (r. AD 96–8) and the reliefs' findspot in a waste dump connected to a sculptor's workshop suggest that the panels were taken from their original setting and reworked before being discarded. The event that precipitated the recarving may have been Domitian's *damnatio memoriae*, the blotting out of his memory in portraits and inscriptions enacted in AD 96 after his assassination.

The pair of the Genius Senatus and the Genius Populi Romani (the sixth and seventh figures from the left in the foreground) are set off from the soldiers behind them by their classically idealized heads (originally with laurel wreaths), longer hair, costumes, and attributes. They represent their groups, and the contrasts are clear – age and youth, bearded and beardless, clothed and bare-chested. The pair also illustrate the rhetorical formula *senatus populusque romanus* (S.P.Q.R., the senate and the people of Rome), the official expression linking the ruling body and the ruled. They juxtapose not only venerable age with youth, but also the sophistication and refinement of the statesman with the raw vitality and virility of the next generation. The world of the Genius Senatus is that of the Forum and courts, civic authority and law, while the Genius Populi Romani bears the gifts of nature, as seen in the cornucopia, his physique, and the shoes made of wild animal skins. But it is nature under cultivation: the character of the ideal citizen will be formed by military training. It is telling that the representative of the Roman people is depicted as a healthy and strong young man, an able-bodied recruit for the army. The surrounding figures, behind and to the right, are soldiers in tunics, with shields, lances, and javelins, their officer looking back at them. Their juxtaposition with the personifications contrasts the arms of the soldier with the toga of the citizen, and suggests that the ranks and roles of the citizenry are defined in simple terms of military duty and civic responsibility, the lines of authority clearly drawn from Mars and Minerva to Domitian, then down to the *lictor*, the officer, and his soldiers, on the one hand; and on the other, from Minerva in her civic aspect to Domitian, then to the Genius Senatus and the Genius Populi Romani, represented as the flower of Roman youth, a potential soldier.

Under Domitian equestrians and new men from the provinces entered the senate, Augustan social policies were revived, and military campaigns in Germany and eastern Europe prospered. Domitian's domestic and foreign policies are thought to pale in comparison to those of Trajan (r. 98–117), who built roads, bridges, and a system to provide for poor children in Italy, and waged war on several fronts, most notably along the Danube and in the Middle East. Trajan distinguished himself as a military leader above all, but his monuments represent him as a dedicated caretaker of his people as well as a triumphant general.

Of the many elaborate monuments that Trajan erected in Italy and abroad, the Arch of Trajan at Benevento (FIG. 51) presents a wealth of imagery for the goals and ideals of his policies. The arch was erected in AD 114–8 on the route of a major road through

51. Arch of Trajan at Benevento, AD 114–8. Marble, h. 28'2½" (8.6 m).

The reliefs on the side facing the city show, below, two events from Trajan's arrival (*adventus*) in Rome in AD 99, and, above, his founding of veteran colonies (left), and building of the harbor Ostia (right). In the attic, the reliefs represent Trajan arriving in Rome after his Dacian victories (right) and the state gods assembled to greet him (left). The static, earnest, and monotonous scenes consist of the emperor standing in a prominent position amidst a group of figures arranged in rows with heads aligned at the same or lower height around and behind him.

Italy, the Via Traiana, approximately halfway from Rome to Brindisi, the port for eastern travel (see FIG. 2). The road demonstrates Trajan's commitment to public works that is also depicted on the relief panels of the arch. Each side of the arch has six relief panels (two on each pier and two in the top zone) that represent the internal policies on the side facing the city of Benevento and external policies on the country side. Each panel depicts a deity, personification, or figure with attributes to make the topic clear to the viewer: in the relief representing the veteran colonies, an allegorical figure holds a military standard with five eagles and, in the opposite relief, the scene is set by the statues of the harbor god and others with shrines near commercial districts of Rome. The pairing of military and civilian subjects implies that prosperity and well-being result from the pacification of peoples beyond the frontiers. Trajan plays a key role, engaging with his subjects whether they are needy children receiving donations, army recruits undergoing physical examinations, or a German chieftain making a treaty. In the attic reliefs on the city side, Jupiter extends his thunderbolt to Trajan, bestowing divine

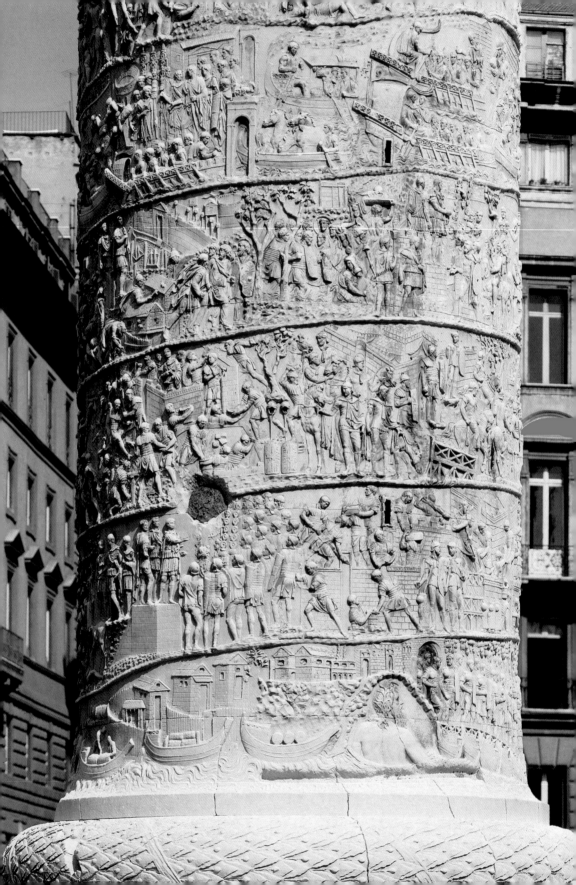

sanctions and powers – Trajan assumed the god's epithet, *optimus* (the best). In sum, the panels of both sides of the arch represent an allegory of good government effected by a devoted, paternalistic figure. Trajan's subjects are the grateful recipients of his beneficence, reflecting his decent and dutiful image with their good-natured acquiescence and deference.

Trajan's Column in Rome (FIG. 52) narrates Trajan's Dacian (Romanian) wars in the first decade of the second century in an epic frieze that spirals around the Column twenty-four times. The Column stood between the Greek and Latin Libraries in the Forum of Trajan, consisting of a large forecourt, basilica, and temple with sculptural decoration glorifying the conquests of Trajan. The frieze may have corresponded with Trajan's commentary on his Dacian wars, kept in the Latin Library. In contrast to the panels of the Arch of Trajan in Benevento that read like illustrations of a political pamphlet with tidy captions, the scénes on Trajan's Column appear dense and unwieldy with 2500 figures in all and innumerable details of soldiers' lives that are impossible for the viewer on the ground to notice. The spiral frieze also offers a portrait of the Roman army as an efficient force composed of individualized figures rendered with extraordinary care despite their regimented behavior. It has been suggested that the more mundane aspects of the subject, the setting up of camps and the routine chores, emphasize the similarities between military and civilian life for the Column's urban audience. Art historians have pointed out that the figures of Trajan appear aligned along the vertical axis of the Column, as if the emperor and general in the field form a fixed point of reference for the mass movements and complicated maneuvers around him. The repetition of the figure of Trajan may have served to slow down the relentless action, to create visual rhythms, and to assert Trajan as a commander who acts through his men and with them. So closely associated with Trajan was the grand narrative of victory that the Column culminated in a bronze statue of him (the present statue of St. Peter dates from 1588). The Column commemorating Trajan's victories also commemorated his death because his ashes were kept in the massive base.

The Great Trajanic Frieze (FIG. 53) casts a different light on the nature of the heroic ruler. Now dispersed among several sites, the panels probably came from the podium or precinct wall of the Temple of the Divine Trajan, built in the Forum of Trajan in AD 117–25 by his successor, Hadrian. Part of the frieze was reused on the Arch of Constantine in AD 312–5. The iconography derives from Hellenistic precedents, especially those depicting Alexander

52. Lower spirals of Trajan's Column, Rome, AD 113. Marble, total h. 125′ (38 m).

The 656-foot (200-m) long band winding up the column is carved in low relief that makes it difficult, if not impossible, for the viewer to distinguish most of the finely detailed figures, setting, costumes, and equipment. The frieze provides an extensive field for representing the two successive Dacian wars, with scenes of the Roman troops crossing the Danube on a pontoon bridge, building camps and fortifications, participating in sacrifices, listening to their leader's addresses, setting out on forays, and fighting battles. The scale of the undertaking depicted in the frieze is overwhelming as was the project of carving the reliefs in place on the Column. The technical achievements, the building of the Forum, and the erection of the Column – along with the victories it commemorates – attest to the Roman domination of the natural world.

53. Trajan on horseback, Great Trajanic Frieze from the Arch of Constantine, Rome, AD 117–25. Marble, h. 10′ (3 m).

With the heroic signature of a mantle sweeping back in arcs over his head, Trajan is shown on horseback trampling the enemy as he charges into battle. The conqueror mounted on a rearing steed had long been an icon of power over beasts and humans alike. To the right is a writhing, compressed mass of Dacians being beaten, begging for mercy, or reduced to decapitated heads held high by Roman soldiers. The figures, both Roman and Dacian, are aligned in dueling pairs along the diagonal and burst out of the relief in frenzied poses that describe the fury of battle and the panic of defeat. The other section indicates how the narrative is treated like a montage, disregarding sequences of time and divisions of space to create dramatic effects: the triumphant Trajan is led into the city while the battle still rages next to him.

the Great (d. 323 BC), who was revered as an empire-builder by many Romans. Rather than the leisured narrative pace and detailed coverage that give epic scope and local color to Trajan's Column, the Great Trajanic Frieze telescopes an account of the same Dacian wars into the climactic scenes of battle and victory. The high relief and deep undercutting create striking contrasts of light areas and patches of smoky shadows on the frieze's surface and depths. Such shaping of the narrative also occurs in the frieze of the Column but is less evident because of its lengthy episodic character that fills in countless details about military routine. In contrast to Trajan's supervisory role in the Column's frieze, here he alone merits glory through his heroic action as signified by his position on the rearing horse.

In the provinces the state relief depicted conquest with different inflections. Near Bridgeness in Scotland a section of the defensive Antonine Wall constructed in AD 142–5 boasted an inscription relief (FIG. 54). Called distance slabs, these works state the length of the wall constructed by each legion. On the Arch of Trajan at Benevento and Trajan's Column in Rome, the imagery dominates inscriptional plaques but here the reliefs serve as mere appendages to the inscribed text. The reliefs show battle scenes and sacrifices familiar from the repertory of the state relief, but the styles depart from the Classicism of those works. The composition of both reliefs stacks up figures on the ground line so that a position higher up on the relief surface can be read as further back in space. To a certain extent, this is seen on Trajan's Column but here the horseman appears to float over the heads of the vanquished without any reference to the ground below. Instead of the individualized heads and classically modeled figures of the state monuments in Italy, the figures of the distance slabs are roughly carved so that mouths consist of gashes, eyes are lozenge-shaped, and limbs appear tubular. Bold and deeply cut lines create a graphic effect that emphasizes the drapery folds of the figures sacrificing on the right and the prone and contorted limbs of the naked barbarians on the left (see also FIG. 30).

Elements of this style, established as the signature of the non-elite orders in Italy in the first and second centuries AD, have been seen as precursors of the changes in the Late Empire of the third and fourth centuries. The style demonstrates that local artists had long accommodated Roman art, not the imperial monuments of the capital but rather the funerary reliefs of soldiers and artisans. Rather than a debased version of Classical form, the vernacular style indicates how artists appropriated imperial themes and adapted them with a range of powerful and imaginative effects.

Other factors may also have affected the look of these reliefs: the remoteness of the border outpost and the presence of indigenous styles, suggest why the reliefs assert the Roman military presence in a simplified and abbreviated form. For instance, the features of the conquering horseman hardly differ from his enemies'. The relief appears as a rough, quick cartoon of a familiar theme, a stock subject of the state reliefs even to those in this far-off territory, in which little effort was expended on fine details. The conquest of the British Isles was a notoriously protracted affair begun under the emperor Claudius (r. 41–54) in AD 43 that required an army of occupation to quell the frequent revolts of tribal chieftains in the first and second centuries: could it be that the relief emphasizes the ferocity of Roman aggression more than the physical differences between the Roman soldiers and the indigenous population because these differences gradually ceased to exist or were no longer significant to portray by the mid-second century? Soldiers stationed in provinces for long tours of duty took local women as their wives and put down roots.

In the Italian monuments depicting Trajan's campaigns the enemy appears obviously non-Roman through clothing, gear, length of hair, facial features, or emotional expression (see FIG. 53). In the reliefs on the Antonine Wall in Scotland the enemy is defined by action rather than by a physical type, although this is not always the case in provincial works: some, in fact, accentuate the differences between citizen and outsider during periods when these categories are losing their distinctions. It is telling that in Rome's conquest and assimilation of foreign peoples the depiction of the enemy or foreigner reflects Rome's extraordinary openness to outside influence at the same time that it fiercely protected its own interests. Yet in the canonical motif of the triumphant horseman the relationship of conqueror to conquered remains constant – the elevation of the vanquishing hero above the subjugated barbarian foe.

54. Inscription relief, from the Antonine Wall, AD 142–45. Marble, 3'11¼" x 9'2" (1.2 x 2.79 m). National Museum of Antiquities of Scotland, Edinburgh.

The inscription states that the II Augusta Legion built 4,652 feet (219.78 m) of the *vallum* (defensive ramparts), which was marked by this slab. The battle scene to the left of the inscription depicts a horseman trampling four naked Caledonian barbarians, one of whom has been decapitated. The sacrifice depicted on the right celebrated the occupation of southern Scotland, which fiercely resisted pacification in AD 142 under Antoninus Pius (r. AD 138–61). The sacrificial animals are greatly reduced in size and the figures are presented frontally.

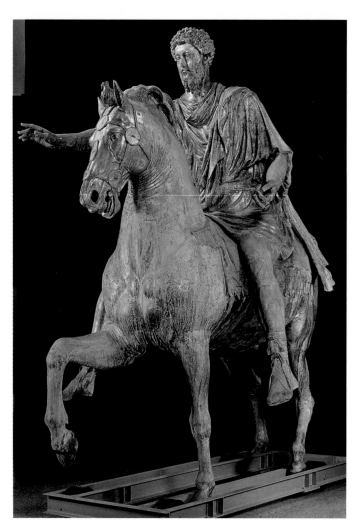

The best example of this type is a gilded bronze sculpture in the round, the equestrian statue (FIG. 55) of the emperor Marcus Aurelius (r. AD 161–80). It has survived because Romans in the Middle Ages and Renaissance assumed that it portrayed Constantine, the first Christian emperor (r. 307–37), and it was spared the punishment meted out to images of the pagans. From its setting in front of the Lateran Basilica it was moved to the Capitoline hill in 1528 where it formed the centerpiece of the piazza that Michelangelo designed. In its ancient context the statue stood at a time in the second half of the second century AD when the Empire was plagued by war on the frontiers in Britain, Germany, and the Middle East, in campaigns that were less offensive than defensive and signaled that the costs of maintaining the Empire were becoming increasingly burdensome. The imposing statue makes the claim that all Marcus Aurelius needed to do was to extend his right hand to make the enemy lay down its arms, yet reality proved resistant to this radiant vision of masterful and effortless conquest. Marcus died at the front near the Danube in AD 180, aware that the once indomitable Empire was vulnerable.

The portrait head shows his strong features set off by a wreath of tightly curled hair and a full beard. The beard, associated with portraits of philosophers or intellectuals, and the penetrating gaze bring to mind that Marcus was not only a man of action but also the author of the *Meditations*, a work of Stoic philosophy written in Greek. The equestrian statue exhibits the sense of gravity and responsibility of an enlightened emperor. The

image of the triumphant horseman riding over his enemies could bear a range of meaning, but as an icon of imperial power it succeeds through a simple formula of inequality by contrasting the posture of the erect rider to that of the prone barbarian, that is, by raising the strong man over the backs of the weak.

The generic character of the state reliefs decorating public monuments and buildings in Roman cities offers evidence of the wide distribution of motifs and the standardization of imperial imagery throughout the Empire. We do not know what citizens thought of these works or, indeed, if residents merely acknowledged the presence of yet another relief or statue bearing a message of imperial authority and moved on. For those who stopped to look at these works, the message may have been one that embraced them as, for example, the soldiers who appear as industrious workers on the frieze of Trajan's Column or the citizens receiving aid for their children on the Arch of Trajan at Benevento. Even the most brutal image of imperial chauvinism, the rampant horse with rider in the relief from the Antonine Wall, assumes that the attentive viewer identified with the victor and, in doing so, partook of a well-ordered society in which nearly constant warfare was deemed necessary and normal, as long as it consisted of border skirmishes on the frontier carried out by a professional army.

The Roman city, after all, was one in which it was desirable to live. The quality of life, as we would call it, was achieved in part by having the rich donate buildings and shows for the public's benefit. The competitive system this established, in which the only way an ambitious man could acquire political capital was by spending his fortune on civic improvements, created many smaller cities that boasted fine amenities, such as elegant colonnaded avenues, circuses with the latest technology, and splendid baths. Although the public spaces of cities were stages for the elite to demonstrate their privileges, the less influential and the poor were not excluded from the city centers, the shows, or games. This civic-mindedness had nothing to do with democracy but it did provide for a richly textured street life, full of sights and sounds that provoked intense curiosity, desire, and jealousy, in front of backdrops of inestimable grandeur and stateliness.

55. Equestrian statue of Marcus Aurelius, AD 176. Gilded bronze, h. 11′6″ (3.5 m). Capitoline Museums, Rome.

Marcus Aurelius sits on a massive restless horse, which was originally striding over a figure of a fallen barbarian under its raised right hoof. The animal's nervous energy as seen in its arched neck, ears pricked forward, and open mouth chomping at the bit contrasts with the aloof majesty of the emperor reining in his mount and gesturing with his right hand that the battle is over and that the defeated will be treated mercifully. The statue now stands inside the Museum, but a lifesize copy will take its place in the center of the piazza on the Capitoline hill.

THREE

Portraiture and Commemoration

56. *Herm* portrait of a charioteer, AD 54–68. Marble, h. of bust 15" (38 cm), h. of *herm* 34¼" (87 cm). Museo Nazionale Romano, Rome.

The charioteer sports Neronian features in the ears jutting out from the head, the hair combed down over the forehead, curling slightly at the ends, and the chiseling of the nose. These similarities are only loosely drawn because the head also has a wide cranium, eyes set closer together, and a square jaw with less full cheeks than many of the imperial portraits. The head is carved in white Luna marble while the *herm* is of *bigio antico* marble, a dark gray stone flecked with white and gray veins.

P ortraiture is central to any study of Roman art. The corpus of Roman portraits abounds with dynasts, emperors, and statesmen whose names are synonymous with the history of the Republic and Empire, but there are innumerable other portraits of nameless individuals who are absent from the historical record. The prevalence of the portrait in its many forms (carved heads, busts, full-length statues, reliefs, and the profiles on coins or carved gemstones) suggests its function as a means to establish or maintain identity throughout Roman society. From the throngs of portraits of emperors cluttering fora and theaters to the sober and earnest reliefs on the facades of freedmen's tombs lining the roads to cities, marble or bronze images of the elite and less distinguished citizenry were ubiquitous.

Commissioning and erecting a portrait was a serious political act. To be awarded a portrait erected in the city center at public expense would mark the culmination of a career studded with civic honors and achievements carried out under intense scrutiny and in keen competition. The portraits for citizens who are nameless or left no mark in the historical annals were also motivated by political and social forces, such as the desire for recognition or pride in acquiring wealth or status. As the fictional freedman Trimalchio knows, in Petronius's novel, *Satyricon* (mid-first century AD), one of the signs of having arrived in society was the care taken to erect a proper funerary monument, planned well in advance: the hopelessly vulgar yet irrepressible Trimalchio reads his will to his stunned dinner guests and describes his monument, complete with images of himself in his official role as priest in the imperial cult, doling out money to the townspeople. Trimalchio aspires to be represented as a great man, a political player in his town, even if the effects are ludicrous (FIG. 57).

57. Funerary relief of
Lusius Storax, AD 41–46.
Limestone, 24 x 44¾″ (61
x 114 cm). Museo
Nazionale, Chieti.

The freedman Gaius Lucius
Storax, like the fictional
Trimalchio, served as a
priest in the college
dedicated to Augustus.
Reveling in self-importance
brought on by his quasi-
official position, Storax is
seated in the center of the
tribunal in larger scale than
the other magistrates and
toga-clad figures, gathered
in the forum of their town.

Other citizens, who lived simply in comparison to Trimalchio's standards of extravagance, kept portraits in their houses or tombs to keep alive their family history, to honor or demonstrate *pietas* to their relatives, or simply to proclaim that they could afford the elite marble busts. Although not every private portrait is funerary, the rituals for the dead indicate the importance of erecting a monument and maintaining the images of the deceased in order to preserve memory. By ordering a portrait of his deceased wife, for example, a husband fulfilled obligations and discharged duties owed to the dead, not to mention any that demonstrated love and grief. This, too, can be termed a public and political act, and will be discussed later in this chapter.

We know little about how portraits were commissioned, except for a few stray comments in ancient sources, although most of these are for rhetorical effect: when Pliny the Younger in the late first century AD writes to the parents of a young man whom he has eulogized to ask their opinion of his speech, he states "if a sculptor or painter were working on a portrait of your son, you would indicate to him which features to bring out or correct; so you must give me guidance and direction as I, too, am trying to create a likeness which shall not be short-lived and ephemeral, but one you think will last for ever" (*Epistles*, 3.10). For the artist, the goal of creating a likeness can be achieved by rendering features observed from life or by drawing on the memory of witnesses. But the goal was tempered by other concerns, such as the necessity for propriety and conveying the imperial majesty or moral convictions suitable for an individual's social role.

A funerary altar from the early second century AD may depict an exchange between a sculptor and his patron (FIG. 58). Works of art were made to order for the patron rather than produced by the artist on speculation. Exceptions to this are some types of funerary sculpture, notably sarcophagi and perhaps some altars, that were partly carved at marble quarries and in workshops with the expectation that they would find a purchaser. The customer who bought them could have portrait features added to the unfinished heads or busts on the reliefs when the deal was struck.

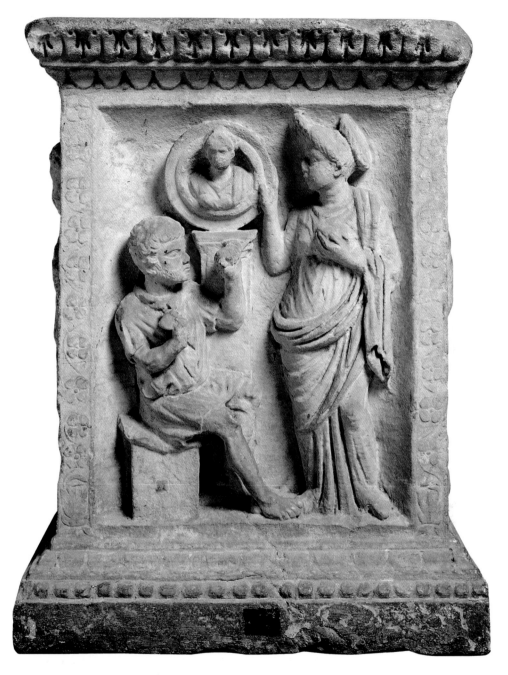

58. Funerary altar with sculptor and patron, early second century AD. Marble, 28½ x 21½" (72 x 55 cm).
Galleria dei Candelabri, Vatican Museums.

The seated sculptor is shown with chisel and mallet putting finishing touches to the portrait medallion on the
pedestal. His patron, the woman wearing a tall, tiered coiffure fashionable at the time, gazes at the portrait that
may commemorate a daughter who died young. The sculptor's short tunic and bare feet contrast with the
matron's long and substantial garments, signs of her respectability.

The sculptors, a few of whom are known by signatures, were men of the lower orders and some came from the Greek east; they had the status of craftworkers who used traditional methods in more or less conventional formats to realize the objectives of patrons. Originality and creativity were not their goals.

High and Low

The question of the portrait's likeness to the individual it depicts has long dominated the study of Roman portraiture. It is easy to conclude that most Roman portraits express distinct personalities from the sense of immediacy and the visceral qualities of the carving. Emperors can be identified in standard portrait types in multiple copies and in coin portraits with legends including names and titles; interpretation often depends on the ancient written sources. The anonymous portrait without inscription poses different problems of interpretation. Portraits of private citizens are usually compared in style and quality to imperial portraits because it is thought that they tend to imitate them, although there are examples that resist classification because they are stubbornly independent of elite models in Rome and abroad (see FIGS 24 and 30). The works that reveal a world apart from the court have been seen by scholars as second-rate or inadequate at best; they are explained as the work of inferior artists commissioned by patrons with questionable taste and meager funds. Yet these charges are often unfounded. First, a few words about the identification and interpretation of portraits of emperors, and then a comparative look at portraits of people from different social ranks.

There have been two approaches to the portraiture of imperial subjects. In the first, the portrait is treated as a historical document that illustrates the biography of the celebrated personage. This rests on the assumption that the portrait represents the subject faithfully or consistently and, clearly, many portraits of emperors are easy to recognize because of the standardized features – for example, in the telltale hairstyle and the lean, bony face of Augustus (see FIG. 15).

Some imperial portraits, however, do not so readily reveal their identities, even to the ancient viewer: Arrian, the governor of Cappadocia (eastern Turkey and northern Iran) in AD 130–37, came across a statue of Hadrian that looked nothing like the emperor and was not even handsome (FIG. 59). In a letter to Marcus Aurelius, the orator Fronto (AD 100–66) complains that the portraits of the young emperor displayed everywhere in Rome in windows, shops, and taverns are poor in quality and lacking in resem-

blance. The ancient accounts imply that imperial portraits ought to resemble, if not ennoble, their subjects. Perhaps the overwhelming demand for such portraits led to inferior production and shoddy work in Rome as well as the distant provinces. Both Arrian and Fronto were well aware of whom the second-rate portraits represented; the context, scale or inscriptions on the bases would have alerted them to the identity of the subject if there had been doubts. Likeness and quality were the problems.

The second approach considers how bureaucrats and sculptors ensured that the images of the emperor conformed to certain standards and were recognizable. Although there is no archaeological evidence of the imperial workshops, scholars have assumed that specific portraits became prototypes from which copies were made in Rome and distributed to the Empire where, in turn, they served as models for local sculptors to produce additional copies. Inherently more technical than the interpretive first approach, this method focuses on what seem to be insignificant details (such as the number and arrangement of locks over the forehead) but which allow scholars to trace a replica back to the prototype. These details signal recognition of an imperial portrait even if the replica bears only a distant resemblance to portraits in the capital. The portraits, then, have less to do with the likeness of the emperor, although recognition was always their aim, than with the process of crafting and controlling the imperial image.

In the late first century BC, the portraiture of Augustus instituted a completely new type of image with its combination of ageless features and Classical gloss. The emperors who succeeded Augustus in the Julio-Claudian dynasty conformed to the model by representing themselves with tepid or stock Classical features and versions of the Augustan hairstyle with its characteristic fringe. Of all these

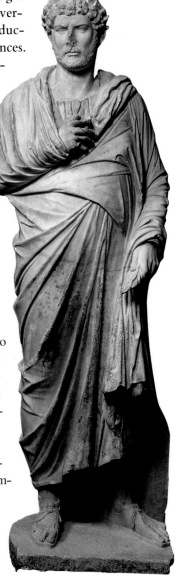

59. Statue of Hadrian from the Temple of Apollo in Cyrene, north Africa, AD 117. Marble. British Museum, London.

Hadrian is depicted wearing Greek dress, the *pallium*, rather than the traditional toga, and is crowned with a pine wreath to signify victory in the Isthmian Games. Characterized as the "Greekling," Hadrian is shown here as an enthusiast of Hellenic culture, also witnessed in his travels to the Greek east and his passion for the arts (he built the Pantheon in Rome and the famous Villa at Tivoli). Although this is not the statue to which Arrian referred, it depicts Hadrian as middle-aged, soft in the middle, and cerebral in the manner of philosopher portraits. It could very well appear unattractive to those expecting the emperor to be portrayed with a powerful physique and robust presence. The head has been reworked but Hadrian's characteristic features are clearly visible.

60. Relief of Nero being crowned by Agrippina, from the Sebasteion complex, Aphrodisias, Turkey, mid-first century AD. Marble, h. 5'3" (1.6 m).

The relief formed part of a series decorating the Sebasteion (from Sebastos, the Greek equivalent of the Latin Augustus), a complex consisting of a propylon (monumental gate), two facing porticoes forming a processional avenue between them and a temple. The young Nero in military breastplate is being crowned with a laurel wreath by his mother, Agrippina the younger. The scene sets out the dynastic sequence granting legitimacy to Nero: Agrippina, great-granddaughter of Augustus and the fourth wife of Claudius, had Claudius adopt Nero (her son by a previous marriage) to succeed him, harbored excessive and unbecoming ambition, and was murdered on her son's orders in AD 59. The relief probably dates to early in Nero's reign when he was still under his mother's influence.

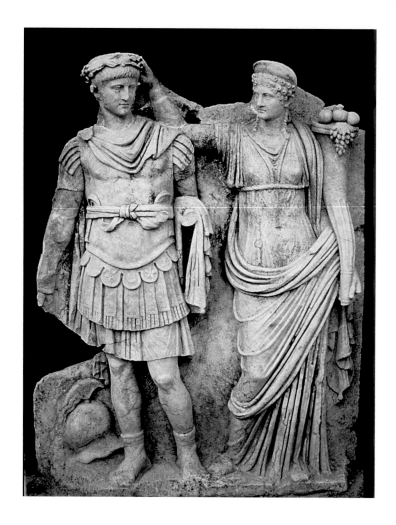

emperors, Nero presents an interesting case because his reputation as a cultivated but monstrous absolutist is thought to have informed his portraiture (FIG. 60). His excesses brought down the Julio-Claudian line, and he committed suicide when faced with the revolt of the army and his supporters in AD 68.

In the coinage a personification typically grants the emperor a crown: in a relief of Nero and his mother Agrippina the younger, from Aphrodisias in Turkey, it is unusual that Agrippina bears the cornucopia of Fortuna, the personification of prosperity and good tidings. The head's oval face, smooth and clean contours, and full chin bear the Classicism appropriate both for a member of the imperial family and for the depiction of personifications – the Classical features allow the subject to be easily assimilated to a personification or deity. The characteristic hairstyles – the corkscrew curls framing Agrippina's face, the hair combed forward on the

forehead and parted slightly in the center for Nero – lend recognition, while the features create idealized images of the imperial elite in Rome. The fleshiness of Nero's later portraits, interpreted as a sign of his maturity and subsequent degeneracy, is not depicted in this image of the youth under his mother's tutelage, whose bloodlines are the source of his inestimable assurance and command.

The relationship between imperial and private portraiture in the mid-first century AD can be observed in a series of seven portraits of charioteers erected in a shrine of Hercules in Rome. The portrait heads (see FIG. 56) were placed on *herms* as dedications by victorious athletes to their patron god, the superhumanly strong Hercules. One athlete is shown with some of Nero's features, but Neronian classicism only serves as a filter through which individual features are interpreted, so some features (ears, hairstyle) imitate the imperial types, while others are more independent from them. The portrait *herm* depicts a youngish man whose firm and fixed square jaw, slightly distended on one side, with a sturdy and muscular neck, projects toughness and resolve. It did not have to conform to the higher standards of perfection in imperial portraiture.

The slight swelling of the left jaw deserves comment. One could attribute this to a second-rate sculptor but the charioteer and his colleagues could have afforded better with their increased popularity and earnings in this period. It is probably not a coincidence that six of the seven portraits in the shrine exhibit such irregularities. Perhaps they did not mar the image of the successful charioteer: imperfections could have been marks of honor, evidence of his boldness and aggression on the racetrack. So the jaw may have been exaggerated by the sculptor for effect. In other words, a different aesthetics would have been at work here.

The charioteer's *herm* demonstrates that imperial or prestigious portrait types or formats were applicable to ordinary citizens, but the scale, medium, or location of the statue would differ. Statues of figures in togas, the dress uniform of the participating citizen, were always popular with patrons from different social groups (see FIG. 15). Two togate statues from the west and east inform us of the expressive range of the type. The western statue (FIG. 61), dated to the reign of Claudius (AD 41–54), was erected in the sanctuary of Diana at Lake Nemi south of Rome. The statue is inscribed twice, once on the base and once on the container near the foot, with the name of the subject, C. Fundilius Doctus, and his profession as an actor. The attitude toward actors in Rome was one of suspicion or even outright scorn.

Not only were they from the lower social orders but since they flaunted their bodies in compromising positions on stage and demonstrated no integrity – they were paid to make spectacles of themselves – actors were considered little better than prostitutes. Fundilius Doctus was probably a freedman of an aristocratic woman, Fundilia C. F. Rufa, for whom he erected a portrait statue and *herm*, both of which were found nearby in the sanctuary. Yet Fundilius Doctus is shown as a man of dignity and integrity. In the figure itself there is nothing to point out the actor – he could pass for a magistrate or local benefactor of the cult. The statue attests to the appeal of standard types and their ability to establish conformity among subjects of diverse social backgrounds. Even a figure in a sordid and lowly profession (according to the elite point of view) could be honored in this manner.

The eastern statue (FIG. 62) creates a completely different effect. The over life-size figure of a young man,

61. Statue of C. Fundilius Doctus, from Lake Nemi, south of Rome, mid-first century AD. Marble, h. 6′ (1.83 m), incl. base. Ny Carlsberg Glyptotek, Copenhagen.

In the inscription Doctus is described as *parasitus Apollinis*, or player of the fourth part, the parasite, in Roman comedy with its stock characters and plots. The long, full-bodied toga, its folds looping in arcs across the relaxed leg, lends the figure respectability. The arms, missing from the elbows down, would have been posed in the act of sacrifice. The head depicts a man in late middle age with a grave and alert demeanor. The eyes are cast in shadow from the raised, tense brows, and the mouth is firmly set, with the loose flesh of middle age observed in the lines from the nostrils and corners of the mouth. The cap of hair combed over the forehead is a familiar style, but the subject's concentration implied by the tension at the brow and mouth, create the effect of an engaged but wary presence.

which adorned the Agora Gate of Aphrodisias in the mid-second century AD, probably represented the son of a leading family of the city. Far from being a provincial backwater, Aphrodisias was a cosmopolitan city with close connections to Rome and a center of intellectual and cultural life in Asia Minor. The erection of the statue in such a prominent civic context indicated the high prestige and honor given to the young man it portrayed. Membership of the equestrian order is indicated by the figure's boot and ring. The scroll in his left hand alludes to the law and letters, the education in declamation and rhetoric given to aristocratic youths preparing for political careers. In this period, the scroll may also evoke the traveling Sophists, such as Polemon (AD 88–144) of Smyrna (modern Izmir, west coast of Turkey), whose verbal pyrotechnics not only drew crowds but also earned them wealth, priesthoods, and friendships with emperors. This togatus bears the marks of the sculptor's style more clearly than the western statue – his preference for animated surfaces, linear patterns, and bodies that barely contain their bulk beneath drapery.

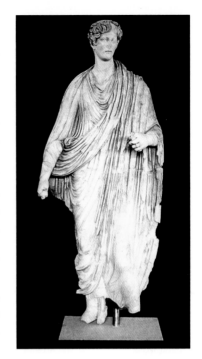

62. Statue of young man in a toga, mid-second century AD. Marble, 7' (2.15 m). Aphrodisias Museum, Turkey.

The figure originally stood in a niche in the Agora Gate at Aphrodisias, keeping illustrious company with statues of the emperors Nerva, Hadrian, and Antoninus Pius. A richly textured toga is arrayed over the left shoulder in deeply undercut folds, creating patterns of light and dark on the surface. The sculptor also aimed for a plastic treatment of the hair with deeply carved curls piled on top of the head. The head, set at an angle from the body, depicts an aristocratic character with high cheekbones, long chin, and a smooth, unmarked complexion.

Modesty and Adornment

Female portraiture too had its stock types and diversity. Models for portraits of empresses are also thought to have been sent out from Rome for copying in the provinces, and replica series for some of the imperial women have been classified, although fewer than those representing the emperors. The first imperial consort, Livia, the wife of Augustus, figured prominently as the *princeps femina* (female leader) in the programs to refashion imperial society. She is presented as an idealized image of womanhood, a counterpart to the ever-youthful and charismatic portraits of her husband. Augustus granted Livia exceptional privileges, including the display of her portraits in public. She was also the patron of various architectural projects, such as the Porticus Liviae with its shrine to Concordia, the virtue of civic and domestic harmony. In Augustus's call to reinvigorate the morals of Romans, private life was inextricably bound up with public duties and civic responsibility. In a portrait statue dated to AD 14–37, the seated figure of the first lady of the empire is heavily draped (FIG. 63). Her covered head indicates her piety. The heavy mantle and tunic, articulated in thick, deeply undercut folds, emphasizes a fully developed femininity with its ample hips and bosom. The head is clearly recognizable as a portrait of Livia with its Classical

features of simple oval contours, widely spaced almond-shaped eyes, and smooth mask-like complexion. The hair is parted in the middle and sectioned off into rows of neatly crimped ridges, a style worn from Hellenistic through imperial times, and there are attachments for a metal diadem. The dowager empress is an aloof, authoritative, and quasi-divine figure, whose role as an exemplary matron raised her out of ordinary womanhood to the status of an icon of the new imperial order.

Aspects of the portraiture of Livia influenced the imagery of subsequent imperial women, as in the face of Agrippina at Aphrodisias (see FIG. 60). The portraiture of private women in the first century AD emulated the imperial model but without wholesale copying. Many private patrons had two, occasionally conflicting, aims in commissioning portraits – to acquire a recognizable image and an affinity with the ruling house. Adornment, such as hairstyles, allowed them to demonstrate their familiarity with imperial imagery while also portraying themselves with their own facial features. Court hairstyles are frequently the only clues to an approximate date for portraits of anonymous subjects without archaeological contexts.

In the late first century AD the women of the Flavian court (AD 69–96) were depicted with showy and sumptuous hairstyles consisting of a large wreath of ringlets framing the face and a chignon at the back of the head. Portraits of women unaffiliated with the court also displayed this hairstyle, and perhaps the imperial women initiated styles that were copied by women of lesser social rank, both in Rome and the provinces (FIG. 64). Not only did they copy aspects of imperial portraits, they also adapted hairstyles and invented new ones. It is not clear, however, that fashion, as we define the phenomenon, is behind the appeal of certain styles. Instead, a cultivated appearance implied socially approved standards of refinement, dignity, and integrity. Habits of dress and adornment signaled rank and status along with character and moral worth (FIG. 65).

In the first century BC toward the end of the Roman conquest of the Iberian peninsula, Hellenistic Emporiae (modern Ampurias), a thriving port north of Barcelona, attracted merchants and businessmen, along with a military contingent and a corps of administrators that initiated the process of Romanization among the indigenous and Greek population. By AD 100, the local elite women were displaying the stately Flavian hairstyle, while the men pursued careers that typically began with the municipal council, then a prestigious priesthood in the imperial cult, and, finally, membership in the equestrian order, which could lead to posts in the

63. Statue of Livia from Paestum, south Italy, AD 14–37. Marble, h. 69½" (1.77 m). Museo Arqueologico Nacional, Madrid.

The statue was originally paired with one of Tiberius, Livia's son and Augustus's successor, posed like statues of Jupiter enthroned. The pairing of mother and son, both probably originally holding scepters, asserts Livia's line in the imperial succession.

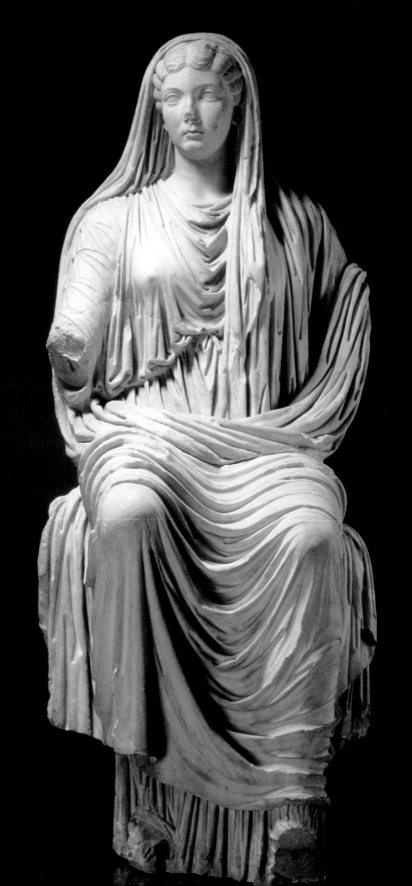

64. Head of a Flavian woman, from Emporiae (modern Ampurias), north of Barcelona, late first century AD. Bronze, eyes inlaid with enamel, h. 15″ (38 cm). Museo Arqueologico, Barcelona.

The expensive bronze has been cast into an image of a still youthful woman with large, simplified features – a long neck, large almond-shaped enamel eyes, and a strong nose with large nostrils. The depiction of the Flavian court hairstyle, however, required different textures for the ringlets in the front and the fine braids twisted in a chignon in the back. The profile view shows the architectonic character of the coiffure best, with the bonnet-like peak over the forehead balanced by the wide nest of braids at the back. This subject demonstrates the rigors of grooming and the expense required to maintain a cultivated appearance that establishes membership in an exclusive order.

imperial administration in Rome. The capital drew ambitious men, intellectuals as well as politicians, whose provincial background did not hinder their rise: the families of the emperors Trajan and Hadrian came from Spain, as did the poet Martial and the rhetoricians Seneca the Elder (c. 55 BC–c. AD 40) and Quintilian (fl. AD 60–90). Pliny the Younger illustrates the connections linking the capital and the provinces in a letter recommending a close friend from Spain: "his father was distinguished in the equestrian order… his mother comes from a leading family. He himself recently held a priesthood in Hispania Citerior [the coastal and northern region], a province well known to you for its high principles and good judgement… In addition, the letters he writes would make one believe that the Muses speak Latin" (*Epistles*, 2.13). Public office-holding, high birth, moral character, and eloquence in Latin were the requisites for the elite in the provinces as in Rome.

Another provincial work comes from Milreu (Faro) in Portugal (FIG. 66). The marble head is carved with subtlety, rendering handsome and strong features – large eyes in crisply contoured lids, high cheekbones, and rather long chin. The subject appears in the prime of life, of marriageable age but not yet old, and her reserve and complete composure exude a sense of command. These expressions, also common to female heads in Rome of the previous twenty years, do not reflect the psychological interior but, rather, are determined by the code of behavior demanded of the *materfamilias*: dedication to the supervision of her household and to bearing and raising children, and the exercise of strict self-control at all times, whether presiding at a dinner party with her husband or serving as a priestess in a state cult. It is this last role that the portrait particularly expresses.

Some affluent women constructed their elaborate coiffures with wigs, as the poets attest: "a woman walks beneath a burden of purchased tresses, and money buys new locks for old" (Ovid, *Ars Amatoria* 3.165–66). Art imitates life: some portraits exhibit marble, detachable hairpieces, which sit on top of the head like turbans or diadems, the insignia of a priestess or empress (even

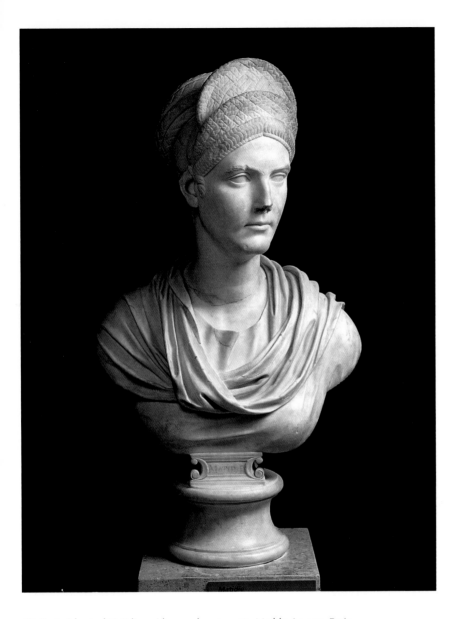

65. Portrait bust of Matidia, mid-second century AD. Marble. Louvre, Paris.

Matidia (AD ?68–119), a niece of Trajan and mother of Hadrian's wife Sabina, was honored by the title Augusta in AD 112 and upon her death was eulogized by Hadrian, deified by the emperor and commemorated with a temple dedicated to her memory and that of her mother, Marciana. Her meticulous coiffure consists of plaited sections of hair (probably hairpieces) arranged like tiaras or fans in steps over her forehead, as if to give the illusion of more substantial or exotic ornaments. This outstanding concoction demands scrutiny, while the stern demeanor seems to repel unwarranted attention. The downturned mouth and furrowed brow portray Matidia as the exemplary matron, dour, resolute, and not susceptible to frivolity or extravagance. The plain face suggests that the coiffure also preserves her modesty: it regulates wayward, undisciplined locks into an orderly, architectonic structure.

66. Portrait head of a woman from Milreu (Faro), Portugal, AD 117–25. Marble, h. 11½" (29 cm). Museu Nacional de Arqueologia e Etnologia, Lisbon.

Rising above the woman's forehead like a diadem, the peak of the complicated coiffure formed from loosely braided hair resembles nothing more than chains, except for the thin bands threaded through them (perhaps originally painted to contrast with the hair). The rows of braids part in the center below the peak. The rest of the hair is tightly wrapped in fine braids around the back of the head. Unlike Flavian court coiffure, this is innovative in its details and may indicate some independence from court styles.

if not carved separately for the portraits, many of the elaborate coiffures would have had to be achieved by wigs). By covering the real hair of the subject, they either preserved her modesty or attracted attention to the complex arrangements of tresses that were not her own. The natural substance of hair was transformed to beautify or empower the subject: in life through the labor of hairdressers, slaves, and maids; in art through the skills of the sculptor and desires of the patron.

Besides the evocation of virtue, ideals of beauty, and notions of fashion, the age of the person depicted often enters the discussion. Yet it is difficult to assign an age on the basis of the carved features alone. Art historians have been quick to call the faces of men or women "old" if they bear a few engraved lines around their mouths or eyes, but middle and old age may have looked rather different in ancient Rome. The average life expectancy of twenty-eight years seems grim, but it means that many Romans died in infancy or childhood and some in adolescence. For men, youthful fatalities occurred in military exercises and campaigns; for women, marriage and motherhood in their teens through early twenties took lives and shortened others; those who reached adulthood had good chances of surviving to a ripe old age, although far fewer than in contemporary industrialized societies.

The subjectivity of portraiture, whether seen in the eternally youthful depictions of Augustus and Livia or in the images of young Romans who look old for their years, seems at odds with the goal of creating a likeness of an individual. Rendering the subject's age – as if numerical age could ever be shown in a schema of wrinkles, crow's feet, and frown lines – was undermined by more important projects, for example, demonstrating the godlike physical powers of an emperor or suggesting the appearance of the subject's potential, particularly in representations of precocious youths who died before coming of age.

That capturing a likeness of the subject was only one aspect of a portrait (and perhaps not always the most crucial) is apparent in the genre of the mythological portrait (FIG. 67). This genre consisted of an individualized portrait head on an ideal body borrowed from Greek statuary representing gods or heroes. Such portraits, frequently commemorating deceased men and women, ennobled their subjects through comparison with a divinity. The assumption of divine identity implied a masquerade, not to signify a miraculous apotheosis but a disguise earned by the very mortal efforts of daily life. Deities were chosen according to the gender, stage of life, or career of the subject: thus, men could assume the role of Hercules, girls Diana, businessmen Mercury.

67. Portrait statue of a girl as Diana from Ostia, mid-first century AD. Marble, h. 4'10½" (1.49 m). Museo Nazionale Romano, Rome.

In this statue, most likely from a tomb in Ostia, a girl is portrayed at a pivotal stage of life in the guise of the goddess Diana, the virgin huntress. The portrait head expresses alertness, with the head on its long neck turned slightly to the left. It has large eyes set far apart, a high-bridged nose, and full, parted lips. The combination of girlish and womanly features – large eyes of a child but a mature facial structure – suggest transition from youth to maturity. Even the hairstyle, combed from the center and gathered in a bun in the back, mixes idealization and specificity. She wears Diana's hunting gear of a short, double-belted tunic, high boots, and a dog at her side (partly visible). The right arm is raised to pluck an arrow from the quiver strapped to the back; the opposite leg is flexed in vigilance, ready to hunt the prey. The portrait statue offers an image of youth, grace, and beauty appropriate for the memory of a girl who died young.

The ancient sources and archaeological evidence indicate the social context of many of these works: freedmen and freedwomen tended to commission mythological portraits of themselves in imitation, it is thought, of the practice of their social superiors.

The elegant and refined carving of some of the mythological portraits has led scholars to assume that they represent imperial personages rather than anonymous subjects of less distinguished ranks, as is the case in two exceptional statues (see FIG. 67 and FIG. 68). The identification of a girl with the virgin goddess Diana honors the girl's virtue, but also shows that she will never marry or become a mother, the culminating experiences of a woman's life. Yet, as a model for girls in transition, Diana is inappropriate with her masculine demeanor and her passion for the chase that exempts her from the duties of domesticity and the yoke of marriage. Instead, the maiden goddess exhibits the premier male qualities of courage, valor, and excellence, that is, *virtus*, that were demanded of statesmen and warriors. Perhaps girls who died young without the traditional repertory of feminine accomplishments (fidelity to a husband, children, tireless devotion to domestic tasks) were represented as bold and aggressive bearers of *virtus*, and their assumption of the goddess's identity brought them glory.

68. Portrait statue of a woman as Venus, AD 130–40. Marble, h. 6'½" (1.84 m). Museo Nazionale Archeologico, Naples.

The statue borrows from the well-known type of the Capitoline Venus (a Hellenistic work) in its pose. The hands at the breast and genitals, ostensibly in modesty, draw attention to precisely the parts that require covering. The mature figure appears fleshy with full, rounded forms, firm breasts, solid thighs and a deeply dimpled navel, erotic features that also suggest her reproductive capacity. The portrait head maintains a sense of composure and reserve, however, very much unlike the beckoning attitudes of nude or scantily clad seductresses. The woman is shown as mature but not old, with a strong nose, broad jaw, and large chin. With creases under the eyes that are set slightly too close, the face is plain. The coiffure, on the other hand, is exceptionally ornate, with crimped hair fanning out over the forehead and a plume-like extension of curls in the center that overlaps a large, braided turban on top of the head. Both elegant hairstyle and goddess's body imply that the subject is cultivated, sophisticated.

In the late first and second centuries AD women were honored by the mythological portrait in greater numbers than before; and of all the goddesses whose identities could have been assumed, Venus provides the most provocative and startling examples because of the complete or partial nudity (see FIG. 68). The female nude statue was a contradictory and complex category for Roman citizens who expected chastity and rigid standards of conduct from the stern women who were praised as their wives and daughters. Full frontal nudity did not shock because it was recognized as a convention of art that brought prestige to the husband who might erect such a work to commemorate his beloved wife. The nude Venus may also be shown bathing, with a tall water container and drapery by her side. Not only does bathing provide an excuse for the nudity, but it also summons the feminine arts of adornment, Venus's transformative ritual with ointments, perfumes, incense. The nudity is then acceptable because it evokes the ideals of cultivation and refinement represented by the perfect physique of the goddess and her beautifying bath. Rather than meriting censure for the lewdness, vanity, or luxury that moralists decried, these statues may have brought approval and acclaim to a matron and her husband as displays of feminine glory, perhaps a counterpart to the male honors of political office or military prowess.

Heroic Modes

The male nude in Roman art is another category entirely. It radiated the heroism of mythological figures and the divinity of the immortals through a strapping, well-honed physique. Many of the massive or monumental figures display a musculature that is hard and taut over the soft organs and inflated over other sections of the body. Without the ambivalent eroticism and modesty of the nude Venus, the male counterpart appears active and aggressive in its full frontal nudity. As in the nude Venus portraits, the body seems "clothed" by the borrowed physique.

That the male nude exudes a confidence in the personal agency of the heroic leader and bears the weight of the Classical tradition is evidenced in a colossal bronze figure (FIG. 69), a rarity from the late Empire. It is thought to depict the emperor Trebonianus Gallus (r. 251–3), a military man who ruled briefly amidst the plague, the erosion of central authority in Rome, and the breakdown of common cultural standards. The distortion plainly visible in the figure could be attributed to a decline in artistic skills in the capital as in other regions of the Empire at this period. How-

ever, the head succeeds in rendering a tough, brutish leader with a bulging, prominent brow and thick nose. The hair and beard cropped close, a characteristic of portraits of soldier emperors in the third century, also adds to the image of a hardened, uncompromising military man. The difference in treatment and scale between the head and the body may have been calculated: the distended body supplied extra bulk signifying an overbearing physical power. That this weight is unevenly applied to the figure indicates how distant the Classical model has become and how authority took on a gross and uncouth form in these times of extreme measures.

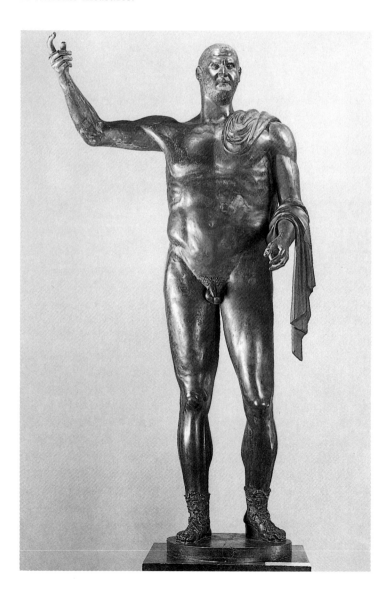

69. Colossal nude statue of the emperor Trebonianus Gallus, from Rome, AD 251–53. Bronze, h. 8'1" (2.46 m). The Metropolitan Museum of Art, New York.

The figure seems to be cobbled together of parts that do not compose a whole: the head is too small for the body, the torso is grossly inflated, and the thighs reach massive proportions. The musculature is rather like surplus padding, swelling the figure sideways through the middle and at the thighs.

70. Portrait of the emperor Commodus as Hercules, c. AD 191–2. Marble and alabaster (base), h. 3'10½" (1.18 m). Capitoline Museums, Palazzo dei Conservatori, Rome.

The half-length portrait of superb quality depicts the emperor wearing the lionskin of Hercules and carrying the hero's club in one hand and the golden apples of the Hesperides in the other. The golden apples were the object of the last of Hercules's twelve labors, the one that secured him the immortality of the gods. The extended bust is supported by an elaborate base with motifs evoking Commodus's triumph over the enemies of civilization and his maintenance of peace and prosperity—an Amazon shield flanked by two entwined cornucopiae; below, an orb and a kneeling Amazon. The barebreasted Amazons, the fierce women warriors of Greek mythology whom Hercules fought as one of his labors, represent conquered barbarian enemies at the edges of the Empire.

Portraiture gave vent to imperial ambitions and allowed emperors to make extravagant claims for themselves by manipulating heroic and divine attributes. One of the more theatrical works of this nature is the portrait of Commodus as Hercules (FIG. 70). The ancient sources report that Commodus (r. 180–92), the son of Marcus Aurelius, governed in a despotic fashion and harbored notions of his own divinity, which he demonstrated costumed as the god in public in the street and arena. Commodus may have valued Hercules not only as a superhero of inestimable strength but also as a hero of culture, the tamer of wild things and supporter of the natural order of men and gods. Historians have made much of the accounts of Commodus's excesses and oddities (his desire to appear in the arena as a gladiator) but the charges of imperial arrogance and megalomania (along with a passion for the theatrical) were commonly leveled against those emperors whom the ancient historians despised. Nothing in the mythological portrait warrants an indictment of Commodus's character, only the combination of motifs adds complexity. Furthermore, the bust was originally part of a group with two flanking tritons holding a billowing mantle over his head. Commodus was thus portrayed as master of the sea (the tritons) and land (the cornucopiae and orb), a standard theme of ruler iconography.

Citizens were portrayed in the image of the emperor but without the imperial rhetoric of conquest and rule. The bust of Volcacius Myropnous (FIG. 71) from Ostia is contemporary with that of the emperor. In the popular format of the time, it includes

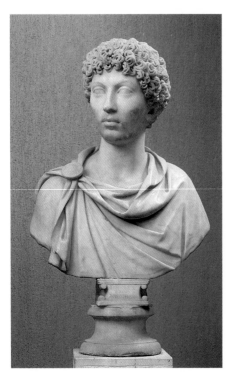

71. Funerary portrait of Volcacius Myropnous, late second century AD. Greek marble, h. 23½" (60 cm), incl. base. Museo Ostiense, Ostia.

In this sensitively carved bust of a young man, traces of color were found on the down of the beard and on the upper lip, as well as gilding in the hair. The head, slightly turned to the right, is narrow with prominent cheek bones and a tapering jaw line. Yet the effect of the drawn cheeks is countered by the large eyes, full lips, fleshy nostrils, luxuriant hair, and finely carved down: the facial features render a youth who has not fully reached manhood.

the upper arms along with the chest and rests on a small *tabula* (inscriptional plaque) with inscription above the base. The inscription of the name in Greek implies that Myropnous took pride in his national origin and its language, the older tongue that resonated with the acquisition of culture and education for elite Romans. The fact that the bust came from the Isola Sacra Necropolis provides a social context in the working classes of the port (see FIG. 24). Some of the merchants and craftworkers who frequented the tombs paying respects and feasting on the days of the dead would have been fluent in Greek because of their similar backgrounds in the Aegean or eastern Mediterranean or, perhaps, through doing business in the ethnically diverse port city; possibly many more could have understood simple Greek inscriptions and standard epithets. The excellence of the bust should warn against making assumptions about a patron's artistic taste in relation to social background.

The portrait head shares certain traits with those of Commodus but creates a different effect altogether. Again, the style may result from patrons and sculptors adapting features of the imperial portrait. Myropnous's portrait exhibits the highly polished surface, the heavy-lidded eyes, and the drilled, fully rounded curls of the imperial portrait in the late second century AD. Yet the chilly demeanor of Commodus's portrait is transformed into an expression of sensitivity and thoughtful attention. The eastern character only emerges in the mantle clasped at the shoulder which, because it lacks a tunic beneath, is a Greek *chlamys* (see FIG. 59). But this is not enough to identify the subject's background; it could simply be a Classical motif that signaled the subject's status as an *ephebe* (a young man entering adulthood in the Greek city state). The dignity of carriage adds poignancy to the work, particularly if it commemorates a youth who died just as he was coming of age. Elements of the imperial style – the optical effects, the contrast of the polished and drilled surfaces, the artfully tousled hair – are manipulated to create an image of a young man in Hellenic garb.

Preserving Memory

The demographics of Rome suggest that death struck frequently and its effects were far more visible in the ancient city than in

the modern metropolis. A traveler entering or leaving Rome could not avoid the roads lined with tombs (FIG. 72), the facades of which bore reliefs depicting the deceased men and women interred within. The tombs' inscriptional plaques also beckoned the traveler to read the names, not only of the deceased but also of the husbands, wives, and parents who had the tombs built for themselves and their departed kin. That tombs were frequented by the living is attested by the stone benches that grace some of them and by the gardens, wells, and banqueting facilities of others for the feast days of the dead. Even the dead were expected to partake of the festivities: pipes into the earth allowed the funerary libation to be poured down to the deceased while family and friends enjoyed the party above ground. The Roman tomb had to be designed with a sense of the conviviality among the living and the dead.

That the planning of one's tomb allowed for invention and creativity emerges from evidence such as Trimalchio's vision of his monument with images encapsulating his meteoric acquisition of wealth, and from caprices such as the Tomb of Marcus Vergilius Eurysaces, commemorating the wife of a baker in Augustan Rome with a monument that features motifs and a frieze representing the baker's trade. Exotica appeared in the Rome tomb of Caius Cestius in the form of a pyramid (FIG. 73), a prominent part of the cityscape near the road to Ostia. It is as if patrons strove for

72. Street of Tombs, Porta Nocera, Pompeii, first century BC–AD first century.

The outlying areas of cities were thick with tombs, built cheek by jowel on the major roads, in which hierarchies fueled by status, wealth, and the desire to be distinguished are readily apparent. The size and variety of tomb types reveal the stakes of competition. The largest of all Pompeian tombs and the most unusual – an exedra raised on a terrace – belongs to Eumachia, the patron of the building in the Forum.

73. Pyramid tomb of Caius Cestius, Rome, c. 15–12 BC. H. c. 118′ (36 m).

Fashioned of marble sheathing over brick and originally adorned with columns at each corner, the pyramid was built for an elite citizen who made Marcus Agrippa, Augustus's close friend and colleague, one of his heirs. As an appropriation of the tombs of the Egyptian pharaohs, it alludes to Augustus's victory over Mark Antony and Cleopatra in 31 BC, the battle that left Augustus as sole ruler of the Empire.

ever more imaginative or bizarre effects to compete for the attention of passersby, yet the investment in tombs and monuments expresses conformity to social practices, the desire for the perpetuation of memory.

Most tombs in the first two centuries AD, however, consisted of a single vaulted chamber with brick facade, some articulated with pediment and pilasters at the entrance. Many of these were family monuments serving one generation along with select members of the household, such as loyal freedmen and freedwomen. Those who could not afford to buy a plot and build a tomb banded together in groups. For example, members of the same trade formed burial clubs to ensure that each member would have a proper funeral and final resting place. These corporate tombs, called *columbaria* (literally, dovecotes), were built both above and below ground, with walls pierced by niches (FIG. 74). Not only did the burial society or imperial household keep company after death but we must imagine their lively meetings about the allotment of niches and the payment of dues for such a serious and final matter.

A remarkable relief from the late first or early second century AD illustrates a magnificent tomb and its sculptural decoration (FIG. 75). The tomb is in the form of a temple with ornate relief sculpture decoration: a bust in the pediment over a frieze of the eagles of Jupiter, and portrait medallions along the temple flank constitute only a few of the works that cover the tomb. It probably does not represent the relief's own tomb but may display the ostentatious tomb that the patron, the building contractor Quintus Haterius Tychicus, could not afford. The zeal with which the sculptor overdecorated the tomb – every surface etched with scrollwork or other ornamental designs – suggests an architectural fantasy, the desire to catalogue all possible forms of ornament and funerary symbolism, from the nude portrait statue of the deceased woman at the top of the tomb to the reliefs depicting the three Fates below the medallions. The portrait busts in the pediment and medallions represent a woman and children, an indication that many such tombs housed the remains of

74. Interior view of *Columbarium III*, Vigna Codini, Rome, first–second century AD.

The tomb chamber consists of a corridor with three branches; wooden galleries allowed mourners to reach the upper niches with their marble ash chests. The names inscribed here indicate that most of the deceased were freedmen of the imperial Julio-Claudian household, although there were some later burials of the freedmen of Trajan and Hadrian.

families and their dependants (most often freedmen and freed-women), thus commemorating the bonds between them.

For patrons of lower status groups without public careers or honors, the opportunity to be the subject of a portrait came only with death, hence the frequency of extant private portraiture from tombs. That citizens of all ranks commemorated their dead indicates the importance of recording the deceased's name in the epitaph and of depicting his image in a portrait, that is, of pre-serving memory. The extent to which citizens honored their dead depended on their means; the crane in the Haterii relief (see FIG. 75) is thought to represent the obviously successful contracting business of Quintus Haterius Tychicus. It is his ability to honor his deceased wife and daughter in style, to use the skills of his pro-fession to create a monument that contains an encyclopedia of tomb decor and canonical imagery from the elite repertory, that establishes him as a man of worth and standing.

Various standard types of tomb spread throughout the west-ern and eastern Empire. The tower tomb, consisting of several sto-ries, emphasized the tall and narrow exterior for decorative effects

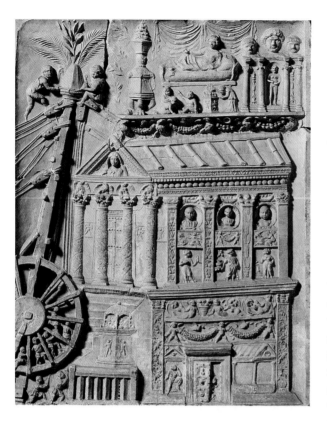

rather than merely serving as the container of a tomb chamber (FIG. 76). Examples are found in northern and southern Italy and in the western provinces (the Torre de los Escipiones on the road from Tarragona to Barcelona in Spain). In Palmyra, Syria, a city in which caravans stopped on their way through the desert, the tombs were erected outside the gates in the so-called Valley of the Tombs (FIG. 77). This group of family tombs, some of them with inscriptions that date them from the first century BC through the third century AD, offers evidence of sequential developments to larger structures (for more burials) with superimposed chambers reached by internal staircases and more regular articulation of masonry on the facades. Whether low-slung vaulted tombs crowding the roads to cities or massive towers commanding views over the windswept desert, the cities of the dead rose in close proximity to the cities of the living and imitated patterns of urbanism.

75. "Tomb-Crane Relief" from the tomb of the Haterii family, Rome, late first or early second century AD. Marble, 41 x 13¾" (104 x 35 cm). Museo Gregoriano Profano, Vatican Museums, Rome.

This and other reliefs from the tomb are exceptional in depicting not only a well-appointed tomb but also the funerary rituals.

It is difficult to locate funerary sculpture and portraiture in a separate category because distinctly funerary themes are relatively rare – identical types and subjects are found in sculpture and portraiture in different contexts (thus the discussion of funerary art is dispersed throughout this book). Motifs exclusively represented in funerary art allude to funerary rituals. Foremost among these is the *conclamatio*, the laying out of the deceased's body in the atrium of the house. The deceased is shown reclining on a *kline* (bed), alone or with a mate or family (FIG. 78), sleeping or feasting, the activities with which death was most often assimilated as an eternal rest or a celebration of life on this earth. The presence of the father in a work of art suggests how important it was to keep his memory alive through his portrait. The memory of a more recently deceased son, even when depicted as if still alive, will be maintained by the mother, veiled in modesty and devotion. Such an account of mortality in a household demonstrates the concern to maintain bonds between the living and

76. Tower tomb of the Julii and arch, outside Glanum (near modern St. Rémy), France, 30–20 BC. Limestone, tomb 59' x 14'2" at base (18 x 4.33 m).

The tower consists of four parts – a stepped podium, a socle (plinth) with relief panels, an open section with an arch on each side, and a canopy supported by a ring of columns which houses two portrait statues – an elaborate and graceful base for the statues. Serving as a commemorative monument in which the remains were not interred, the tower was dedicated by three sons of a Gaius Julius to their ancestors (portrayed in the statues). Their name and the date of 30–20 BC imply that the Julii received citizenship as a result of their participation in Julius Caesar's Gallic wars, 58–49 BC. The reliefs on the socle demonstrate the degree to which this province was saturated with Hellenic culture through contacts with the Greek colony at Marseilles and later through the Roman conquest. The reliefs manipulate the standard Greek themes, also inherited by the Romans as their stock in trade, that convey the triumph of civilization over barbarianism. The Julii may have celebrated their ancestors' role in the conquest of Gaul. The tomb stands outside the gate of the town, and next to a commemorative arch with reliefs depicting prisoners of war.

77. Tower tombs in the Valley of the Tombs, Palmyra, Syria, first century BC–third century AD.

Although most of the upper stories are not extant, these tombs were largely undecorated on the exterior with only slit windows providing light for the stairs and, in some cases, a projecting balcony with a window and a banquet scene carved in relief.

78. Testamentum relief, early second century AD. Marble, 33½ x 57¼″ (85 x 145 cm). Capitoline Museums, Rome.

The funerary relief alludes to a family's upward mobility in representing the slave at left holding a counting board, which may have connoted the profits from trade. The deceased young man reclines half-nude as if still alive, accompanied by his mother, the veiled matron seated beside him wearing the Flavian hairstyle, and his deceased father in the shield portrait, an honorary commemoration of military leaders in earlier periods. The emphasis is on the nuclear family, the son framed by his two parents, one whom he joins in death and the other whom he leaves behind to mourn both of them.

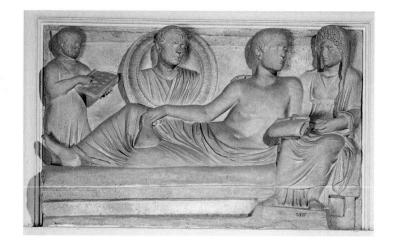

the dead and the ubiquitous presence of the dead in families of modest origins striving for acceptance and social mobility. The works of art convey the achievements of a family that properly honored its dead not only by the purchase of relief sculpture but also by observing the rituals – the meals taken at the tomb and the offerings left at birthdays and feast days.

The *kline* type of monument would have stood independently in tombs (later they were used as the covers of sarcophagi). That of Julia Attice in Rome (FIG. 79) appears to be misnamed because the reclining figure is a middle-aged man, but he embraces a portrait bust of a woman. An inscription, once visible on an urn at the back of the *kline* but now lost, indicated that Julia Attice was the freedwoman of a C. Julius, who may have freed his slave in order to marry her, a fairly common occurrence among the non-elite orders. This would identify the male figure as C. Julius and explain his embrace of the portrait of Julia Attice. He holds the bust to acknowledge both her untimely death and his continued devotion to her memory at the time of his own death. The portrait also suggests that the survivor fulfilled responsibilities in death as in life. As a memorial to Julia Attice, the portrait bust signals her social ascent from slave to respectable freedwoman and matron, her

79. Monument of Julia Attice, late first century AD. Marble, 33½ x 61″ (85 x 155 cm). Museo Nazionale Romano, Rome.

The *kline* (bed) monument was placed in a tomb to commemorate the sequence of deaths separating a couple: by holding the bust portraying his wife, the husband demonstrates his devotion to her memory at the time of his own passing.

shoulders and upper torso draped in a tunic and mantle, and her hair coiffed in tightly wound curls popular at the time.

Painted images of the deceased are less common but a fascinating corpus of painted portraits on mummies was recovered from Roman Egypt. The portraits, mostly in encaustic (hot wax in which pigments are mixed) or in tempera on wood or on the linen mummy shroud, have no doubt survived because of the dry desert climate. Often identified as coming from the Fayum, an oasis close to the Nile valley, portraits were also found at other sites. The culture of Roman Egypt, eminently recoverable with a wealth of documents on papyrus ranging from business contracts to personal letters, was polyglot – and more recently characterized as multi-ethnic – with its cosmopolitan society of Greek traders or mercenaries, Roman administrators, and Hellenized locals fluent in Greek. One thousand or so "Fayum portraits" give us a picture of some aspects of this society and its dead.

The portraits were painted on wooden panels placed over the mummy wrappings or on linen shrouds to cover the head of the deceased. Given the likelihood of sudden or premature deaths, the portraits may have been painted to carry in funeral processions and then cut down to fit the mummies. One portrait of two men in a medallion (FIG. 80) shows Egyptian features combined with Roman and Greek attributes. Their clothing reflects imperial customs: the figure on the left wears a Roman military cloak fastened by a jeweled brooch on the shoulder while the tunic of the other figure sports a thin dark stripe imitating the Roman insignia of high status. The handsome and stylish pair with light mustaches of adolescents also evokes the Greek ideal of the ephebe and the system of educating such youths in the gymnasium that was practised in the towns of the Fayum. The painting's provenance in Antinoopolis, the city founded in honor of Antinous, the emperor Hadrian's young lover who drowned in the Nile in AD 130, has promoted speculation that the young men also drowned in the Nile. In the background of the painting stand two deities of death. The god on the left is crowned and naked, suggesting the nudity of the ephebe and reinforcing the theme of the premature loss of vitality and prowess.

80. Fayum "Tondo of the Two Brothers" from Antinoopolis, Egypt, second quarter of second century AD. Encaustic on wood, diam. 24" (61 cm). Egyptian Museum, Cairo.

The two figures have similar features – thus the assumption they are brothers – but the one on the right differs with a darker complexion, fuller face, stronger jaw, and thicker lips. The double portrait may commemorate the untimely death of the young men when they were enrolled as ephebes, an honorary rank for aristocratic youth in the Hellenic world (see FIG. 71). A date, perhaps the date of death corresponding to the tenth of May, is inscribed in Greek on the portrait.

By far the most common funerary monument is the sarcophagus (literally, flesh-eater), the stone box or coffin that contained the body of the deceased. Some five thousand carved marble sarcophagi have survived from the period beginning in the middle of the second century AD, although a few earlier examples exist from the Republic and early Empire. Their emergence has been linked with a change in mortuary practice from cremating and placing the ashes in an urn or altar to interring the bodies of the deceased. This intriguing change has so far received no satisfying explanation. Given the investment of time and money in the cult of the dead, one would expect that any change in custom, and especially one dealing with corpses, would reflect a shift in attitudes, but nothing in the ancient sources supports this notion. The rise of Christianity is frequently linked with the change, yet the subject matter and inscriptions of second-century sarcophagi suggest that they were made for pagans not Christians. Whatever the reasons for the change, we can be more certain about how sarcophagi were produced: we have evidence for the workshops in Rome, Athens, and the cities of Asia Minor; the practices of cutting stone and roughing out the sarcophagi at the quarries; and the decorative or mythological subject matter of the exterior relief panels all around the oblong boxes. Most sarcophagi are dated by the style of the reliefs and, in the case of mythological subjects, the selection and arrangement of their motifs.

Sarcophagi made in the western Empire were carved with relief panels on three sides, with the back left blank because it was placed against the wall of the tomb. Those made in the east were carved on all four sides and were positioned so that a visitor could move around them and see the back as well. They also have gable roofs, rather than the flat or slightly sloping lids of the western types. Whether western or eastern, the sarcophagus provided a field for relief sculpture, with the most important scenes on the long front side and subsidiary scenes or decoration on the rest.

Relatively few of either the western or eastern types have extant lids with inscriptions giving the name of the person(s) interred in the sarcophagus; it has also been difficult to view sarcophagi as belonging to the deceased or the survivors because few have documented findspots in tombs. In the periods following antiquity, many sarcophagi were reused and their relief panels removed to decorate other surfaces thus destroying their original meaning. That the primary function of the sarcophagus was indeed to house the remains of the deceased is evident in the sarcophagus of one Crepereia Tryphaena (FIG. 81), discovered in Rome with the bones of a young woman intact within.

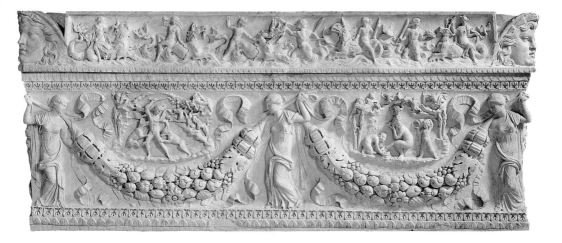

The mythological themes of the sarcophagi reliefs demonstrate the appeal of Greek subjects to Roman patrons. The repertory of Greek myth offered stories – some more appropriate for the commemoration of the dead than others – adapted by Romans with varying levels of education and familiarity with the literary culture. A look at three sarcophagi suggests the meanings evoked by the popular mythological subjects of the hunt, battle, and conjugal piety. Diana and Actaeon adorn a sarcophagus (FIG. 82) that combines their story with decorative garlands. In the front panel young women hold up garlands bursting with fruit and flowers, which figure prominently in Roman art as markers of sacred space, as symbols of the cycle of the seasons and their bounty, or as offerings to the dead. It is this range of meaning that made garland sarcophagi far outnumber any other type. The tale of the scenes above the garlands turns on the ironic fate of the hero Actaeon, the hunter who becomes the hunted. He must endure his fate because as a voyeur who stumbled on the goddess Diana in her bath he offended the goddess. The juxtaposition of the two scenes on the front announces how swiftly one's fortune could change, how unforgiving the gods could be. The central figures are nudes, although the hunter being mauled by his dogs contradicts the usual stateliness and prowess embodied by the heroic nude, and the chaste Diana appears in the form of a well-known statue of Venus, no doubt to heighten the erotic atmosphere. Death comes suddenly, violently to Actaeon, interrupting his momentary glimpse of the radiant goddess in her bath. For Actaeon this vision was fatal, threatening to overturn the relationship between mortals and immortals. In return, Diana unleashes the fury of the animal world against him. Actaeon not only serves as an example of a man succumbing to powers greater than himself and to

82. Diana and Actaeon sarcophagus, mid-second century AD. Marble, 26 x 91¼″ (66 x 233 cm). Louvre, Paris.

Two small scenes above the garlands represent the myth of the goddess Diana and the hunter Actaeon: on the right, the hero spies Diana bathing nude and, on the left, he is killed by his own hunting dogs in punishment for violating her privacy. (The two end panels represent the beginning of the hunt and the end of the story, the mourning over Actaeon's corpse.)

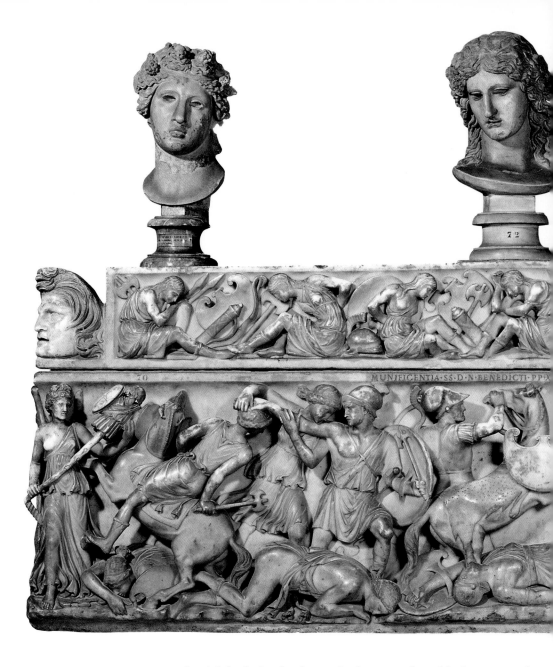

a bestial death, but he does so in the pastoral world of streams and glades where a man could become enchanted by his proximity to the divine. This idyllic atmosphere, evoked by jewel-like carving and a lovely frieze of marine creatures on the lid and delicate vegetal ornament on the body, undermines the gruesome nature of Actaeon's demise.

For a militaristic society the battlefield provided the ultimate display of worth and the test of mortality. A sarcophagus

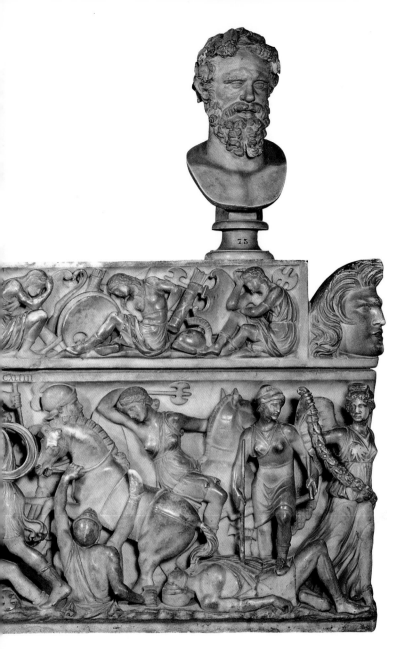

83. Amazon sarcophagus, mid-second century AD. Marble, 36½ x 98" (93 x 249 cm). Capitoline Museums, Rome.

The furious fighting in pairs or threes shows the Amazons as worthy foes. Even though the ground is littered with dead Amazons, some of the women get the better of the Greeks, as in the pair to the right in which a mounted Amazon swings her axe at a warrior who has fallen off his horse. However, the frieze on the lid displays the Amazons as the defeated barbarian, bound, huddled, or squatting on the ground amidst their weaponry.

depicting the mythological battle between Greeks and Amazons (FIG. 83) exemplifies the combat genre. The Amazons, the traditional adversaries of Greek heroes, were women warriors who encountered men only on the battlefield. Their eastern origin and repudiation of all things feminine (that is, domestic) made them a peculiar menace who threatened the foundation of civilization, the natural order of things. As sepulchral symbolism, the Amazon myth, in which the social order (whether Greek or Roman)

is defended in the face of a barbarous attack, provided the gloss of Classical culture for the deceased and his survivors. The myth justifies war against hostile and transgressive enemies, and, of course, destroying such enemies brings the hero immortality.

Myths on sarcophagi could serve as a script for heroic action even for those who lived rather humdrum bourgeois lives. In the story of Alcestis and Admetus, the wife Alcestis proves her devotion to her husband by giving up her life so that he may live (FIG. 84). Portrait heads are placed on the bodies of the mythological protagonists not merely in role-play but because the myth embodies ideals of behavior to which upstanding citizens aspired. The homely virtues of everyday life are ennobled by the testing of Alcestis's virtue and her triumphant return from the underworld with Hercules in tow.

The Alcestis myth, like some Greek myths that Romans depicted on their sarcophagi, demonstrated that death could be defeated, that the boundaries between this world and the next could be crossed in both directions. Other myths conveyed death tinged with eroticism, such as the popular myths of Meleager, the slayer of the Calydonian boar who gave the spoils of the hunt

84. Sarcophagus of Metilia Acte and Junius Euhodus, from Ostia, c. AD 150–75. Marble, 17 x 32" (79 x 210 cm). Museo Chiaramonti, Vatican Museums, Rome.

The central section of the relief shows the wife Metilia Acte as the dying Alcestis reclining on a bed, while her husband, Junius Euhodus as Admetus, approaches from the left. The group to the right of the center represents the next scene of Alcestis with head veiled returning from the underworld as a reward for her exemplary sacrifice. The inscription on the lid, a rare survival, states that Metilia Acte was a priestess of the cult of Magna Mater (the Great Mother or the Greek goddess Cybele) and her husband was an official in a professional association of carpenters. They may have been from freedmen stock, and their dealings in Ostia's commerce made them prosperous. Acte and Euhodus rested together in the sarcophagus on which they were cast as protagonists of a tale that endlessly reunites them, conquering death not through battle or aggression but through virtue and sacrifice.

to his lover Atalanta rather than to his kin, and of Endymion, the beautiful youth put to eternal sleep by the moon goddess Selene, as well as the tale of Actaeon and his fatal vision.

In funerary art victory over Rome's enemies grants the hero immortality that can stave off the consequences of death – in other words, glorious deeds will keep the hero's reputation alive. In the reliefs on Roman sarcophagi and in freestanding portrait sculpture ordinary citizens can play the part of heroes, heroines, or gods of Greek myths. Yet the honor of these commemorations was often earned by the homely virtue of living decent and ordinary lives, of fulfilling obligations and meeting expectations. Less glorious are the standard types of portraits, citizens in togas or matrons with well-dressed hair, that may have obscured individual identity while ennobling their subjects with the dignity and ideals of privileged ranks.

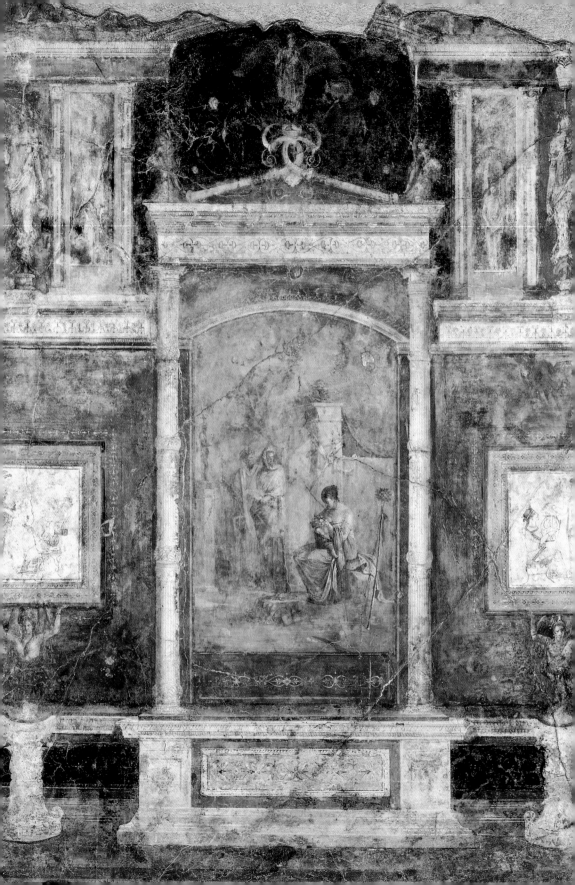

Houses and Painted Interiors

85. Painted wall from the Villa Farnesina (Bedroom B, back wall), Rome, 19 BC. Fresco, 7'8½" x 7'7" (2.35 x 2.31 m). Museo Nazionale Romano, Rome.

Attributed to the Second Style because of the architectural framework and its large mythological panels, the fresco also exhibits transitional features to the Third Style such as the small framed panels and other paintings with hinged doors as if they were placed in cupboards. The centerpiece of the infant god Bacchus (the Roman Dionysus) being cared for by nymphs is defined by a large panel set in a gabled shrine, its supporting columns rather attenuated by the standards of the Second Style.

ome for the elite Roman or well-to-do citizen was the *domus* (townhouse). The contemporary visitor to Pompeii sees these homes as rather stark and hollow interiors (FIG. 86), yet they would have appeared crowded with visitors during the morning *salutatio* when dependants of the household came to call (see Chapter One). Not only could passersby glimpse the sky-lit atrium through the dark entrance hall but the Roman found this lack of privacy desirable because a crowded hall reflected the master's prestige and political power. When the architect of a prominent Roman promised to make private the house that he was building overlooking the Roman Forum, the owner replied, "No, you should apply your skills to arranging my house so that whatever I do should be visible to everybody" (Velleius Paterculus, 2.14.3; c. 19 BC–after AD 30). The axial view through the house (FIG. 87) also indicates the primacy of the *tablinum*, the room in which the master, silhouetted by the light of the open peristyle garden coming from behind, sat to receive those in need of his services. As a room that originally held the marriage bed and the portraits of the ancestors (they may also have been located in the *alae*, wings, on either side of the *tablinum*'s entrance), the *tablinum* functioned to display the owner's heritage and genealogy. The *domus* gave a sense of the master's standing among his peers, of his political position and social prominence.

The house was also peopled with the staff – the doorkeeper monitoring visitors and slave girls working at the looms kept in the atrium. The wool-work that evoked the wife's devotion to the maintenance of the house and her impeccable virtue was carried out here: the work of the household was not closeted away, out of sight of visitors. We are missing the products of such labor,

86. House of the Silver Wedding, Pompeii, view through the atrium, first century BC.

The name refers to the silver wedding anniversary of the king and queen of Italy in 1893, the year of the stately house's excavation. It possesses the largest tetrastyle atrium (in which the opening in the roof is supported by four columns) in Pompeii.

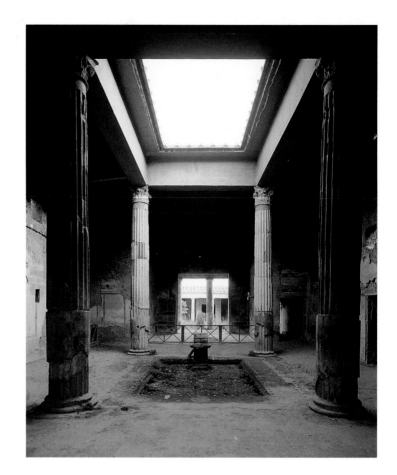

87. Plan of an elite house (*domus*).

The plan shows the house's axial orientation with the centrally-lit atrium and its *impluvium* (the basin in which rain water collected from the rectangular opening in the roof). In the third and second centuries BC the house developed outward with a peristyle court enclosing a garden, frequently with a *piscina* (a pool sometimes with fountains). Several dining or reception rooms, some for seasonal use, flanked the peristyle.

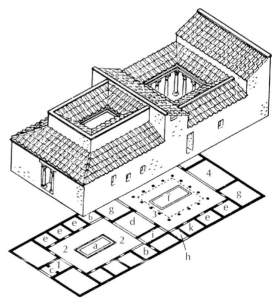

Key

1	fauces	d	tablinum
2	atrium	e	cubiculum
3	peristyle	f	piscina
4	exedra	g	triclinium
a	impluvium	h, k	side rooms off
b	alae		the peristyle
c	vestibulum	i	corridor

the tapestries and textiles that would have decorated the interior with colors, designs, and textures. The wall paintings discussed in this chapter provided elegance by representing exterior views, either of nature or architecture, or Greek mythological themes. As wall paintings create a sense of spaciousness and grandeur in narrow or cramped quarters, so tapestries and other furnishings could be used to divide rooms, not only to block drafts but perhaps to create more intimate spaces for invited guests rather than the clients and dependants at the *salutatio*. The house required a number of rooms, from large halls to small bedrooms (*cubicula*), to provide for public access and private encounters.

Duty and Domesticity

To the modern mind the house is often synonymous with the pleasures of family life. Yet the traditional *domus* seems to lack rooms reserved for women and children, two groups whom we most closely associate with domestic life. The Greek house had been noted for its women's quarters, either in the back or upstairs, to ensure that wives and daughters would not come across male visitors, but Roman women were free to circulate throughout the house and join their husbands at dinner parties. Their children played in the atrium, but the ground plans (although lacking upper stories) show no rooms that could be identified with nurseries or the staff to care for the children; rather, the rooms could be adapted to different functions by the addition or removal of furniture.

The Roman house sheltered not only the nuclear family but also their slaves. Although slaves' quarters are often difficult to distinguish in plans, it is thought that, like modern pets, they slept on mats on the floor (or in adjoining structures like stables), perhaps to provide security.

Over time, from about the third century BC, the *domus* gradually developed outward along the dominant axis. The increase in the number and size of rooms reflects the social obligations of the elite Roman of later periods who, besides the daily *salutatio*, was required to entertain on a lavish scale by hosting dinners and receptions in his home. Some of the early houses had small plots of land in the rear, which were cultivated as kitchen gardens; from the second century BC onward the backyard of grand houses was transformed into a peristyle, an open-air court surrounded by covered colonnades (FIG. 88). The rooms for dining (*triclinia*) and receptions (*oeci*) were often arranged around the peristyle. Formal gardens graced the peristyles with fountains and statuary

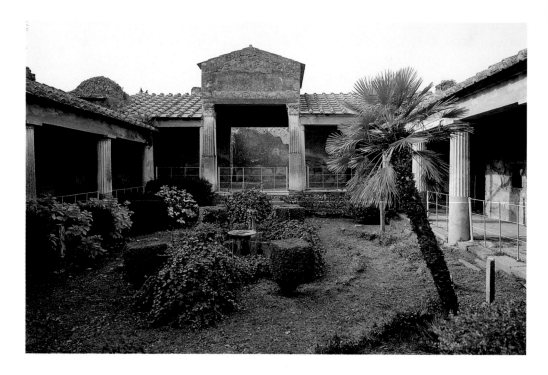

88. Peristyle garden and pediment in the House of the Golden Cupids, Pompeii, AD 62–79.

Architecture was manipulated to create impressive or stately effects. Here the peristyle has replaced the atrium as the center of the house, and all the rooms are oriented toward it. The colonnade to the rear is elevated and given a central pediment, which could not fail to recall dignified public edifices such as temples. It also frames a view into the *triclinium* entered by steps from the garden. The motifs from public architecture and the scenic vista together create an effect of grandeur and opulence that masks the modest size of the garden.

to create a cool, green oasis toward the rear of the house. They illustrate the Roman tendency to domesticate nature, to simulate a luxuriant overgrowth in the confines of an urban pocket. The integration of fountains in marble basins and sculpture of woodland deities enhanced the artificiality of the setting.

Architectural motifs copied from the public sector marked the important rooms of the house, where the public or invited guests congregated. Other allusions brought status to homeowners. Carved capitals at the threshold of the House of the Figured Capitals in Pompeii (FIGS 89 and 90) show feasting and merry-making. Banquets were frequently competitive affairs with sought-after invitations for a range of guests. Although wives and daughters could attend these dinner parties, they were elaborately staged affairs in which the male participants engaged in witty or rude bouts of boasting and power play; in other words, the rivalry of the forum and law courts infiltrated the domestic confines. The entertainment provided by the host could include the recitation of literature or the performance of scenes from Greek tragedy, but was probably more often of a lower variety. Pantomimes, acrobats, and dancing girls may have broken tensions and loosened inhibitions until the party was given over to purely physical pleasures. Poets imagined love triangles with the husband present while his wife and her young lover attempt to send each other signals.

89 and 90. Capitals with satyr and maenad, and man and woman reclining while banqueting, House of the Figured Capitals, Pompeii, second century BC. Tufa, h. 19¼" (49 cm). Museo di Pompei.

The figured capitals at the entrance of the house depict two couples – a drunken satyr (half-human, half-beast) clutching a wineskin accompanied by an ivy-crowned *maenad* (a wild female follower of Dionysus), and a man and woman reclining, the proper posture for eating and drinking at dinner parties. The couple may represent the householder and his wife as the host and hostess of banquets (*convivia*). Posture makes the men: as the bearded and wreathed satyr throws his arm over his head in a pose of abandon, the nude man sits upright and rests his hand on his wife's shoulder. Dress distinguishes the females: the maenad's tunic slips off her shoulder, the matron is attired in a more modest tunic and veil over her head. While it is clear that the satyr and maenad have lost themselves in their revels, the man and wife also partake in the pleasures of the banquet, albeit in a more restrained fashion.

Moralists decried dissolute young men, overindulging in wine and sex (both heterosexual and homosexual) at these affairs. In some aspects the model for the Roman banquet was the Greek symposium, a male dinner mingling intellectual and erotic desires that gave free vent to sexual gratification. By evoking the Hellenic pedigree of the Dionysian banquet, the satyr and the maenad on the capital brought cultural cachet to the house and its owners.

Gardens

The Mediterranean climate allows for indoor and outdoor living for a good portion of the year, and for the Roman that meant dining, if not completely *al fresco*, at least in a room (*triclinium*) with a view of the garden and close enough to hear the gurgle of the fountains. Grand houses included several rooms for dining depending on the season: winter or summer rooms could catch the varying angles of sunlight or cool fragrant breezes. While the *domus* presented a facade fortified against the dangers of the street, its interiors were open to a patch of greenery under the blue sky. The garden provided a refuge from the cares of business, even while the social obligations fulfilled in the house served to further the master's career. The term *amoenitas* refers to the attractions provided by the landscape for the aristocratic life of thoughtful leisure. As mentioned above, the Roman garden kept nature under cultivation, hemmed in by rows of columns, fed by ponds that were the products of hydraulic engineering, and inhabited by animals that were carved in marble.

Many gardens not only brought the country into the city but also imitated on a smaller scale the elaborate landscaping of villas in the countryside. The garden of the House of M. Lucretius from the first century AD (FIG. 91) forms a Dionysian *tableau vivant* on high ground raised above the level of the back of the house. The mosaic niche resembling a half-shell that houses a marble Silenus (a shaggy old satyr) contains a fountain; the

91. The garden of the House of M. Lucretius, Pompeii, AD 62–79.

The statues were found with traces of their original color at the time of the excavation.

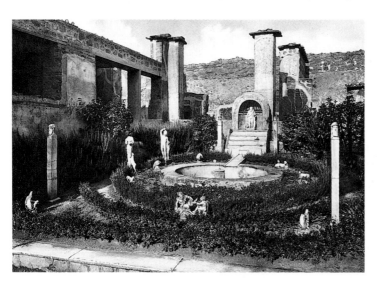

satyr's wineskin poured water down steps into the canal that leads to a large round pool with a jet in the center. Surrounding the basin are statuettes of animals and birds (rabbits, a reclining cow, and a deer), and of Dionysiac figures of Pan (an Arcadian god half-human and half-goat), double-headed herms, and satyrs holding goats; some of the figures of animals were also fountains that poured water back into the basin. Diners could view the garden from a window in the *triclinium* and wander out to it through steps next to the *tablinum*. Rather than a park that invites quiet reflection, the garden appears to have been created for entertainment, to elicit delight and amazement at the elaborately staged scene presented in a fairly small space. It was probably intended to be taken in as a view rather than to be explored at close range because many of the animal sculptures were roughly fabricated. Extraordinary effects of the animation provided by the waterworks contradict the frozen quality of the statues caught in action poses, capering, striding, or twisting. The garden summons the Dionysiac world of physical vitality ruled over by a drunken old Silenus who transforms his wine into water; yet for all its allusions to a world of antics and ceaseless flux, the view never changes and the scene remains the same. In designing his garden, M. Lucretius domesticated Dionysian motifs: the installation of garden with fountain, pool, and statuary asserts discipline and order even while summoning up an atmosphere that celebrates misrule, animal instincts, and a loss of self-control.

Other houses in Pompeii displayed elaborate ornamental gardens, called by one scholar "villas in miniature," because of the extensive grounds with fountains, pools, shrines, and statuary constructed in imitation of the country residences of the very wealthy. The House of D. Octavius Quartio (FIG. 92) consists of a garden that takes up more land than the house. The panoramic terrace covered by an arbor features a water channel crossed by two bridges, one in front of the biclinium – two wedge-shaped masonry benches for outdoor dining that allowed the diner to feast on dishes floating in the basin in front – and the other in

92. The arbor and water channel in the garden of the House of D. Octavius Quartio, Pompeii, AD 62–79.

The water channel was marked by two fountains with pergolas above and one pavilion, structures that framed a vista through the garden. A path ran along each side of the waterway, setting it off from the statuary, shrubbery, and trees of the surrounding park.

93. Statue as lampholder, from the House of the Ephebe, Pompeii, late first century BC–early first century AD Gilded bronze, h. 4'10½" (1.49 m). Museo Nazionale Archeologico, Naples.

The well-muscled physique makes an elegant figure, recalling the monumental bronze statuary of temples and fora, while reducing those statues to a collectible object. Rather than carrying a weapon, the figure descended from statues of warriors originally held the brackets of the candelabra for the lamp. The reworking of this statue derived from Greek works as a utilitarian object demonstrates the resourcefulness of Roman non-elite patrons and the liberties they took with Greek art.

front of the triclinium decorated as if it were a picture gallery. From the *triclinium* water cascaded from a pavilion with jets of water to a *nymphaeum* below and from there to a channel that extended the length of the garden. The many amenities of this garden are all familiar from the country villas of prominent Romans but reduced in scale to fit the long, narrow plot. As in the House of M. Lucretius, the garden appears as scenery arranged for the delectation of the diner whose point of view was taken into consideration. The size of the outdoor area given over to entertaining is impressive, as must have been the expense of the upkeep of the garden and waterworks. Guests were to be transported out of the confines of an urban lot to an environment simulating exotic (the Nile) and exquisite places by ingeniously disguising a backyard with the landscaping, outbuildings, and statuary (of animals, river gods, muses, Dionysus, Isis, a hermaphrodite) of elegant villas. There is less evidence of the owner's social life but we must imagine a nonstop flow of visitors for all this expense – other proprietors rented out rooms, houses, and gardens to make ends meet.

Couches for outdoor dining also appear in more modest houses in Pompeii, such as the House of the Ephebe (see FIG. 26). The masonry couches were arranged near a fountain in a garden that may have been a common area for several houses or a courtyard for one house cobbled out of smaller adjacent houses for the freedman Cornelius Tages. One lampstand (FIG. 93), originally placed on a round base next to the couches, gives a sense of the owner's cultural aspirations or, perhaps, the appeal of a desirable work of art. The bronze statue of a nude male youth, an ephebe, is in the style of the highly regarded Greek sculptor Polykleitos, of the fifth century BC. It stands in contrapposto, the hallmark of Polykleitos's well-known work, the *Doryphoros* (spearbearer), with the weight on one leg and the rest of the body revealing the tension between relaxation and rigidity. In one sense the figure stands in for the slaves attending the diners, but at the same time its artis-

tic pedigree elevated the surroundings. The male nudity was also suggestive for the homoerotic pursuits made possible by the convivial atmosphere. It has been proposed that the statue had been displayed in an aristocratic villa before its purchase by Tages, but he had it adapted as a lampholder and gilded, that is, made more precious.

Some of the garden statuettes represent servants or slaves bearing trays of delectables (FIG. 94). If the statue of the ephebe alludes to the high culture and rarefied tastes of the elite, then this statuette brings the proceedings down to street level with its sexual jokes, sharp observance of the workings of the social hierarchy, and commerce in human flesh. Burdened with an overdeveloped penis, also found in depictions of lower creatures such as satyrs or beasts, the slave is shown to be ruled by his groin rather than his head. The statuette justifies the master's view of his slave's intrinsic subordination: his ugliness connotes social inferiority and sets him up for scorn and ridicule. He is depicted at the beck and call of the diners by holding a silver tray that held pastries or sweets, that is, the statuette served as a raised dish. It is striking that it co-existed with the statue of the ephebe, but we should not be quick to attribute this juxtaposition to the bad taste of the freedman Tages (if he, indeed, was the owner); rather, both works attest to a lively, quickwitted culture in which allusions to high and low art could bounce off one another without flattening them to the same level of banality.

Turning a modest garden into spectacular scenery was well within the means of Pompeii's magistrates and affluent freedmen. Many art historians and archaeologists look upon the villa-in-miniature as a debased popular form of the high art of villa design, yet clearly the splashing pools and suggestive statuary carried a cachet that redeemed their expense. For those without a country seat (or the several houses that aristocrats divided their time among), the townhouse with a luxurious garden allowed them to entertain in a style ultimately derived from elite practices but adapted to different requirements and lesser incomes. M. Lucretius and Tages probably were not unduly concerned that their gardens lacked the acreage of the grounds of villas; after all, the garden brought pleasure.

94. Statuette of tray-bearer (*placentarius*) from the House of the Ephebe, Pompeii, first century AD. Gilded bronze and silver plate, h. 10″ (25.4 cm). Museo Nazionale Archeologico, Naples.

Four of these statuettes were recovered in a wooden box in the atrium of the house but were probably used in the outdoor dining room. The figure's face and physique are a caricature of the type of the slave: the prominent nose, bulging eyes, scrawny ill-proportioned body with, most important of all, a huge drooping penis. Depictions of the male organ could signal potency or aggression in some cases, but here it marks the destructive and humiliating effects of a lack of self-control.

Dining, whether indoors or outdoors, required attention to formalities. In the *triclinium* the diners reclined, three to a couch, on three couches arranged in a "U" shape around a low round table. The seating plan reflected the social hierarchy with the host giving the best place to an honored guest. Slaves kept a silent vigil at the sides of the room, scurrying from behind the couches with the dishes for the many courses of the meal. The poet Horace (65–68 BC) is impressed by his friend's account of an elaborate banquet:

> When these plates went off, one slave with a silk servi-ette and his apron tucked up wiped off the maplewood table quite clean; another swept up the scraps lying round on the floor, odds and ends, and crumbs, whatever might trouble the guests. Dark-skinned Hydaspes marched in with the Caecuban wine, like a maid of Athens bearing the emblems of Ceres in solemn processional...
>
> (Horace, *Satires*, 2.8)

Exotic or refined fare made invitations to dine highly desir-able. Drinking followed the meal, along with entertainments. It has been pointed out that the banquet was inherently theatrical, from the entrance of the guests to the serving of the courses, and the musical, literary, or dramatic interludes were only one of a sequence of carefully staged events demonstrating the host's sense of showmanship.

The host was also judged by his tablesetting. Silver ser-vices graced the best tables with platters, bowls, and cups, the most sumptuous of which were dec-orated in relief with mythological themes or subjects familiar from state art. A silver cup (FIG. 95) is decorated with the vine scroll familiar from the Ara Pacis (see FIG. 16). The tendrils are intertwined in graceful arcs that terminate in leaves or rosettes. Only birds and other small creatures dis-rupt the symmetry and regularity of the linear abstraction of the vines. The person drinking from this cup might have recalled the Ara Pacis; if not, the patterns of delicate trac-ery were also appropriate for an ele-gant table.

95. Drinking cup, early first century AD. Silver, h. 3½" (8.9 cm); diam. 3⅛" (9.8 cm). British Museum, London.

Made of two sheets of silver soldered together, the cup bears decoration on the outer surface, which is hammered or punched from the inside (*repoussé*), while the inner surface forms a lining. Some of the motifs were also engraved by hand.

Tableware in other materials could also add to the atmosphere of elegance and exclusivity (FIG. 96). Pliny the Elder (AD 23–79) reports that Livia dedicated a large specimen ("the biggest ever seen") of rock crystal on the Capitoline hill (*Natural History*, 37.27). The public exhibition of the mineral suggests that it held the appeal of a

96. Drinking cup (*skyphos*), from Pompeii, first century AD. Rock crystal. Museo Nazionale Archeologico, Naples.

natural wonder. The refractive quality of the crystal, its shimmering spectrum of colored lights, gave rise to belief in its curative properties (useful in cauterizing) that were, perhaps, inseparable from its aesthetic appeal, just as silver goblets spoke of old money and bankable value. Too small to be used at table, the cup from Pompeii may have served as a memento or *objet d'art* in contrast to vessels of stupendous sizes, some holding many pints or even gallons. The size of such containers was even more luxurious considering that rock crystal could not be repaired once broken. A mania for collecting rock crystal plagued Rome: Pliny reported that a respectable married woman paid 150,000 *sesterces* for a single dipper, a ridiculously high price that signals conspicuous consumption (Natural History, 37.29).

Rock crystal was valued because of its provenance in remote mountain ranges. Collectors marveled at its perfection that surpassed even the most assured skilled work. Desiring or, conversely, destroying rock crystal became a telltale sign of a manic personality: according to Pliny the Elder, Nero's reaction to his impending overthrow was to smash two crystal cups so that no one else could drink from them.

The garden also serves as a decorative motif in paintings providing a backdrop for the master's hospitality. Pompeians did not find it redundant to have the walls of their enclosed gardens painted with flowering plants and shrubs behind low trellises or fences. Such paintings may have magnified the effects of the small patches of green sandwiched between rows of columns. Garden paintings also adorned rooms, blurring the boundaries between the indoors and outdoors. One such painted wall, from a bedroom in the House of the Orchard (FIG. 97), exemplifies the preference for a highly civilized view of nature. The undergrowth of fruit trees is painted as if it grows behind a low fence, yet the scene lacks any illusion of depth – its leaves seem to have been pressed flat between panes of glass. This garden also displays art in the form of small Egyptian statues of striding figures and painted panels with Dionysiac scenes. The Egyptian statues were artefacts from a civilization considered ancient and exotic by the Romans. Nature serves as the background for a kind of sculp-

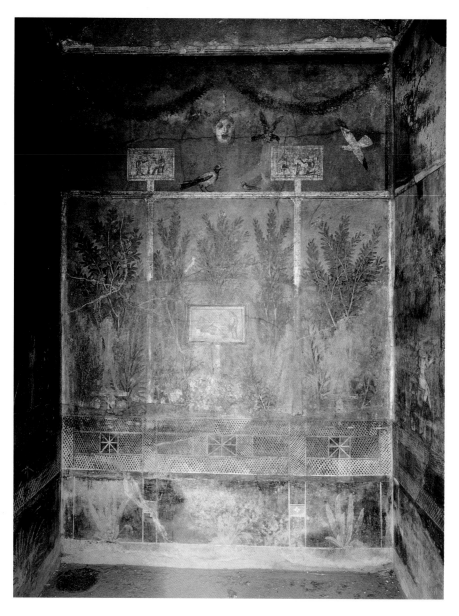

97. Garden fresco in the House of the Orchard (Bedroom 8), Pompeii, AD 40–50.

Columns crowned by an architrave form the spindly architectural frame that organizes the wall into three vertical sections with a frieze zone above the garden in the manner of an ornamental screen. The birds on the architrave do not impart a sense of the outdoors; it is the theatrical mask hanging from the garlands that sets the civilizing tone. The techniques of Roman wall painting in fresco included preparing the wall with coats of plaster incorporating powdered limestone and marble dust, and applying the pigments to the damp surface. Seams in the plaster indicate the surface painted in one session, until the plaster began to dry. Guidelines, drawn in red ochre or scored with a pointed instrument, aided painters in plotting their designs. Polishing the surface gave Roman fresco its distinctive luster.

ture park, the greenery contrasted with the stable and static poses of the statues. To us now, the painted panels recall explanatory placards in a public garden, a manicured wilderness.

Garden walls offered a surface for paintings of other subjects besides gardens. A *paradeisos* painting (FIG. 98) depicts wild animals rampaging through a hilly landscape. The *paradeisos* refers to animal reserves kept on estates in order to supply hunters with game. As in the design of the garden, the Pompeian householder intends to emulate the leisured life of his social superiors. Hunting had long been an aristocratic pursuit, as a preparation for military training and the activity of heroes. Yet the Pompeian paintings emphasize the bulk and power of the beasts, some of which would have been imported from other parts of the Empire to fight gladiators in the arena (*venationes*). One would expect these scenes to include the hunter or gladiator, yet the human predator is not depicted here. Instead of alluding to hunting, the *paradeisos* paintings may depict rare, dangerous, or graceful wild species assembled for the pleasure of the spectator. The display of exotica and the play of reality versus illusion continue in the flanking paintings that depict a stylish fountain on a sphinx; the painted water empties from the fountain into real gutters at the bottom of the wall. Perhaps the beasts careening on the back wall of the garden originally looked as if they could burst out of their painted menagerie into the viewer's space.

98. Fresco of animal reserve in the garden of the House of the Ceii, Pompeii, middle or third quarter of the first century AD.

In the foreground a lion pursues a bull along a rocky shore. The middleground shows a cavalcade of animals – wolves and wild boars in the center, a leopard attacking two mountain rams on the right, and a stag and gazelle on the left.

Painted Perspectives

Most of the extant Roman wall paintings decorated the interiors of houses. Although many paintings have been taken to museums, it should be understood that they were meant to be seen as part of the architecture and were complemented by the other paintings on the walls of the rooms. The body of painting, mainly but not exclusively from Pompeii, has been classified chronologically according to style. The First Style, also known as the Masonry Style, represented walls dressed with faux paneling of marble and other stones (200–80 BC); the Second Style opened up the wall with architectural vistas (80–20 BC); the Third emphasized the decorative architectural frameworks and created the illusion of pictures hanging on the wall (20 BC–AD 40); the Fourth incorporated many elements of the Third Style (AD 40–79) to represent textile patterns of wall hangings or views of vaguely defined architectural forms that seem to hang in space, together with mythological panels and floating figures. The four styles trace a chronological development from the simple to the more complex in which the illusionism of architectural schemes gives way to the proliferation of frameworks for central panel paintings. The faux picture galleries of the Third and Fourth Styles were appropriate for the self-image of aristocrats who, denied the vehicles of public acclaim under Augustus, wielded power through friends in high places, cultivated at small dinner parties and more intimate entertainments. The Second Style regal settings for the reception of clients were no longer relevant. The Fourth Style, represented by the most paintings but the least studied, is diverse in its effects – the division into panels by decorative borders, riots of pattern on flat color fields, and receding views through gridlike architectural sections. This range allowed for greater differentiation according to the requirements of the patron and the function of the room. Modern scholarship analyzes decorative systems rather than individual motifs.

From the *triclinium* of a country estate near Pompeii, the villa of P. Fannius Synistor at Boscoreale, a painted wall (FIG. 99) depicts characteristic architectural motifs of the Second Style. As the style not only opens up the wall but also allows it to assert itself, so the flanking wings show walls with panels of stone familiar from the Masonry Style. The architecture derives from various sources – theatrical stage sets, Hellenistic palaces (the latter perhaps known to Roman audiences through the former), and the grand mansions of the Roman elite. The illusionary vista makes the diners in the *triclinium* feel as if they are reclining

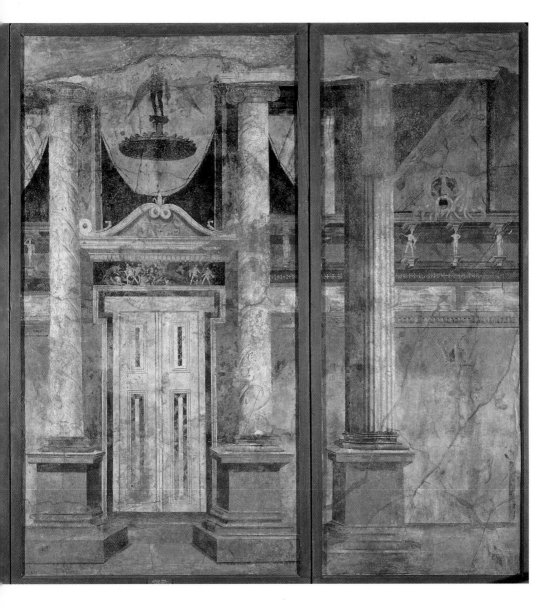

99. Architectural fresco from the villa of Publius Fannius
Synistor at Boscoreale (*triclinium* G, west wall), 50–40
BC. H. 11'2" (3.4 m). Museo Nazionale Archeologico,
Naples.

Large columns set on high bases form a screen through
which the viewer sees another pair of columns, ornately
decorated, flanking a door made of alabaster and topped
by a fine gable. Above the door a bronze statuette is
visible that is intended to dominate the open-air
courtyard beyond the door, defined by a patch of blue
sky and the receding cornices of a portico.

in a colonnaded pavilion of unrivaled splendor. The columns refer to the public edifices of fora and basilicas; the extravagant setting of sumptuous materials (the alabaster door, the inlaid stone panels) and ornate decoration (the columns with spiraling vine scrolls in relief) derive from the showy villas of the rich and famous. Theatrical masks and incense burners, touches that allude to a rarefied style of entertaining and ceremonious occasions, fit the grandeur of the architectural setting. Although there is an illusionary view to the outside, it is only a glimpse of sky visible in the center above the door: the external world evoked here rebounds with the weight of marble and masonry, a decidedly urban scenery.

The architectural framework can be subordinated to figural decoration in the form of mythological panels set in the wall as if they were paintings hanging on the wall. The painted wall from a bedroom in the Villa Farnesina in Rome (FIG. 85) lacks an illusion of depth but, instead, represents a wall cluttered with pictures, some held up by statuettes on stands. The main subject of the infant Bacchus attended by nymphs at first appears appropriate for a bedroom, but its tenderness belies the unsettling nature of the mature god who was as familiar as he was terrifying. The Villa's prestigious setting on the banks of the Tiber in Rome has led to speculation that Augustus's daughter Julia lived there during her marriage to Agrippa, her father's colleague and advisor. That their two boys were adopted by Augustus as his successors may give particular meaning to the theme of the raising and education of the infant god. Bacchus may seem an odd choice because his cults had been blamed for corrupting women and the young, but the nymphs' maternal devotion idealizes the subject as one, perhaps, fitting for the education of exceptional children like the young princes of the imperial household. Furthermore, stucco panels from the vaulted ceiling show the young god being initiated into his own mysteries, and perhaps it is the initiate's gradual acquisition of knowledge and experience that offers an analogy to the training of an aristocratic youth. More intimate gatherings may have been held in this *cubiculum*, which was not only a place to sleep.

The decoration also alludes to the owner's taste as an art collector. The small framed pictures on either side recall Greek vase paintings of the fifth century BC, and their fictive gold frames and white backgrounds make them seem precious. The picture gallery continues in the upper zone with small pictures of erotic scenes. The assortment of imagery, along with the rich color of the walls and the delicacy of the filligree-like ornament, offers the pedigree of an aristocratic collection with its Hellenic

art and erotica. In a luxurious villa such as the Farnesina, easel paintings or statuettes must have been displayed in front of the walls or in the colonnades of porticoes; now, we can only wonder how these works might have complemented or contrasted with the painted images of works of art on the walls behind them.

To see the refinement of the illusionary picture gallery we need only look at a painted wall in the *tablinum* of House of M. Lucretius Fronto (FIG. 100). The compact central panel of Bacchus and Ariadne is surrounded by other works of art – above a small painting of a still life in browns and grays representing fish, the catch of the day or gifts given to guests, and in the side panels two elaborate silver stands supporting small wide paintings of seaside

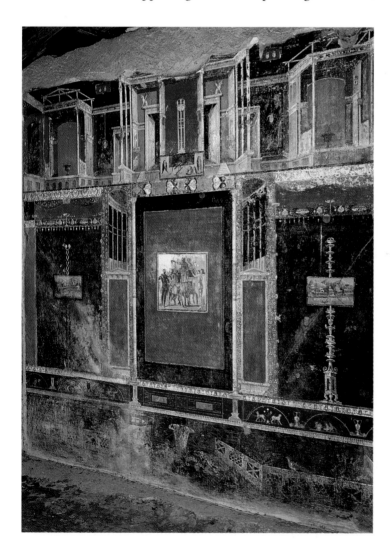

100. Fresco in the *tablinum* of the House of M. Lucretius Fronto, Pompeii, AD 40–50. 10 x 11' (3 x 3.3 m).

Fronto had chaired the Pompeii town council and financed public building projects and games from his own funds. The late Third-Style painting with a color scheme of intense red, gold, and black has a central panel depicting Bacchus and Ariadne in a lively procession celebrating the god's rescue of the abandoned young woman. The wall shows large flat areas of saturated color with the architecture reduced to a skeletal framework, particularly in the upper zone where columns barely thicker than threads support shed-like roofs. This design approximates that of stage sets, the *scaenae frons,* and offers a sense of theatricality. Abundant ornament threatens to overrun the design, and the fields of color are balanced by a precise, jeweled trim. The green panels that appear to be set at an angle framing the central section are carpeted with tiny garlands, and miniature sphinxes, silver vessels, and a tripod in the center adorn the upper zone.

villas, their multi-storied, rambling porticoes almost reaching the bay crossed by a boat. Motifs alluding to hospitality and leisure are appropriate for the *tablinum*. All of the panel paintings evoke themes of pleasure, whether it is the sexual ecstasy of the god and his consort, the contentment provided by a full larder, or the elegant standard of living of a seaside retreat. These pleasures could have been purchased by Romans with sufficient means but the Bacchic revel shows the god in an uncharacteristically masculine role as savior of the helpless female. The meaning of these motifs underwent revisions from the transcendent experience of Bacchic possession to a pattern of heroic action.

Garlands and tripods in the center of the wall summon offerings to Apollo, whose representation by these miniature attributes

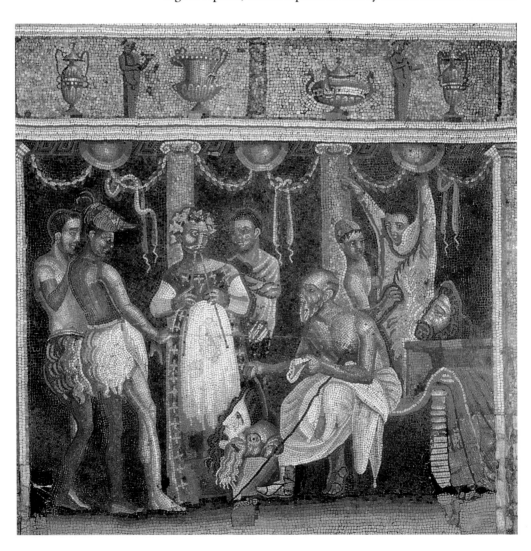

counterpoint those of Bacchus (silver drinking cups, panthers). Perhaps Apollo and Bacchus are paired so that the cool intellect of Apollo is balanced with the unbridled desire of Bacchus; or the attributes of Apollo may have merely provided allusions to the sacred while those of Bacchus suggested more earthly delights. On the black ground at the bottom is a motif familiar from garden paintings, the low fence of an enclosed plot opening on to a large vessel in the center. Although a bird is shown seated on the fence, there is no attempt to portray an illusionistic landscape with a view beyond the wall. The Third Style emphasizes the wall as a flat surface on which images are projected to create the opulent atmosphere of a house well provided with delicate furnishings, mythological paintings, and exotic clutter.

The floors of many of these well-appointed rooms were covered with mosaics made of cut pieces of stone, usually in black and white repeat patterns, occasionally with polychrome centerpieces or *emblema,* particularly in the early phases. Many mosaics were designed with decorative borders at the edges, indicating where doorways, corridors, or, in the case of bedrooms, niches for the beds were located. In a few Second-Style rooms the mosaics indicate the preferred vantage point for the illusionistic perspective, and many mosaic designs were coordinated with the wall paintings to create a general effect. Besides marking the boundaries of rooms, the mosaic designs also emphasized routes through the house, such as in the dynamic patterns used in corridors.

From the *tablinum* of the House of the Tragic Poet (FIG. 101) comes a polychrome mosaic representing a rehearsal for a Greek satyr play. Clearly, the intention was to depict a Greek entertainment familiar to Romans and to show the preparation rather than the performance itself. The theatrical props, masks, costumes, and the lilting song of the pipes indicate the spellbinding stage illusion, but here it is all work and attention to detail in the scene of the younger actors gathered around the master, who sits hunched forward and gestures with his right hand giving directions. This type of scene identifies the residents of the House of the Tragic Poet as sophisticates who can take pleasure in a genre scene that lifts the curtain, so to speak, on a craft that requires diligence and dedication to create the illusion of effortless entertainment. In the Roman house, with its staging of dinner parties and receptions, an atmosphere of conviviality depended on protocol and political patronage – as one scholar has observed, theatrical illusions served as allusions to culture and refinement.

101. Mosaic with theatrical scene from the *tablinum* of the House of the Tragic Poet, Pompeii, AD 62–79. 21¼ x 21¾″ (54 x 55 cm). Museo Nazionale Archeologico, Naples.

A rehearsal takes place in front of a blue portico hung with wreaths, fillets, and *oscilla* (marble masks and disks) below an entablature of golden vessels and musicians in the form of *herms*. The chorus master, depicted as an older man bearded and bald, watches two actors wearing goatskin loincloths practice dance steps to the music of the double pipes played by a figure in a long garment and garland; a third actor is shown putting on a costume that identifies him as the old Silenus. The *emblemata* (polychrome figured scene inserted in the center of the floor) was surrounded by black and white geometric mosaics.

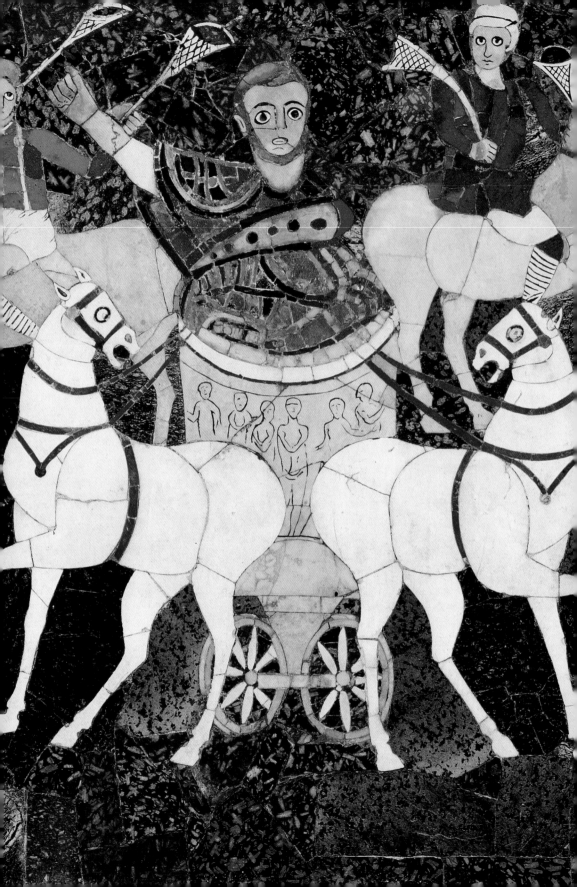

The Limits of Empire

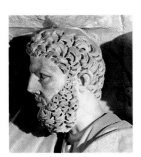

102. The consul among the circus factions, from the Basilica of Junius Bassus, Rome, AD 330–50. *Opus sectile* marble, stones, and glass paste. Palazzo Vecchio, Florence.

The economic stability of the fourth-century renovation permitted this ostentatious marble decoration in place of less costly wall paintings. The other extant panels depict animals being attacked by tigers, the mythological subject of Hylas and nymphs, and a wall hanging decorated with Egyptian motifs. The Basilica is known from sketches made between the fifteenth and seventeenth century; it was later built into a monastery and demolished.

The story of the end of the Empire hinges on the question of decline. In traditional accounts, the late Roman Empire is seen to be weakened by the burden of defending the frontiers, the lack of manpower for its forces or competent leadership from the capital, and even the loss of a common cultural currency, the Classical idioms of the Mediterranean basin. More recent scholarship emphasizes the roles of change and continuity in the third and fourth centuries AD. Change is apparent in the form of central authority and the increased role of the military, whereas continuity appears in the patterns of everyday life. The latter assumes greater importance with the realization that Rome did not touch the lives of many in the Empire's remote outposts, that emperors had no master plans to export its way of life but, instead, depended on local habits or the cooperation of the municipal elite. The collapse of central authority, therefore, did not greatly impinge upon the lives of many in the Empire whose first-hand experience of the state came with the tax collector or the bureaucrat who requisitioned supplies.

Notions of change and continuity depend upon one's picture of imperial society at its height. The acclaimed stability and prosperity of the Antonine period (AD 138–92) affected the cities rather than the hinterlands; those of the cosmopolitan elite orders with their network of connections across the Mediterranean made more of this beneficial climate than the vast majority without the means to maneuver and friends in high places. According to some, the Antonine period witnessed the first signs of what was to come in late antiquity, considered as either the transformation of the Classical world or its breakdown, depending on the point of view. The specter of interminable warfare

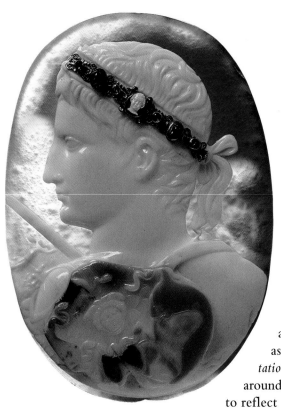

103. Blacas Cameo of Augustus, early first century AD (reworked in medieval period with eighteenth-century restorations). Sardonyx, 5 x 3½" (12.8 x 9.3 cm). British Museum, London.

The cameo is produced by carving down from the surface of the stone to its variously colored layers. The later diadem encrusted with emeralds, diamonds, a topaz, and a garnet along with three other small cameos transforms the founder of the Empire into an ancestor of the medieval monarchs who may have looked upon this sumptuous gemstone as a sacred artefact. This may not be so far from the work's original intention, because Augustus assumes a divine or heroic stature through the *aegis* (the breastplate and attribute of the goddess Minerva) that warded off evil with the protective device of Medusa's head.

already haunted Marcus Aurelius (r. AD 161–80), as suggested in his Stoic discourse, the *Meditations*. Before this, Hadrian's incessant travels around the Empire (AD 117–38) have been thought to reflect his political wish for consolidation of the Empire's overextended borders rather than any enthusiasm for renewed conquest. In a discussion of identity the grand sweep of historical change may have less to tell us about the texture of lives across the social spectrum than the art and architecture embedded in the structures of everyday life, that is, representing and reinforcing images of hierarchy and order.

To begin at the top, the image of imperial authority is reassuringly familiar in the so-called Blacas Cameo portraying Augustus (FIG. 103). The carved gemstone depicts the characteristic classically austere features and hairstyle that allow instant recognition centuries after his reign. Invested with a considerable value because of its majestic imagery and delicate work, the cameo was made more precious by the addition of the jeweled diadem in the medieval period. The accumulation of dazzling gems – especially the refined redundancy of cameos adorning a cameo – recalls the objects of traditional societies that hold power from the accretion of materials with magical effects. Cameos, a medium associated with the imperial court since the Julio-Claudians in the first century, are thought to have been gifts commemorating anniversaries or the assumption of offices or priesthoods among the imperial family or their circle. In the private sphere, the preciousness and porta-

bility of cameos made them suitable as lovers' gifts: Cicero (106–43 BC) mentions in a letter the shocking discovery of cameos of distinguished women among the possessions of a man who, he assumes, has had extramarital affairs. As gifts circulating as tokens of respect, gratitude or affection, the carved gemstones also represented the bonds between the donor and recipient; perhaps the Blacas Cameo served to create an unacknowledged bequest of divine power and regal majesty from the legendary Augustus to its possessor.

Town and Country

City and country existed in a state of tension: the city drained the surrounding farmlands of their wealth and its elite recuperated in villas amidst the rolling hills beyond the city gates, yet it would appear that they lived in separate worlds. Stereotypes of the simple unwashed peasant working the earth from dawn to dusk and the cultivated perfumed urbanite lounging in the marble porticoes were long ingrained in the popular imagination. However, these stock characters, staples of the theater, mask the encounters and exchanges between city dwellers and country folk in the course of business, travel, and administration. In the third and fourth centuries mounting economic pressures forced people out of the smaller towns into the countryside, yet many Mediterranean cities prospered. As security was threatened by troops, brigands,

104. Relief of a harbor from Ostia, AD 180–90. Marble, l. 4' (1.22 m). Museo Torlonia, Rome.

The tiny dock workers scurrying with heavy loads on their backs are obscured by the colossal figures of statues dominating the skyline and serving as landmarks not only of Ostia but also of Rome. Near the center the sea god Neptune, a robust nude, rises over the water's snaky waves. The vista is crowded by three other over life-size statues, the lighthouse of the harbor spouting flames, and the elephants pulling the chariots that stand on the Porta Triumphalis in Rome, as if to boost Ostia's gritty reputation by emphasizing its proximity to the capital.

and marauders, country-dwellers congregated in fortified communities built around villas of large property owners upon whom they depended. In spite of this, the fourth century was also a period of revival in which a peaceful existence could be maintained in some areas and Classical culture set the standards for a new elite who spent their wealth on their country houses. The society of town and country can be glimpsed in the representations of popular quarters of cities and of villas in the country.

A look at a second-century work is instructive for a discussion of continuity and change in the late Empire. In AD 180–90, at the height of the Empire, the harbor at Ostia was a hub of commercial activity, as evidenced by a contemporary relief (FIG. 104). The series of landmarks in the relief does not offer a map of Ostia but a collage of sights and wonders at the gateway to the glamorous capital. Even the sails of the ship bear the motif signifying Rome's founding, Romulus and Remus with the she-wolf (see FIG. 3). The high relief carving, the density of motifs piled behind and on top of one another, and the diminutive stocky figures performing their jobs below create an unusually static and lifeless impression, more appropriate for an illustrated guidebook than for a view of a harbor.

The most striking symbol is the large disembodied eye on the right, a device to keep danger at bay. It connotes magic and superstition, appealing to the viewer who would find numinous presences in the monuments of the city. Perhaps the monuments themselves are not enough to impress the imagination or convey the protection of the gods without allusions to a world beyond the marble bric-à-brac of the Classical city. Mimicking the appraising eye of the viewer and, perhaps, catching the viewer off-guard, the eye also refers to the power of sight to affect emotional and physical states (desire, greed, jealousy) in the close quarters of the cities. The physician Galen (AD 129–99) describes the claustrophobia of the towns: "we all know each other, know who was whose son, what education each of us had received, how much property each owned, and how each one of us behaved" (*De praenotione,* 4). The symbol of the staring eye summons the undercurrents of social life, the petty rivalries, disputes, and abrupt changes of fortune, as well as the powers called upon to resolve them. Although depictions of inner life or states of spirituality are thought to emerge only in the late Empire, the tendency towards the symbolic has deep roots in Roman art (see FIG. 17). Here, a scene of commercial activity in a port is invested with a magical aura.

Life in the countryside is represented in stately splendor in a floor mosaic from the villa of Dominus Julius in Carthage, North

105. Mosaic with scenes of country life around a villa, from the villa of Dominus Julius, Carthage, late fourth century AD. 18'1" x 14'10" (5.5 x 4.5 m). Musée Bardo, Tunis.

Rather than the stately and well-proportioned figures of second-century state art, here figures with short stocky bodies and large heads are used throughout; only the master and mistress are shown in a slightly larger scale in the bottom row. Detail is lavished on the costumes, which are distinguished by bold vertical stripes and stippling that may indicate embroidery or appliqué. Space is rendered in a schematic manner with the action on three registers interrupted in the center by the representation of the villa, the hub of this small universe.

Africa (FIG. 105). The villa, a fortified building guarded by tall towers at either end, stands in the center. In the top register of the mosaic the tenants bring their seasonal rents (in produce and live-stock) for the *domina* (the lady of the house), in the middle register the master and his men depart for the hunt, and in the bottom the master performs administrative tasks while his wife leans on a pillar in the pose of a muse, as depicted in the statuary of theaters as well as on sarcophagi relief panels. The allusion is enhanced by her elegant attire and the servant who hands her a necklace. The mosaic defines the new elite of the fourth century: the master administers his property and engages in aristocratic pursuits such as hunting. Here and in others with similar motifs, the master dominates a smaller world than that of the battlefields, fora, and law courts in the imagery of the elite life of public service. Even so, the high esteem accorded the study of the classics plays a role as witnessed in the wife gracing her husband's presence as a muse standing beside a poet or philosopher. The scenes

106. Plan of a villa at Piazza Armerina, Sicily, early fourth century AD.

The villa was once thought to have been the seat of Maximian (r. 286–305), who served with Diocletian (r. 284–305), but the owner was probably an aristocrat with property in north Africa, considered as part of the same cultural sphere as Sicily. The floors of the villa were covered with almost 400,000 square feet (37,160 sq. m) of polychrome mosaics produced by artisans from north Africa.

Key

a entrance archway
b entrance court
c vestibule
d baths, hall
e aqueducts
f main peristyle and fountain court
g grand corridor
h basilica
i southeast suite
j Orpheus room (shrine?)
k triconch
l curved peristyle
m nymphaeum

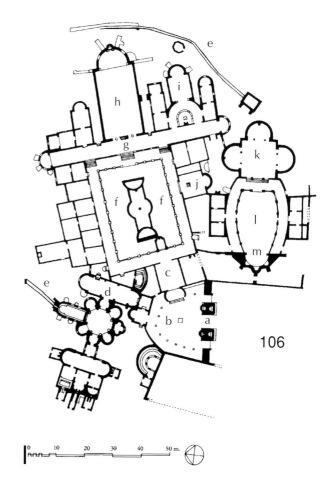

106

suggest a secure and orderly world in which, one imagines, a villa compound with a gate, high walls, and towers would not be necessary.

The plan of a villa in Sicily at Piazza Armerina (FIG. 106) shows a vast arrangement of halls, rooms, and colonnaded courtyards on uneven terrain. Not only does its loose plan with contrasting axes seem eccentric in comparison to the axial focus of the early *domus* (see FIG. 87) but the rooms in separate suites take on fanciful shapes with swinging walls and large apses. The scale of the plan and the variety of its chambers have prompted scholars to consider the villa as a city in itself, for it can be subdivided into quarters with different characters and functions ranging from the open rooms for the entertainment of guests (baths, basilica, nymphaeum), to corridors for processions, to less well-appointed areas for service and even the production of goods. The villa deep in the countryside has no need of a town and has become a self-sufficient entity. This is not in itself a sign of the deterioration of civic life but that the forms of urbanity still provided the model for civilized living.

Power and Privilege

Over the third and fourth centuries the gulf widened between the rich and poor. For the western Empire, wealth was mostly agricultural, and vast land holdings were accumulated by relatively few families. In the eastern cities, competition continued among wealthy individuals for titles and services from the emperor. The legal definitions of status and rank were revised after the emperor Caracalla (r. AD 211–7) granted citizenship to all free residents of the Empire in 212, a policy that signaled the devaluation of citizenship and, instead, stipulated unequal treatment of citizens of high and low status under the law. A pyramid still illustrated the social order, but its slopes inclined more steeply. The army, as always, provided advancement but now with spectacular success stories: many of the soldier emperors of the volatile third century and its aftermath, who were proclaimed emperor and backed by their troops, started as sons of freedmen (Diocletian) or peasants who herded cattle (Galerius; r. c. AD 305–11).

The political system also changed to meet the requirements of a bloated empire. In 293 Diocletian established a new system known as the Tetrarchy in which four men ruled from separate capitals, dividing the Empire among them or multiplying the power of the emperor by four. Diocletian took the title as Augustus along with Maximian; their subalterns, Galerius and Con-

107. Arch of Galerius, Thessaloniki, northern Greece, AD 298–303. Marble, h. 41′ (12.5 m).

The arch commemorated Galerius's Persian conquest of 298 but also honored the four Tetrarchs (emperors) with portraits in niches on the sides of the arch facing their respective provinces. The reliefs, arranged in panels set in horizontal registers on the piers of the arch, lack an obvious orientation for the sequence of events so carefully narrated by the panels.

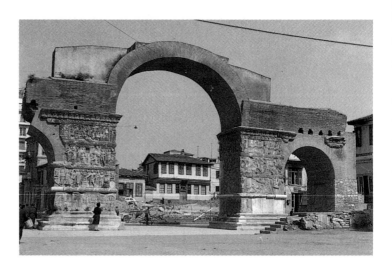

stantius I (r. c. 305–6), each took the title of Caesar. Unity among the foursome was cemented with the practice of the Caesars marrying the daughters of the Augusti. While the portrait sculpture of the Tetrarchs portrays them as clones of an abstract and reductive imperial type, the individual men pursued their own initiatives to shore up the Empire. Galerius distinguished himself with brilliant victories over the Persian king and the Armenians in 298, and built a palace in Thessaloniki in northern Greece as his base of operations.

After this double conquest, Galerius erected a triumphal arch (FIGS 107 and 108) in his palace complex. The palace, like Diocletian's in Spalato (modern Split, Croatia), took the plan of a military camp with the crossing of two major streets, the intersection of which was crowned by the arch, a four-sided structure bearing a dome and surrounded by piers that formed covered passageways. On one side it is connected to the colonnaded avenue that led to a building with a rotunda. In many respects it upholds the tradition of the triumphal arch developed in the second century: its integration in the urban fabric, its marking of a passageway as symbolic space, and its commemorative function with relief panels representing battle scenes and court ceremonies. Yet the complexity of its plan, its siting in a palace rather than a city proper, and the style of the reliefs point to its late imperial date. Only two piers are extant today, making it difficult for the viewer to imagine it in the context of a palace intended to replace and, in some ways, rival Rome.

Other forms of art honor officials for their role in civic life. Several panels made of *opus sectile* (designs of inlaid marble, stones, and glass paste) adorned the walls of the Basilica of Junius Bassus,

a consul of Rome in AD 330–50. The consul is represented in a chariot with the circus factions (see FIG. 102), the wildly popular teams that raced in the arena. Sponsoring games or races was a more efficient and cost-effective means of gaining public acclaim than the building projects favored by earlier grandees. Magistrates often basked in the glory of their favorite teams: ivory diptychs (a pair of small hinged panels that held wax tablets for writing) show consuls signaling the start of the races. The medium and technique of *opus sectile* are similar to those of mosaic, with the exception that these panels feature broad forms set off by their richly colored stones rather than the finely cut stones (*tesserae*) and intricate blending of colors more frequently seen in mosaics. The consul is depicted frontally, a pose favored in the late Empire as well as in earlier reliefs of freedmen and craftsmen, yet his pair of horses are positioned as if they are pulling the chariot in opposite directions rather than forward (note the position of the wheels as well). Although awkward, this device allows the artist to avoid foreshortening the horses' bodies and presents the horses in three-quarter profile to give the most characteristic view of the consular procession. It also captures the delightful pomp, the springing gait of the horses, and the excitement of the procession before the start of the races. Flat, simplified forms characterize this work without loss of significant details – the figured frieze on the front of the chariot and the complicated design of the consul's garment, perhaps showing the bands and embroidered badges of this period, in comparison to the clothing of the riders flanking him.

Dress still distinguished the ranks in the army and the civilian bureaucracy as in the height of the Empire, but the types of dress changed. Paintings in a tomb in Silistra (Bulgaria) on the banks of the Danube (FIG. 109) demonstrate the overarching importance of the uniform to the bearing and dignity of an official. The paintings illustrate the remark, "When a man changes his garments he immediately changes his rank" (Salvian, *Governance of*

108. South pier of the Arch of Galerius, Thessaloniki, Greece.

The deeply carved decorative moldings and the linear style of the reliefs, with its emphasis on a strong and supple contour line for the figures, distinguish the monument with a fluid scroll-like texture.

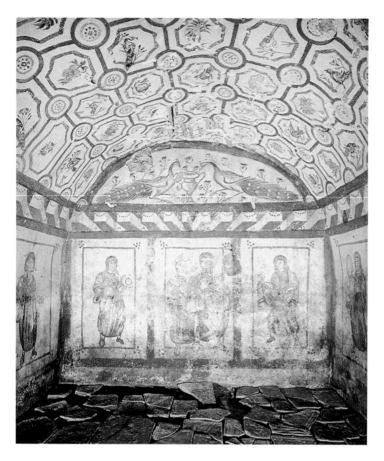

109. Tomb painting showing the costume and insignia of an imperial official, late fourth century AD. Fresco, chamber 7′6½″ x 10′10″ x 8′6½″ (2.3 x 3.3 x 2.6 m). Silistra, Bulgaria.

Slaves carry the items of dress as if they were sacred garments or offerings – trousers, a cloak with a pin, and jeweled military belt. The trousers and the inlaid belt, once barbarian gear that marked defeated and degraded enemies in the state reliefs of the high Empire, have moved from the frontier to the society of the late antique bureaucracy.

God, 4.7). The military background of the new elite is thought to have been responsible for the dress code but elements such as the embroidered patches or strips of cloth sewn onto cloaks and tunics are not exclusive to the camp and battlefield. The patches or badges sometimes depict emperors, Biblical figures, or abstract designs that as emblems of the wearer's loyalty or devotion may be more important than the clothing itself. In the paintings of this well-appointed tomb the deceased is defined by the appearance that he makes. The style of the paintings – a white ground, frames for the images in bright blue and red, and ceiling panels with miniature images within frames – emphasizes divisions, both of the architectural interior and of the figures whose forms and drapery are defined by blunt contours.

Not only was clothing synonymous with certain professions but it also evoked the virtues and exemplary life required by specific careers. The sarcophagus known as the Brother Sarcophagus (FIG. 110) offers a conservative view of the traditions of Classicism in elite culture. The figure of the deceased is repeated in varying uni-

forms appropriate for the cultivated life of a senator with his administrative, intellectual, religious, and moral responsibilities. Both public and private life are balanced in the vignettes on the end of the sarcophagus while the center pair of figures implies the dual allegiances of the aristocrat to the Greek life of the mind and the Roman preoccupation with traditional values. In the early Empire a senator would have maintained a split identity between his public duties and esoteric intellectual pursuits because such leisurely occupations seemed soft, corrupting, and unroman. But in late antiquity, knowledge of the classics was required for advancement in the higher posts of the civil bureaucracy; a traditional education connected men with the past in a changing world; and the standards of excellence espoused by the classics distanced the elite further from the masses – a rhetorician was said to have pronounced that a robber should be punished by having to learn the classics by heart as he had done. Given the extraordinary prestige accorded to the man of letters, there was no contradiction in portraying a statesman as a philosopher advocating withdrawal from society.

Gods and Cults

The emergence of Christianity has often served to explain the increasing abstraction and otherworldliness of the art of the late

110. Brother Sarcophagus, from Rome, after AD 260. Marble, 3'10⅛" x 8' 4⅜" (1.17 x 2.54 m). Museo Nazionale Archeologico, Naples.

The deceased is depicted in four portraits on the front that can be identified by the hair combed forward, full curly beard, and long, thin face with a prominent brow and a chiseled nose. From left to right, he is shown in a toga with a flat band assuming office, in the dress of a Greek philosopher with his chest bare, in a simple toga, and in another version of the same for his marriage.

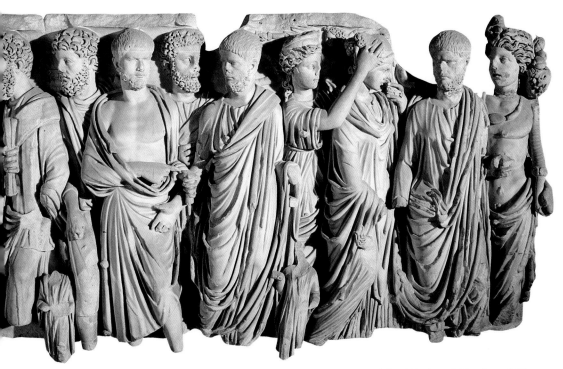

Empire but, as has been pointed out, these tendencies cut across imperial art appearing in the state monuments of the capital, provincial works, and art of non-elite patrons in periods that precede the beginning of the "decline." Clearly, the rise of one cult among the many in the third century cannot claim responsibility for the wholesale adoption of a new artistic style. Christianity provides one aspect of the changing horizons and outlook of the citizenry that neatly dovetails with other symptoms of dissatisfaction and restlessness – the questioning of the status quo, yearning for community of a different sort, or even retrenchment into gilded aristocratic lifestyles. It is also important to consider that what we understand as "religion" did not coincide with the ancient practice of worshipping and serving gods.

Religion for the Romans usually meant ceremonies or sacrifices presided over by priests, members of the elite political class, to ask the gods' favor before taking a census, setting out for the battlefield, or other business of the state. There were also gods of the hearth, guardian spirits to look after individuals, and crowds of lesser deities to attend to various ailments of the body or disappointments of the heart or ego. *Providentia deorum*, "the gods are looking after us," summed up an attitude of wishful thinking retailed on the legends of coins in the second and third centuries. Worshippers expected their gods to answer their appeals, preferably directly. Images of the gods abounded in cities and sanctuaries, yet their high visibility may have diluted the sense of awe or mystery expected in confrontations with the divine.

The eastern cults that attracted initiates in the military and flourished among residents of foreign extraction provided communities of a more intimate nature than those of the legions, professional organizations, or the streetcorners of neighborhoods. Many of the cults also promised a life after death. In the first through third centuries Christianity was one among a number of eastern cults worshipping Mithras, Zoroaster, Helios, Isis and the like. The appeal of Christianity was not widely apparent until the third century when suddenly artisans and tradespeople (not the underclass or the down-and-out) converted in greater numbers than before. It is thought that Christians attracted a following because of the notoriety resulting from their occasional persecution by the state, provoked by their refusal to take part in the imperial cult. By refusing to make the gestures of respect that the state demanded, Christians asserted their unwavering belief in an authority above and beyond the legal and political apparatus of the state. They cultivated the stance of outsiders.

Their insistence on the significance of living one's life according to moral precepts and religious doctrine also set them apart from the other cults and set the stage for their popularity. Furthermore, social status meant nothing in the eyes of the early Christian community whose members treated slave and noble alike. The wealth that the Church eventually commanded could not have been imagined in the second century when the Christian bishop in Rome drew a salary of 7,000 sesterces while the professor of rhetoric collected 100,000 sesterces. But the simple sermons offered valuable advice for getting on in this world in comparison to the lofty language and lengthy tutorials of the professors. Not otherworldly, the early Christians were profoundly down to earth.

The Christians met for worship in private houses in which halls for fifty people or so could be fashioned by taking down a wall between rooms. The only required equipment was the large basin for baptism, the rite of initiation and conversion. That the architecture and art of early Christianity was not appreciably different from that of other religions is evident in the town of Dura Europos in Syria, a military outpost on the banks of the Euphrates with sixteen cults to serve the needs of Roman soldiers. There, the Christian house of worship was painted with scenes from the Old and New Testament. A similar treatment is found in the painted walls of the synagogue from Dura (FIG. 111), dated to the mid-third century. The Jewish communities of the Hellenic world provided models for the Christians in many aspects. The style of the wall paintings emphasizes a flat, reductive rendering of figures, architecture, and objects without any intention to create illusions of depth or movement. Large colorful scenes are arranged on the walls without regard to the architecture or to an easily grasped thematic program. The Christian paintings in the burial chambers of the Catacombs in Rome may have relied on Roman styles of portraying the figure, but in the paintings of all the cult centers in Dura the figure is presented to the viewer as a symbol rather than an actor in a self-contained narrative. The paintings can be read as simple declarative statements with no need for the nuance of modeling or shadows.

The emperor Constantine (r. 306–37) attributed his victory in AD 312 at the Milvian Bridge in Rome to the intervention of the Christian God, conveyed to him in a vision. Son of the tetrarch, Constantius Chlorus, and an officer in Galerius's Persian campaign, Constantine was the first Christian emperor. The Church was quick to take advantage of his dispensation. Yet Constantine's conversion can be interpreted as tolerance for the new religion that included respect for the pagan establishment as well. Constantine

111. Painting from the Synagogue at Dura Europos, AD 250. Fresco. National Museum, Damascus.

The paintings depict Hebrew stories with figures lined up and posed frontally, their arms frozen in gestures of prayer or exhaltation. The Jewish prohibition against images affected only the figure of God, who is not depicted. The wall paintings serve to focus the worshipper on the events and deeds recorded in the scriptures.

did much to shore up the landed aristocracy in the west and the Roman senate, at the same time that he founded Constantinople on old Byzantium as the capital of the eastern half of the Empire (AD 330). He took the most highly regarded Classical statues to adorn his city on the Golden Horn, offered the well-heeled Christian elite of the cities of Asia Minor greater opportunity for political advancement and commercial gain, and accepted pagan honors from the city of Athens. The iconography of the emperor reflects the spirit of *rapprochement* between the Christian church and the state. On the obverse of a silver coin minted in 315 (FIG. 112) Constantine is shown with the Christian monogram on his helmet as a soldier of Christ and with an imperial Roman shield. The message is that of the Christian apologists who supplied the thinking of the day: the Empire can be saved and Classical culture maintained only under the protection of the Christian God. Although Constantine is portrayed as a heroic rider (whose mount is abbreviated as a miniature horse's head), the old soldier accepted Christianity not only as a religion but also for the accessible forms of Classical culture that it brought in its wake to the uneducated, isolated, or regimented residents of the Empire – the majority of its citizens.

The coin's head, said to portray a godly and inspired leader, conforms to the type seen in the colossal heads in Rome in which

the huge staring eyes, here with heavy lids, have the power to transfix the viewer. Enlarged with bold dark irises, the eyes possess a penetrating gaze as if charged with a fiery determination or urgent mission. The other features appear rigid, reduced to simple geometric forms contained within a clear contour line. This impression of a remote and superhumanly poised ruler is complemented by accounts of court ceremony. The chronicler Ammianus Marcellinus (330–95) describes the entry of Constantius II (r. 337–61), a son of Constantine, into Rome: "he showed himself immobile... keeping his gaze straight ahead, nor turned his face to left or right, and like a statue of a man was never seen either nodding when the wheel jolted, or spitting, or wiping or rubbing his face or nose, or moving his hands" (16.10, 2–10). Besides its suggestion of what ordinary citizens did to break up the discomfort and monotony of a journey by carriage, this look at Constantius's stately bearing is telling in its comparison of the emperor to a statue. Whereas the portrait galleries of the fora rendered likenesses of the emperors of previous centuries, in this anecdote the person of the emperor imitates a statue. The analogy underscores a sophisticated appreciation of the uses of state art and of the rules of comportment found in physiognomic handbooks (ancient versions of our "how to..." or psychological self-help manuals geared to those bent on success) that catalogue the meanings of physical appearance. According to the physiognomists, the erect carriage and controlled movements or, rather, the glacial stillness of the emperor convey his extraordinary sense of discipline and restraint, a mark of nobility and its refinements.

112. Coin (*miliarensis*) representing Constantine, AD 315. Silver, diam. 1" (2.8 cm). Staatlichen Münzsammlung, Munich.

The shield that Constantine carries into battle bears the motif of Romulus and Remus suckling the she-wolf, the symbol of eternal Rome, now fortified by its juxtaposition with the Christian symbol of the *Chi-Rho* (the first two letters of Christ, *Christos*, in the Greek alphabet) on the helmet.

The restoration of order in the fourth century allowed for Christianity to continue filtering and diluting aspects of Classicism for its new audience on the fringes of society. The aristocracy in the city of Rome, however, lived in a world in which pagan and Christian culture co-existed in a nostalgic glow. An example of luxury goods that belong to overlapping worlds is found in a gilded silver box for toilet articles from the Esquiline hill (FIGS 113 and 114). The box, the lid and body of which have sloping pyramidal sides with a flat top and bottom, is worked in relief with chased and engraved motifs. A Latin inscription on the edge between the lid and body reads SECUNDE ET PROJECTA VIVATIS IN CHRISTO ("Secundus and Projecta, may you live in Christ"). The elegant silver box may have been a wedding present to the couple who maintained a high social profile.

The mythological motifs of Venus and cupids and the genre scene of a woman's toilette are entirely appropriate subjects for

113. Wedding box of Secundus and Projecta, from the Esquiline hill, Rome, late fourth century. Gilded silver, 11 x 21½" (28 x 55 cm). British Museum, London.

This container was found with a collection of silver objects known as the Esquiline Treasure, which included a *patera* (flat dish), a flask, and a box with related pagan motifs. The motifs are decidedly pagan: *erotes* (cupids, the sons of Venus) flank a portrait medallion of the couple on the top of the box; below, a scene of Venus seated on a shell and adorning herself with a hairpin and mirror; and directly below this, a seated woman fixes her hair and holds a cosmetic jar. The figures arranged between columns and under alternating pediments or arches are servants who bring equipment or toiletries to the woman seated in the center. She is probably to be identified as Projecta, and the comparison with Venus is made clear through their similar gestures indicating their commitment to the process of making themselves beautiful.

114. Detail from the lid of the wedding box of Secundus and Projecta: the procession to the baths.

the decoration of a box that contained such items of feminine adornment. Yet the mostly nude figure of Venus would seem to contradict notions of Christian modesty, and the figure of the woman could also offend with its absorption in acts of vanity. Scenes on the back of the lid depict a procession to the baths (see FIG. 114), another urban ritual with illicit pleasures that Christians scorned. The motifs of Venus on the shell and the procession to the baths evoke the transformative ritual of the goddess's bath with its perfumes and ointments, but the beautification of a Roman matron was undertaken not to attract men but to complement her husband's position with her cultivated, well-groomed appearance. The coiffures (see FIG. 65) had a role to play in this process, as also seen in Projecta's and the goddess's efforts to style their hair.

The identification of Projecta with the partially clad Venus would not offend a Roman steeped in traditional values but a Christian's reaction is more difficult to gauge. The invocation of the inscription may allow for an interpretation of Projecta as a bride of Christ with the baths alluding to baptism. The waters of the baths also recall Venus's birth in the foam of the sea, the first of her many ablutions that liken her to a bride who prepares herself for the wedding night with a purifying bath – again an appropriate theme for a wedding gift. It is most likely that the combination of pagan and Christian elements caused no comment, and that the inscription and mythological motifs were not antithetical to the fourth-century viewer, who would have taken pleasure in the costly materials and skilled work of the container. The gleaming surface with its gilt figures on silver creates rich effects with the frothy ornament of the goddess's attendants, the sea creatures and nereids (sea nymphs) defined by swirling lines and arabesques. A container with such exquisite motifs conveying the tasks and delights of feminine beauty would not have been out of place in a Christian home in which even seemingly frivolous activities reflected, initially, the love of a wife for her husband and, ultimately, their mutual love of the Lord. It is a credit to the foresight and flexibility of the early Church that it accommodated a range of activities and habits of consumption.

Collecting in late antiquity responded directly to fluctuating markets and the sense of deepening economic crisis. Evidence of this comes in an unusual form of jewelry made from coins (FIG. 115). The coins are the *aureus* denomination, a large gold coin of considerable value termed the *solidus* (a solid bit) in army slang. The creation of coin jewelry depends on a series of reactions to hard times: with the reduced weight of new coins mandated by the

inflation of the third century, the value of older coins increased and they were hoarded. Value was also added by incorporating them into jewelry, although in this case the coins were definitively taken out of circulation as a negotiable instrument. The coin as jewelry became a decorative object that still signified wealth and a historical artefact because of its images and legends of emperors.

The coins in the necklace depict profiles of emperors and empresses from Hadrian through Gordion III, and it is thought that the necklace dates to the latter's reign (238–44), because his coin portrait is honored by the central position and largest setting. The representation of previous emperors and the re-use of their art – particularly of those whose reigns are synonymous with better times, such as Hadrian (r. 117–38) and Antoninus Pius (r. 138–61) – is also found in state monuments such as the Arch of Con-

stantine in Rome (312–5). In the case of the Arch, the appropriation of reliefs from earlier monuments may be explained by the lack of resources and the need to assert continuity with the greatness of Rome past. For the coin jewelry a similar dissatisfaction emerges with the current coinage, but it is less likely that the owner of the necklace selected the coins because of the historical merits of the emperors they portray. We needn't imagine a collector with a curatorial quest for specific coins. It may not necessarily be significant that the necklace is graced with two coins each of Hadrian and Antoninus Pius but is without one of Marcus Aurelius (r. 161–80), a logical candidate for inclusion because of his popularity (his wife, Faustina the Younger, is represented). These were the valuable coins on hand for conversion from the medium of exchange to their display on a gold chain around a woman's neck.

The coin necklace and the Blacas Cameo (see FIG. 103) point to the new contexts of imperial imagery at the end of the Empire and in the medieval period. In the former, the coin of the realm is transformed into wearable art, although one with a bankable value and, in the latter, the carved gemstone becomes a talisman for later generations brought up on the tradition of eternal, indomitable Rome. Both works are small portable objects, easy to move and hide during periods of insecurity and violent upheaval. Both also suggest the inadequacy of the terms public and private for works in which ostensibly political subjects can be charged with personal or cryptic meanings tempered by use, custom, and familiarity.

Late antiquity is commonly described as a period that abandoned Classical forms, but the evidence of these two works seems to contradict the notion of a sudden and overwhelming change in taste. Roman art, with its styles inherited from the Hellenistic world and adapted for new patrons in a wide variety of circumstances, held fast in many quarters of the Empire. What changed was the greater demand made upon this Classicism – a loose bag of styles and genres with a common denominator in the representation of the figure – by patrons impatient with the formality of its grand traditions and not hesitant about adapting it to their own purposes or even ignoring its impressive achievements when they no longer had relevance.

The beginnings of this transformation of Roman art have been detected in the art of the affluent tradespeople and artisans in the Mediterranean cities and in the monuments erected by civilians and soldiers in the provinces in the first and second centuries AD. This is only partially true, and assumes that style and

115. Coin necklace with pendants, AD 241–3. Gold, 30¼ x 1½ x 1¼" (76.8 x 3.8 x 3.1 cm). Nelson-Atkins Museum, Kansas City.

The gold chain holds eleven coin pendants separated by spacers while a twelfth is used as the clasp. The coins are framed by openwork settings of different types. Not only the fine work but also the number of coin pendants indicates the exceptional quality of this necklace – no other has so many. The necklace may have come from Egypt, perhaps from Alexandria.

social class are closely and clearly correlated across the board. Yet, as we have seen, freedmen chose from a variety of sources in composing funerary monuments: some aspects were borrowed from the art of the court while others looked to the freedman's commercial *milieu*. It may seem extraordinary that although the society of the Roman Empire classified and stratified its citizens according to wealth and birth, Roman art cannot be categorized in the same precise hierarchical scheme. Not only do variables in status, rank, ethnicity, and gender of patrons complicate the picture of transformation said to have been initiated by the lower orders and provincials, but many of the works commissioned by these groups mask social differences.

Differences in status and rank were muted by the adoption of standard statue types, such as the portraits of citizens in togas or the heavily draped matrons. Conventional statue types appealed to the conservatism of Roman society and created cohesion among members of the same group. Yet some works inflated a sense of self by depicting the patron as more prominent or heroic than he was, as in the stele of the shoemaker Julius Helius with its nude bust (see FIG. 19). Just as the individual was defined by the group, so too, was the group made of individuals who modified the honorific imagery with allusions to grandeur and divinity. Non-elite patrons acquired celebrated Greek statuary in the form of mythological portraits that satisfied their ambition to appear elevated and ennobled by identification with the immortals (see FIGS 67 and 68). That these statues were associated with the imperial court added to their glamor.

Style plays an important role but it is often difficult to extricate style from subject matter in many works. Discussions of Roman style feature a rather impoverished vocabulary polarizing the high classical styles of the processional friezes of the Ara Pacis and the Cancelleria reliefs (see FIGS 16 and 50) with that of the so-called "plebeian" styles – marked by a preference for frontality, hierarchic scale, and a lack of spatial development (see FIGS 24 and 57) – of the art of the urban working classes in the first and second centuries AD. The styles falling in between these two means are less clearly described. Classicism certainly enjoyed a privileged position yet the other stylistic choices may have formed a spectrum around it rather than a hierarchical scale in descending order beneath it. Roman art is often described as "eclectic" in its styles (and subjects) but this may reflect social processes in which patrons moved with ease among several social roles and identities, each with their own motifs and conventions of representation, or sought to keep up with and surpass their

peers with ever more ostentatious wall paintings or imposing houses to enhance their prestige.

Establishing Roman identity is precarious because of the inclusive and open nature of imperial society that encouraged assimilation and also permitted the retention of local customs or indigenous forms of culture. Zoilos (see FIG 29), fluent in both Latin and Greek like many others in public life, achieved renown in the capital and his hometown of Aphrodisias. The sculpted frieze of his tomb exhibits a mastery of the visual codes connoting political honors in the Roman west and the Hellenistic east. Even imagery without overt political content can indicate cultural ties: the sumptuous hairstyles of the portraits in Barcelona and Lisbon (see FIG 64 and 66) do not connote allegiance to Rome nor do they necessarily document the arrival of court fashions in the provinces, but, rather, they embody the cosmopolitan standards of refinement and elegance for proper matrons. Provincials with posts in Rome or wives of local magistrates juggled different social roles out of necessity. Others with prospects of advancement and careers marked by swift turns of fortune commissioned works juxtaposing vernacular and stately motifs in a profusion of styles. Not only were freedmen represented by these works, but freeborn citizens, including bureaucrats, administrators, and the children of freedmen, evoked their affiliations and security through imperial motifs and their backgrounds and affluence through other idiosyncratic motifs in the same works (see FIGS 75 and 78).

The ambivalence between standardization and variation in Roman art, conformity and competition in social life, suggests that the manipulation of the diverse traditions of Roman art allowed for certain discrepancies or dissonances. Given the various functions of Roman art – from distinguishing local notables as benefactors of their cities, to perpetuating the emperor's powers and the responsibilities of the rank and file of soldiers and citizenry – it is not surprising that even standard types and conventions of representation were subject to change and reinterpretation by both high- and low-ranking patrons. Whereas the law codes classified citizens according to status groups without much ambiguity, art allowed for the dissembling of the masquerade and the bombastic overstatement of political rhetoric. Roman art, although conventionally considered "realistic," may not have reflected social reality as much as it conferred the distinction of unattainable ideals or roles performed to perfection by subjects with complex identities and divided loyalties.

Historical events

Culture and the Arts

509 BC	Temple of Jupiter on the Capitoline, Rome
240–247 BC	Livius Andronicus, Roman poet and playwright, active
204–169 BC	Ennius, poet and teacher, active
204–184 BC	Plautus, playwright, active

120–110 BC	Temple of Fortuna at Praeneste
78 BC	Tabularium (Record Hall) built into the slope of the Capitoline, Rome
68 BC	Cicero's correspondence begins
58–52 BC	Caesar writes his account of the Gallic wars
54–46 BC	Forum of Julius Caesar begun
37–30 BC	Horace's *Satires*
28–23 BC	Vitruvius writes *On Architecture*; Virgil writes the epic *Aeneid*; Mausoleum of Augustus

13–11 BC	Theater of Marcellus
9 BC	Ovid's *Art of Love*; Dedication of the Ara Pacis
2 BC	Forum of Augustus dedicated
AD 1–10	Maison Carrée built
AD 49	Seneca is tutor to young Nero
AD 64–8	Nero's Golden House
AD 66	Suicide of Petronius, author of the *Satyricon*

AD 79	Eruption of Vesuvius and death of Pliny the Elder (author of the encyclopedic *Natural History*) while observing it
AD 80	Inauguration of the Colosseum
AD 92	Palatine Palace under construction; Poets, Statius and Martial, and rhetorician, Quintilian, active
AD 100–11	Pliny the Younger (the correspondent and orator) governor of Bithynia; Tacitus writes *Histories* and *Annals*
AD 112–13	Forum of Trajan and Column of Trajan

AD 117–38	The Pantheon in Rome, the villa in Tivoli, and Hadrian's wall in Britain built
AD 143	Herodes Atticus, Greek orator and consul in Rome
AD 144	Aelius Aristides makes his speech in praise of Rome
AD 161–80	Physician Galen active
AD 174–80	*Meditations* of Marcus Aurelius
AD 176	Bronze equestrian statue of Marcus Aurelius
AD 180–92	Column of Marcus Aurelius
AD 193–211	Renovations to Lepcis Magna, the hometown of Septimius Severus, and the erection of the Arch of Septimius Severus in the Roman Forum
AD 216	Baths of Caracalla
AD 271	Aurelian Walls of Rome
AD 307–12	Basilica of Maxentius, appropriated and completed by Constantine (after 312)

Select Bibliography

GENERAL

ANDREAE, B.,*The Art of Rome* (trans. by R.E. Wolf; New York: Abrams, 1977)

BIANCHI-BANDINELLI, R., *Rome: The Center of Power* (trans. by P. Green; New York: Braziller, 1970)

—, *Rome: The Late Empire* (trans. by P. Green; New York: Braziller, 1971)

D'AMBRA, E. (ed.), *Roman Art in Context* (Englewood Cliffs, N.J.: Prentice Hall, 1993)

FANTHAM, E., H.P. FOLEY, N.B. KAMPEN, S.B. POMEROY, and H.A. SHAPIRO (eds), *Women in the Classical World* (New York and Oxford: Oxford University Press, 1994)

KAMPEN, N.B. (ed.), *Sexuality in Ancient Art* (Cambridge and New York: Cambridge University Press, 1996)

KLEINER, D.E.E., *Roman Sculpture* (New Haven and London: Yale University Press, 1992)

KLEINER, D.E.E., and S.B. MATHESON (eds), *I, Claudia: Women in Ancient Rome* (exh. cat.; New Haven: Yale University Art Gallery, 1996)

POLLITT, J.J., *The Art of Rome c. 753 BC–AD 337: Sources and Documents* (Cambridge and New York: Cambridge University Press, 1983; repr. of 1966 edition)

SEBESTA, J.L., and L. Bonfante (eds), *The World of Roman Costume* (Madison: University of Wisconsin Press, 1994)

INTRODUCTION

BRENDEL, O., *Prolegomena to the Study of Roman Art* (New Haven: Yale University Press, 1979)

—, *The Etruscans* (Harmondsworth: Penguin, 1978)

CRISTOFANI, M. (ed.), *La grande Roma dei tarquini* (exh. cat.: Palazzo delle Esposizioni, Rome, 1990; Rome: L'Erma di Bretscheider, 1990)

GRUEN, E.S.,*Culture and National Identity in Republican Rome* (Ithaca: Cornell University Press, 1992)

HOLLOWAY, R. ROSS , *The Archaeology of Early Rome and Latium* (London: Routledge, 1994)

NODELMAN, S., "How to Read a Roman Portrait," *Art in America*, 63 (1975), pp. 26-33 (repr. in D'Ambra, *Roman Art in Context*, pp. 10-26)

PUGLIESE CARRATELLI, G. (ed.), *The Greek World: Art and Civilization in Magna Graecia and Sicily* (trans. by A. Ellis; exh. cat. Palazzo Grassi, Venice, March-December 1996; New York: Rizzoli, 1996)

SILBERBERG-PEIRCE, S., "The Many Faces of the Pax Augusta: Images of War and Peace in Rome and Gallia Narbonensis," *Art History*, 9 (1986), pp. 306-24

THOMPSON, N., *Female Portrait Sculpture of the First Century BC in Italy and the Hellenistic East* (Diss.; Institute of Fine Arts, New York University, 1995)

TRILLMICH, W., *Das Torlonia-Mädchen* (Göttingen: Vandenhoeck & Ruprecht, 1976)

ZANKER, P. (ed.), *Hellenismus in Mittelitalien* (Göttingen: Vandenhoeck & Ruprecht, 1976)

—, *The Power of Images in the Age of Augustus* (trans. by A. Shapiro; Ann Arbor: University of Michigan Press, 1988)

—, "Individuum und Typus," *Archäologischer Anzeiger* (1995), pp. 473-81

CHAPTER ONE

DAVIES, R.W., *Service in the Roman Army* (New York: Columbia University Press, 1989)

GARNSEY, P., and R. SALLER, *The Roman Empire* (Berkeley and Los Angeles: University of California Press, 1987)

GIARDINA, A. (ed.), *The Romans* (trans. by L.G. Cochrane; Chicago and London: University of Chicago Press, 1993)

KAMPEN, N.B., *Image and Status: Roman Working Women in Ostia* (Berlin: Gebr. Mann Verlag, 1981)

KLEINER, D.E.E., *Roman Group Portraiture: The Funerary Reliefs of the Late Republic and the Early Empire* (New York: Garland Press, 1977)

—, *Roman Imperial Funerary Altars*

with Portraits (Rome: Bretschneider, 1987)

KOCKEL, V., *Porträtreliefs Stadtrömischer Grabbauten* (Mainz: Philipp von Zabern, 1993)

SMITH, R.R.R., *The Monument of C. Julius Zoilos* (Mainz: Philipp von Zabern, 1993)

ZANKER, P., *Pompei* (trans. by A. Zambrini; Torino: Einaudi, 1993)

ZIMMER, G., *Der römische Berufsdarstellungen* (Berlin: Gebr. Mann Verlag, 1982)

CHAPTER TWO

ALFÖLDY, G., "Die Inschrift des Aquäduktes von Segovia: ein Vorbericht," *Zeitschrift für Papyrologie und Epigraphik*, 94 (1992), pp. 231-48

BARTSCH, S., *Actors in the Audience* (Cambridge, Mass.: Harvard University Press, 1994)

BIEBER, M., *The History of the Greek and Roman Theater* (Princeton: Princeton University Press, 1961)

BOATWRIGHT, M.T., *Hadrian and the City of Rome* (Princeton: Princeton University Press, 1987)

CURRIE, S., "The Empire of Adults: The Representation of Children on Trajan's Arch at Beneventum," in J. Elsner (ed.), *Art and Text in Roman Culture* (Cambridge and New York: Cambridge University Press, 1996), pp. 153-81

D'AMBRA, E., "Mythic Models of the Roman Social Order in the Cancelleria Reliefs," *Fenway Court* (Boston: The Isabella Stewart Gardner Museum, 1994), pp. 72-90

DUNBABIN, K., *"Baiarum Grata*

Voluptas: Pleasures and Dangers of the Baths," *Papers of the British School at Rome*, 57 (1989), pp. 6-46

FEHR, B., "Das Militär als Leitbild: Politische Funktion und Gruppenspezifische Wahrnehmung des Traiansforums und der Traianssaüle," *Hephaistos*, 7/8 (1985-6), pp. 39-60

FELLETTI MAJ, B.M., *La tradizione italica nell'arte romana* (Rome: Bretschneider, 1977)

K. FITTSCHEN, "Das Bildprogramm des Trajansbogen zu Benevent," *Archäologischer Anzeiger*, 87 (1972), pp. 742-88

HAMBERG, P.G., *Studies in Roman Imperial Art with Special Reference to the State Reliefs of the Second Century* (Copenhagen, 1945)

HÖLSCHER, T., *Römische Bildsprache als semantisches System* (Heidelberg: Carl Winter Universitätsverlag, 1987)

HUMPHREY, J., *Roman Circuses* (London: B.T. Batsford Ltd., 1986)

JACOBELLI, L., *Le pitture erotiche delle Terme Suburbane di Pompei* (Rome: L'Erma di Bretschneider, 1995)

MACDONALD, W., *The Architecture of the Roman Empire*, 2 vols (New Haven and London: Yale University Press, 1982-86)

MAGI, F., *I relievi flavi del Palazzo della Cancelleria* (Rome, 1945)

PURCELL, N., "Forum Romanum (The Rebublican Period)," and "Forum Romanum (The Imperial Period)," in E.M. Steinby (ed.), *Lexicon Topographicum Urbis Romae*,

vol. 2 (Rome: Edizioni Quasar, 1995), pp. 325-42

RICHARDSON, Jr., L., *Pompeii: An Architectural History* (Baltimore and London: Johns Hopkins University Press, 1997)

RYBERG, I.S., *Rites of the State Religion in Roman Art* (Rome, 1955)

SETTIS, S. (ed.), *La colonna traiana* (Turin, 1988)

TORELLI, M., *The Typology and Structure of Roman Historical Reliefs* (Ann Arbor: University of Michigan Press, 1982)

WARD-PERKINS, J.B., *Roman Imperial Architecture* (Harmondsworth: Penguin, 1981)

WIEDEMANN, T., *Emperors and Gladiators* (London and New York: Routledge, 1992)

YEGÜL, F., *Baths and Bathing in Classical Antquity* (New York and Cambridge, Mass.: The Architectural History Foundation and MIT Press, 1992)

CHAPTER THREE

BIANCHI BANDINELLI, R., *et al.*, *Sculture municipali dell'area sabellica tra l'età di Cesare e quella di Nerone*, StMisc, 10 (Rome, 1966)

BRILLIANT, R., *Visual Narratives* (Ithaca and London: Cornell University Press, 1984)

CALZA, R., *Scavi di Ostia: I ritratti*, vol. 9 (Rome: La Libreria dello Stato, 1977)

CONLIN, D.A., *The Artists of the Ara Pacis* (Chapel Hill and London: University of North Carolina Press, 1997)

D'AMBRA, E., "The Calculus of

Venus: Nude Portraits of Matrons," in N.B. Kampen (ed.), *Sexuality in Ancient Art* (Cambridge and New York: Cambridge University Press, 1996), pp. 219-32

—, "Mourning and the Making of Ancestors in the Testamentum Relief," *American Journal of Archaeology*, 99 (1995), pp. 667-81

FELLETTI MAJ, B.M., *Museo Nazionale Romano: I ritratti* (Rome: La Libreria dell Stato, 1953)

FITTSCHEN, K., "Bildnis einer Frau Trajanicher Zeit aus Milreu," *Madrider Mitteilungen*, 34 (1993), pp. 202-9

—, "Courtly Portraits of Women in the Era of the Adoptive Emperors (AD 98-180) and their Reception in Roman Society," in D.E.E. Kleiner and S.B. Matheson (eds), *I, Claudia: Women in Ancient Rome* (New Haven: Yale University Art Gallery, 1996), pp. 42-52

H. VON HESBERG, *Monumenta: I sepolcri romani e la loro architettura* (trans. by L. di Loreto; Milan: Longanesi, 1994)

KOCH, G., *Sarkophage der römischen Kaiserzeit* (Darmstadt: Wissenschaftliche Buchgesellschaft, 1993)

MONTSERRAT, D., "The Representation of Young Males in Fayum Portraits," *Journal of Egyptian Archaeology*, 79 (1993), pp. 215-25

ROSE, C.B., *Dynastic Commemoration and Imperial Portraiture in the Julio-Claudian Period* (Cambridge and New York: Cambridge University Press, 1997)

SMITH, R.R.R., "The Imperial Reliefs of the Sebasteion in Aphrodisias," *Journal of Roman*

Studies, 77 (1987), pp. 88-138

SMITH, R.R.R., and C. Ratté, "Archaeological Research at Aphrodisias in Caria, 1995," *American Journal of Archaeology*, 101 (1997), pp. 20-22, figs. 16-18

TOYNBEE, J.M.C., *Death and Burial in the Roman World* (Baltimore and London: Johns Hopkins University Press, 1996; repr. of 1971 ed.)

WALKER, S., and M. BEIRBRIER (eds), *Ancient Faces* (exh. cat., British Museum, London, 1997; London British Museum Press, 1997)

WOOD, S., "Alcestis on Roman Sarcophagi," *American Journal of Archaeology*, 82 (1970), pp. 499-510 (repr. in D'Ambra, *Roman Art in Context*, pp. 84-103)

WREDE, H., *Consecratio in Formam Deorum* (Mainz, 1981)

CHAPTER FOUR

BERGMANN, B., "The Roman House as Memory Theater: The House of the Tragic Poet in Pompeii," *Art Bulletin*, 76 (1994), pp. 225-56

CLARKE, J.R., *The Houses of Roman Italy 100 BC-AD 250* (Berkeley and Los Angeles: University of California Press, 1991)

GAZDA, E. (ed.), *Roman Art in the Private Sphere* (Ann Arbor: University of Michigan Press, 1991)

JASHEMSKI, W., *The Gardens of Pompeii*, 2 vols (New Rochelle, N.Y.: Caratzas Bros., 1979)

LING, R., *Roman Painting* (Cambridge and New York: Cambridge University Press, 1991)

PURCELL, N., "The Roman Garden as a Domestic Building," in I. Barton (ed.), *Roman Domestic Buildings* (Exeter: University of

Exeter Press, 1996), pp. 121-51

WALLACE-HADRILL, A., *Houses and Society in Pompeii and Herculaneum* (Princeton: Princeton University Press, 1994)

—, "Engendering the Roman House," in D.E.E. Kleiner and S.B. Matheson (eds), *I, Claudia: Women in Ancient Rome* (New Haven: Yale University Art Gallery, 1996), pp. 104-15

ZANKER, P., *Pompei* (trans. by A. Zambrini: Torino: Einaudi, 1993)

—, "Die Villa als Vorbild des späten Pompejanischen Wohngeschmacks," *Jahrbuch des Deutschen Archäologischen Instituts*, 94 (1979), pp. 460-523

CHAPTER FIVE

BIANCHI BANDINELLI, R., *Rome: The Late Empire* (trans. by P. Green; New York: Braziller, 1971)

BROWN, P., *The World of Late Antiquity, AD 150-750* (London: Thames and Hudson, 1971)

DUNBABIN, K., *The Mosaics of Roman North Africa* (Oxford: Clarendon Press, 1978)

ELSNER, J., *Art and the Roman Viewer* (Cambridge and New York: Cambridge University Press, 1995)

MACCORMACK, S., *Art and Ceremony in Late Antiquity* (Berkeley and Los Angeles: University of California Press, 1981)

MACMULLEN, R., "Some Pictures from Ammianus Marcellinus," *Art Bulletin*, 46 (1964), pp. 435-55

WILSON, R.J.A., *Piazza Armerina* (Austin: University of Texas Press, 1983)

ZANKER, P., *The Mask of Socrates* (Berkeley and Los Angeles: University of California Press, 1995), ch. 6

Picture Credits

Collections are given in the captions alongside the illustrations. Sources for illustrations not supplied by museums or collections, additional information, and copyright credits are given below. Numbers are figure numbers unless otherwise indicated.

Aerofototeca dell'Istituto Centrale per il Catalogo e la Documentazione, Rome: 34

Alinari, Florence: 10 (Villa Albani, Rome # 984), 32, 91, 104

Antalya Museum, Turkey: 28 (# 3453)

© The British Museum, London: 12 (# BMC RR Rome 4030 OBV 3:1), 59 (# 1381), 95 (# 1960.2-1.2), 103 (# 3577), 113, 114

© Canali Photobank, Capriolo: frontispiece, 3, 4, 7, 11, 17, 19, 21, 47, 48, 53, 55, 56, 57, 67, 68, 71, 73, 74, 78, 83, 86, 94, 96, 97, 99, 101

Colchester Museums, Essex: 41, 30

Ny Carlsberg Glyptotek, Copenhagen: 23 (# 2799, photo © Ole Haupt), 61 (# 536)

Courtesy the Director General of Antiquities and Museums, Damascus: 77, 111

© Araldo De Luca, Rome: 50, 58, 75

Photo Deutsches Archäologisches Institut, Rome: 14 (negative number 55.93) Villa Albani Rome # 489

Photo Deutsches Archäologisches Institut, Madrid: 64 (negative number L 124)

C.M.Dixon, Canterbury, Kent: 105

Skulpturensammlung, Dresden: 44 (# ZV, photo Hans-Peter Kult, Dresden, 27

Fotografica Foglia, Naples: 6, 26, 45, 72, 88, 89, 90, 92, 93, 98, 100, 110

Robert Harding Picture Library, London: 36 (photo Ken Gillham), 38, 40

A.F. Kersting, London: 42

© Studio Kontos, Athens: 108

Arquivo Nacional de Fotografia - Instituto Português de Museus, Lisbon: 66

Photographic Archive, Museo Arqueológico Nacional, Madrid: 63,

(c) Paul M.R. Maeyaert, Mont de l'Enclus, Orroir, Belgium: 18, 37

The Metropolitan Museum of Art, New York: 69 (Rogers Fund, 1905 (05.30)

The Nelson-Atkins Museum of Art, Kansas City, Missouri: 115 (Purchase: Nelson Trust), 56-77

Courtesy of the New York University Excavations at Aphrodisias: 60, 62

© Franc Palaia, New Jersey: 15, 22, 24, 29, 31, 39, 43, 44, 46, 49, 76, 79, 81

© RMN, Paris/H.Lewandwoski: 65 (Louvre # 1196)

© RMN, Paris/R.G.Ojeda: 82

Scala, Florence: 1, 5, 8, 9, 16, 51, 52, 70, 84, 85, 102, 109

Soprintendenza Archeologica di Pompei: 35, TAP Service, Athens: 13

Chapter opener details:
Introduction p. 9, detail of FIG. 17 p. 34
Chapter One, p. 39, detail of FIG. 27 p. 51
Chapter Two, p. 59, detail of FIG. 52 p. 84
Chapter Three, p. 93, detail of FIG. 75 p. 116
Chapter Four, p. 127, detail of FIG. 101 p. 144

Index